Santa Monica Public Library

I SMP 00 1819868 5

W9-AUD-748

rials

niques

SANTA MONICA PUBLIC LIBRARY AUG - - 2008

Complete Guide to

Materials and Techniques

for Drawing and Painting

SANTA MONICA PUBLIC LIBRARY

AUG - - 2008

Complete Guide to Materials and Techniques for Drawing and Painting

English language edition for the United States,
its territories and dependencies, and Canada
published 2008 by Barron's Educational Series, Inc.

© Copyright of the English edition 2008
by Barron's Educational Series, Inc.

Original title of the book in Spanish:
Materiales y Técnicas Guía Completa
Copyright © 2007 by Parramón Ediciones, S.A.—
World Rights

All rights reserved. No part of this book may be
reproduced in any form, by photostat, microfilm,
xerography, or any other means, or incorporated into any
information retrieval system, electronic or mechanical,
without the written permission of the copyright owner.

All inquires should be addressed to:
Barron's Educational Series, Inc.
250 Wireless Boulevard
Hauppauge, NY 11788
www.barronseduc.com

ISBN-13: 978-0-7641-6111-7
ISBN-10: 0-7641-6111-3

Library of Congress Control Number: 2007931258

Editor: María Fernanda Canal
Editorial Assistant: Carmen Ramos
Text: David Sanmiguel
Exercises: Josep Asunción, Vicenç Ballestar, Ricardo
Bellido, Marta Bermejo, Almudena Carreño, Mercedes
Gaspar, Gabriel Martín, Esther Olivé de Puig, Óscar
Sanchís, David Sanmiguel, Josep Torres, Yvan Mas
Graphic Design: Toni Inglès
Photography: Estudio Nos & Soto, Parramón Archives
Production: Rafael Marfil

Translation: Michael Brunelle and Beatriz Cortabarria

Printed in Spain

9 8 7 6 5 4 3 2 1

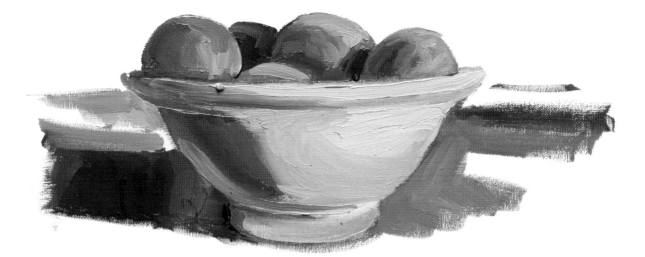

Complete Guide to
Materials
and Techniques
for Drawing and Painting

Contents

MATERIALS

TECHNIQUES

Introduction

The enormous number of materials and tools that are available to artists nowadays is exponentially greater than the number of materials that were available in art stores just ten or fifteen years ago. The reasons are varied: the merging of brands into multinational conglomerates that constantly offer new products is one reason; the opening of local markets to those conglomerates is another. In addition, the advances of modern chemical industries have revolutionized the production of binders, and with it, the fabrication of paints. The result is that the availability of fine art products is growing and changing all the time. This gives the artist the advantage of being able to find products that are much more in tune with their particular needs. But it also has some disadvantages, one of them being that the tools that the artist was accustomed to disappear overnight due to the inflexible demands of a global market.

Based on the idea that the artist has always been able to obtain, what he or she needs, no matter the period, the goal of this book is to educate the reader so he or she can make the best choices from among the products that flood the shelves of art stores. Today more than ever, both the beginner and the professional need reliable information that will help them discern the real novelties from the products in "disguise." This is a book that allows artists to identify any material, new or traditional, that may come their way.

All of the drawing and painting materials are covered in the first half of this book: from drawing pencils and papers to acrylic paints, including the different mediums, solvents, varnishes, and the many additives that are available. This is not only a complete guide but it also contains comments, advice, and suggestions about the use of each tool and how to choose from among them, with the different consequences that result from each choice.

The second half of the book is devoted to techniques. Here we show the results that can be achieved with the tools presented in the first part. Only those materials that are truly relevant and that can provide an idea of the range of products derived from them are used. There are a total of 50 examples covering a wide field of subjects and styles so the artist can see how the materials that he or she studied on the previous pages can be handled and the results that can be obtained with them.

This is an accessible book for the beginner and the professional alike; it is a reference book that is useful and needed by anyone who wishes to learn or to improve their skills in the field of fine arts.

Materials

The graphite pencil

Pencils were first made toward the middle of the 16th century in Keswick (United Kingdom) as a result of the discovery of graphite in the town of Borrowdale. The primitive form of the pencil consisted of a piece of graphite wrapped in sheepskin.

When its use spread across Europe, artists tried different variations until the Italians came up with a wood cover that made pencils easier to use. The graphite was cut into sheets and then in turn into bars that were fitted into long grooves carved in wooden sticks. Mass production of pencils did not begin until the middle of the 18th century, at the onset of the industrial revolution. In those days, Cumberland in England and Nuremberg in Germany became the two big centers of pencil production. The discovery in Asia of graphite mines of great purity allowed German and French manufacturers (Faber-Castell and Conté, respectively) to break the almost complete monopoly of Cumberland and to begin mass production. Nowadays, Nuremberg is the main center for pencil manufacturing.

European manufacturers deliver their pencils already sharpened mechanically.

When the pencil wears down during the process of drawing it creates edges. The line varies in thickness according to the position of the lead.

Faber-Castell series 9,000 graphite pencil, the oldest series of quality graphite pencils still in use.

hexagonal section

information regarding the hardness of the pencil

protective finish

Cedarwood

This is the wood with which pencils are made: it is sufficiently soft to facilitate sharpening and it is sufficiently resistant and rigid to assure a good quality pencil. Nowadays, the immense majority of the pencils produced in the world are made of cedarwood from California. The cedar tree is constantly replanted in an effort to maintain our ecosystem. As an alternative, there are pencils designed for school use that replace the wood with a compound of pasteboard and recycled fibers. Much less advisable are pencils made with soft tropical wood, which are less ecological. These can be identified by the small reddish marks visible in the wood.

cedarwood

plastic

This is the ideal way of holding the pencil for drawing.

Only cedar has all the quality requirements for a good pencil. Other woods have a clearly different texture and are either too soft or too hard.

low-grade wood

The manufacturing of pencils

Cedar trunks are cut into cubes and they in turn are cut into planks. A series of parallel grooves the size of the diameter of the pencil is cut on each plank. The leads are placed in the grooves and the entire piece is precisely glued to an identical plank. This sandwich of leads is cut into strips so that each one contains a lead; finally, each strip is shaped into a hexagon, and its surface is varnished or painted and the tip sharpened.

The cedarwood is cut into blocks and they in turn are cut into 1/8 inch (3 mm) planks. Grooves are cut lengthwise into the planks where the leads are inserted. Another plank is glued on top of the first one. The sandwich is cut into strips, each of them containing a lead. Each strip is shaped, varnished, and stamped, and finally the pencil is sharpened.

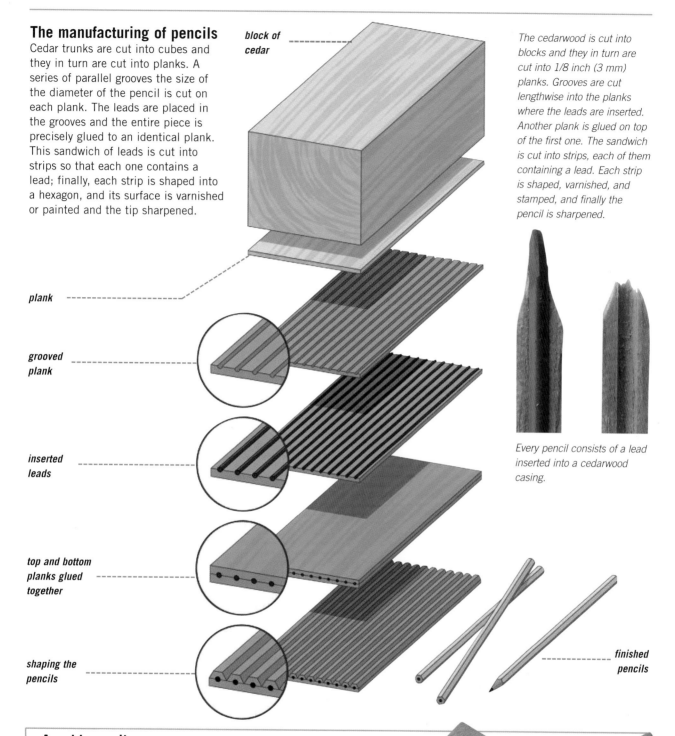

block of cedar

plank

grooved plank

inserted leads

top and bottom planks glued together

shaping the pencils

finished pencils

Every pencil consists of a lead inserted into a cedarwood casing.

An old pencil

Among several of the old versions of graphite pencils are some made of wire wrapped around a piece of graphite. The wire was unwrapped as the lead wore off. The immediate predecessor of the modern pencil was a strip of graphite inserted into a piece of wood that had a deep groove cut into it. A modern version of a similar style would be this "emergency lead holder" made with a clothespin.

The hardness of graphite

Graphite is a shiny lead-colored metal discovered in 1564 in Borrowdale, England. It was first believed to be some form of lead until the Swedish chemist Karl Wilhelm Scheele showed in 1779 that it was crystallized coal. In 1789 the German geologist Abraham G. Werner named it graphite in honor of its use as a writing instrument.

The confusion with lead persists to this day: people still talk about "lead pencils" when referring to graphite and the English word used for the pencil tip continues to be lead. Originally, graphite was used in its pure form and its hardness varied tremendously depending on where it came from. Manufacturers Conté, Faber, and Hartmuth simultaneously developed the method for producing modern graphite leads at the end of the 18th century by mixing the

powdered form of this metal with ceramic clay and then firing the mixture to harden it. The higher the clay content the harder the lead will be, whose thickness is about 1/10 inch (2.5 mm) in most brands. A hard lead can be sharpened much more often than a soft one and it will make a thinner and much lighter line. All pencil manufacturers make pencils of various hardness, reaching up to a maximum of 20 different types.

Pieces of natural graphite. Graphite is crystallized coal that is oily to the touch and leaves a mark when rubbed against a hard surface.

Graphite powder used to make pencil leads.

Ceramic clay powder. The clay is mixed and fired together with the graphite in various proportions to make pencils of different grades of hardness.

Powder graphite is very dark and does not adhere to paper very well.

Proportions of graphite and clay

2H pencil **HB pencil** **2B pencil**

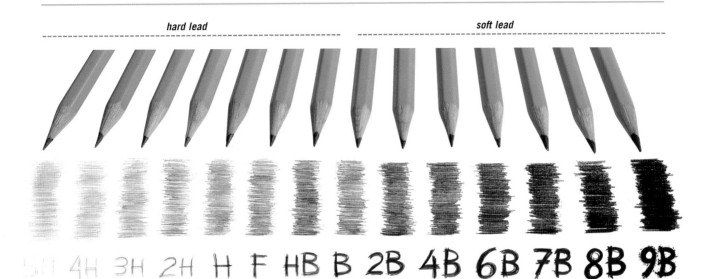

hard lead · · · · · · · · · · · · · · · soft lead

5H 4H 3H 2H H F HB B 2B 4B 6B 7B 8B 9B

Degrees of hardness

The hardness of a pencil lead is stamped on its handle with a single number: the higher the number the harder the lead will be. This is characteristic of the writing varieties (typically in the ones manufactured by the Staedler brand), which range from 1 to 4. In high quality varieties the inscription includes the letters H (hard) or B (soft) together with the numbering system that indicates the degree of hardness or softness. Some writing pencils include the inscription F, which means that the lead can be sharpened a lot (because the lead is hard). The inscription HB, which can be interpreted as "neither hard nor soft," corresponds to a mid range in the most common varieties and is the most suitable for writing.

Pencils are arranged in a progressive sequence of hardness. The label B indicates soft leads and H hard leads.

Many manufacturers provide graphite pencils in various degrees of hardness. Artists always use softer leads, while illustrators and draftsmen that work with technical drawings use pencils with harder leads that make lighter and more precise lines.

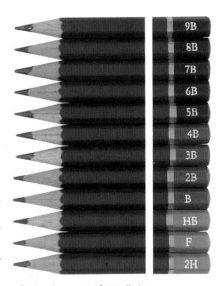

Cretacolor range of pencils in 12 different degrees of hardness.

Most of the manufacturers make graphite pencils that are soluble in water (watercolors), which usually have softer leads (a). The Lumograph variety, by Staedler, has the particular characteristic that its 7B pencil is softer than the pencils made by other manufacturers labeled with higher degrees of softness (b). The Noris series, also by Staedler, includes a color code in its lower part, which indicates its hardness, in addition to a number, from 0 to 4, next to the conventional label (c).

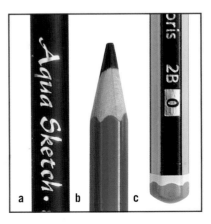

Graphite sticks and leads

The advantage of graphite mixed with ceramic clay is evident in the many varieties available of leads and graphite sticks.

The hardness of the leads manufactured through modern technology makes it possible to bypass the need for a wood casing with pieces of solid mineral in various forms and sizes. The appeal of these tools resides in their direct handling, the ability to use the entire piece of graphite, and in the fact that the artist does not require a sharpener (unless there is a need for a very sharp tip), because the tip is always exposed. The advantage of these tools can be found in the absence of wood: the thinnest leads, due to this very characteristic, do not need to be sharpened and the thickest ones make it possible to draw lines wider than any pencil could, in addition to the ability to draw areas of gray shading when the stick is held flat on the paper.

Sticks

The thicker pieces of bound graphite range between 3/8 and 3/4 inches (10 and 15 mm) in width. The thickest ones available are manufactured by Cretacolor, which are round and similar in shape to the pastel sticks and with a single degree of hardness (7B). Faber-Castell and Lyra make hexagonal sticks in four and nine levels of hardness, respectively; the softest variety by Lyra (9B) is probably the one that make the densest line of all the types available on the market. The Derwent and Cretacolor brands also produce smaller square (in six levels of hardness) and rectangular (in four levels of hardness) sticks.

Large sticks contain large amounts of graphite mixed with a required amount of ceramic clay to provide the necessary hardness that makes the stick hold its shape.

- - - - - - - - - smooth sides

**granules of
graphite and clay**

Shading created with a graphite stick. *Shading created with a graphite pencil.*

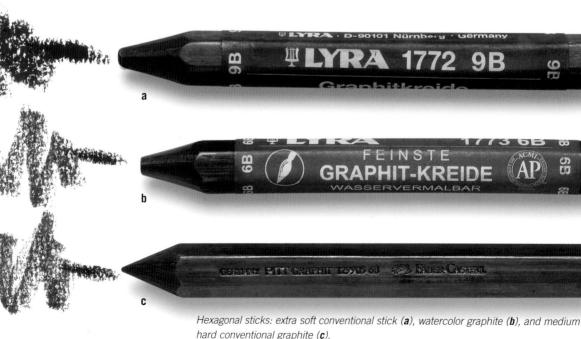

*Hexagonal sticks: extra soft conventional stick (**a**), watercolor graphite (**b**), and medium hard conventional graphite (**c**).*

Leads

Graphite leads can be divided into two groups: the ones designed to be used with a lead holder and those that can be handled as a conventional pencil. The former range in thickness from 1/24 inch (1 mm) (and even less) to 1/4 inch (6 mm), depending on the brand. The leads in the shape of a pencil ("all lead") can be easily sharpened and are available in different degrees of hardness (from four to six, depending on the manufacturer). In the last few years, the tendency to produce watercolor varieties for all graphite leads and sticks has increased. Nowadays, almost all brands have these versions in the different types and presentations.

Together with the hexagonal varieties, the thickest graphite sticks are the round, rectangular, and square formats.

Water soluble graphite

The water soluble varieties of graphite reach their full potential when they are presented in lead format, and especially, in stick format. Obtaining shading and washes with dry applications is most effective when those applications are wide and the wash can be extended liberally on the paper. The softer varieties of watercolor graphite are greatly recommended if the artist wishes to get the most out of this medium.

Even though the standards of hardness of graphite leads are always the same (soft varieties labeled with the letter B), each brand offers slightly different intensities and different color lines due to the raw material's origin and the manufacturing process.

Graphite stick and the grain of the paper

The applications of graphite expose the texture of the paper on which they are drawn. This must be taken into consideration before drawing: a heavy grain paper provides a textured finish that is more open in appearance than smooth paper.

soft grain *medium grain* *heavy grain*

Colored pencils

The lead in a colored pencil is a mixture of pigments, clay, wax, and binders. Pigments are the substances that give color to the lead; the rest of the components provide the hardness (the clay), softness (the wax) and, in the case of watercolor leads, solubility. Despite their simple appearance, colored pencils are sophisticated tools. For a small lead to be durable, contain the maximum amount of pigment, and be able to make a continuous and soft line, it must go through a very involved manufacturing process. Many of the colored pencils that are available on the market contain too much wax, they are hard, and their color is not sufficiently strong: they are only suitable for schools.

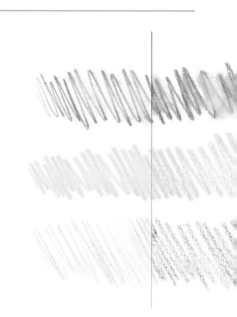

The lead in colored pencils is made of very finely ground pigments bound with clay and different types of wax.

Hard lead pencils

Large manufacturing companies of colored pencils produce (at least) two large series: hard lead pencils and soft lead pencils. The former contain a greater amount of additives so the lead can be sharpened very finely, allowing the artist the opportunity to work on minute drawings. This requires a reduction in the amount of pigments, and, therefore, the pencils have less covering power and it is more difficult to achieve surfaces of saturated color. These pencils tend to be hexagonal.

Color combinations are created with crosshatching.

Hard lead pencils have a low level of saturation.

Large colored pencil manufacturing companies make varieties of up to 120 different colors.

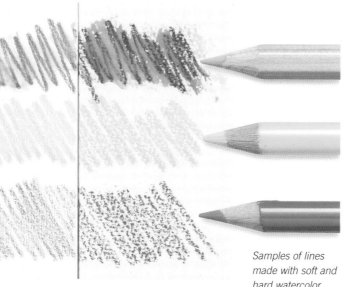

Watercolor pencils

Some of the good quality, hard-lead colored pencil varieties can be used as watercolors, that is, they can be diluted with water. This way, their low covering power is compensated by the possibility they provide for making washes. The result is not exactly the same as that of a watercolor because the amount of pigment involved is much lower. But one must keep in mind that the appeal of colored pencils resides precisely in the delicate and graceful line, and this gets lost with watercolors.

Samples of lines made with soft and hard watercolor pencils on three different types of paper; from left to right: satin paper, conventional drawing paper, and medium grain watercolor paper.

Soft lead pencils

The greater content of pigment in the leads of these colored pencils makes them thicker and this forces the reduction of the amount of other additives; the line is also thicker and presents a more saturated color. The greater presence of pigment makes the lead more fragile and the tip wears down very quickly. These pencils are usually round.

Hard lead pencils (left) have less covering power than the soft ones (right).

Soft lead pencils have a high degree of saturation.

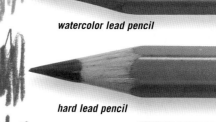

watercolor lead pencil

hard lead pencil

soft lead pencil

Assortments and special varieties

Caran D'ache, Derwent, Lyra, Faber-Castell, Bruynzeel, and Cretacolor are some of the main manufacturers that produce high-quality colored pencils. Every one of them has extensive color selections in the different generic varieties (hard, soft, and watercolor lead pencils). The boxes and assortments are spectacular in many cases, although each color can be purchased separately. In the case of colored pencils, unlike other art

mediums, it is better to purchase a large assortment from the beginning rather than buying the favorite colors one by one: the difficulty of creating combinations makes it necessary to have the greatest selection possible and the boxes become almost a required item to store the material in an orderly fashion.

An assortment of about 40 colors is usually enough, although professionals use varieties of up to 120 colors.

Arranging the pencils

The boxes sold by large art supply companies are very useful: their individual compartments help keep the pencils organized and always visible, avoiding the confusion that can ensue on the worktable when using very many different colors. To find every color quickly, it is important to keep the pencils organized by range (grays, reds, greens, etc.) from lightest to darkest or vice versa. This is how the pencils are arranged in the large boxes that are shown on this page.

Basic assortment of 24 soft lead, professional grade colors for sketching and general projects.

A selection of 40 high-quality watercolor pencils suitable for precision illustration as well as for conventional drawing.

Each manufacturer provides different size boxes of varying degrees of luxury, depending on the quality of the pencils.

Coloring with graphite

The Derwent brand offers a line of watercolor pencils (Derwent *Graphitint*) made with a mixture of graphite and pigments. The colors (with a grayish tendency) go very well with the tones of graphite drawings and are designed to complement them.

These are colored pencils and leads of special quality designed for sketching and for work that requires particular tones, blends, or for large pieces.

Metallic colors

Derwent *Metallic* and Faber-Castel *Metallic* are two lines of metallic colors that include bright colors that mimic metallic tones.

Large pencils

Normally, these are designed with children in mind and are not of high quality. But Lyra and Stabilo produce quality large pencils that can be used for sketching and spontaneous work.

Permanent colors

The Stabilo brand produces a series of permanent colors (*Lumocolor*) with an oil base, designed to draw on shiny or satin surfaces. Their line is dense and thick.

The pencils by Dixon *China Marker* fulfill a function similar to the former. The tip of this pencil does not need to be sharpened, instead it is exposed by pulling a string that removes the thin layers of wood that are wrapped around its lead.

Pencils for blending

Lines made with colored pencils are hard to blend together. Artists use hatching to achieve similar effects to those of a real blend. A white pencil can be repeatedly rubbed over colored lines to make the waxes blend together. The *Rembrandt Splender* pencil by Lyra is especially designed to achieve this fusion effect.

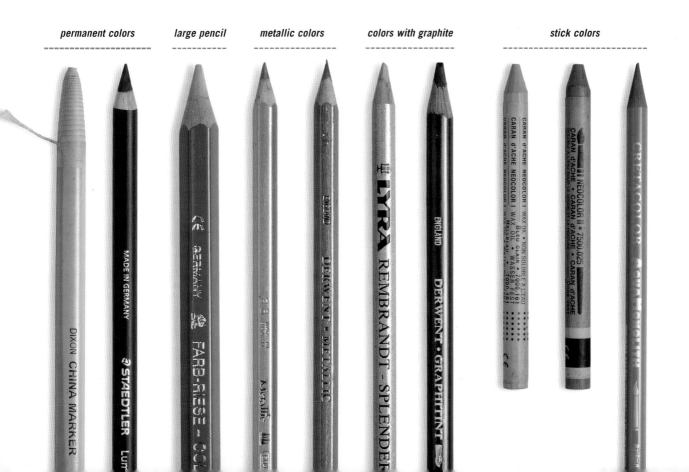

permanent colors *large pencil* *metallic colors* *colors with graphite* *stick colors*

Pastel pencils

These are pencils whose leads have a high percentage of pigment and just enough binding material to make them hard enough to stand sharpening. This larger content of pigment results in thick lines of very saturated color and good covering power with visible free particles of pigment, similar to the typical effect of pastels. The lead is not easy to sharpen and is too thick and brittle for conventional pencil sharpeners; an alternative is to use special sharpening blades that are in very good condition or a craft knife with a sharp blade.

Characteristics

Pastel pencils are somewhat larger than normal pencils; this is due to the fact that the lead has a greater amount of pigment in it than a conventional colored pencil and is thicker. This is also the reason why the lines are denser and have greater covering power than a normal colored pencil. The lead is coarser than that of a color pencil and harder than a pastel stick. It is brittle and some-what fragile; it is important to avoid dropping the pencil because the lead can break in different places inside, rendering it practically unusable.

The lead in pastel pencils is very brittle due to its high pigment content and its low proportion of agglutinative.

Low-quality pencils can scratch the paper because the binding of the lead's pigment is bad. The lines should be even and continuous.

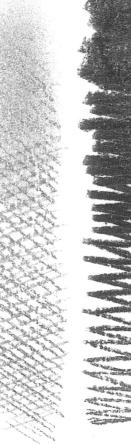

Pastel pencil lines can be crosshatched like conventional pencils and blended like typical pastels.

The lines of a good quality pastel pencil can be almost as thin as those of conventional colored pencils, but they also allow maximum color saturation.

Pastel pencils are not easy to sharpen with conventional pencil sharpeners: the delicate lead is prone to breaking. It is better and safer to sharpen them with a blade or craft knife.

Assortments

The manufacturers of pastel pencils provide very complete assortments of colors, although not as extensive as colored pencils. This is due to the fact that pastel pencils are used primarily to create more liberal and less precise art work than that made using conventional colored pencils. Drawings created with pastel pencils look more similar to pastel paintings than linear pencil drawings.

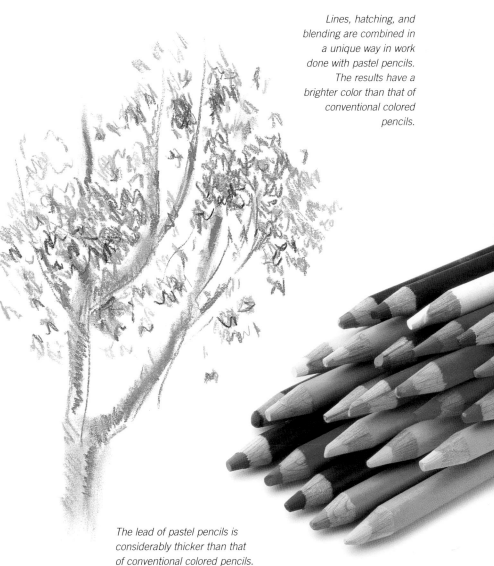

Lines, hatching, and blending are combined in a unique way in work done with pastel pencils. The results have a brighter color than that of conventional colored pencils.

Lines drawn with pastel pencils can be easily blended with a cotton ball, rag, or with the fingers.

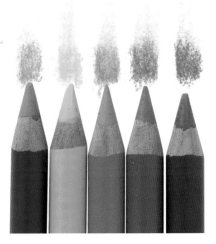

The lead of pastel pencils is considerably thicker than that of conventional colored pencils.

Using pastel pencils

For a person who has never worked with them, pastel pencils are somewhat demanding and require a period of adaptation. They are not suitable for small work, they are difficult to handle, and the line does not respond well to the pressure that the hand exerts on the paper. They work best when combined with conventional pastels in medium-size pieces; it is here where they display their versatility when working with lines, nuances, and touch-ups. The lines can be easily blended with the fingers, a cotton ball, or a blending stick.

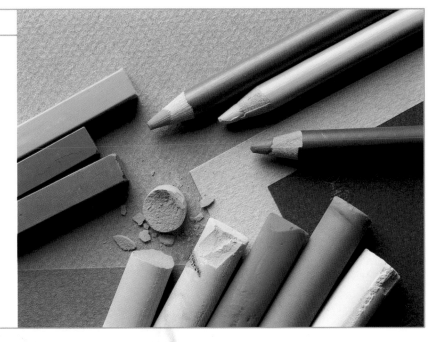

Sanguine pencils and sticks

Sanguine is the traditional name of a red iron oxide pigment that, bound in leads or sticks, is used for drawing.

The name sanguine is given to a lead that has an earth red color (an iron oxide red). Sanguine has been used by artists since the Renaissance. It is a natural pigment that is not used in the production of paints due to its low coloring power. It is sought after by a great many artists for the quality of its color in drawings, where it is used by itself or together with other drawing media. It is sold in pencil format (pastel pencils with sanguine lead), in lead form, sticks, and also as a powder.

Sanguine colors

Those who love to draw with sanguine know very well that every manufacturer produces a sanguine color that is slightly (and sometimes not so slightly) different. The color variation ranges from purplish red to reddish orange. Even the same manufacturer can market sanguine pieces with the same name that vary slightly in color due to the differences in the batches of pigment used. It is therefore important to check the color of the stick or pencil before buying.

Sanguine sticks make it possible to create wider gradations than pencils.

Sanguine sticks and leads. From left to right: large round stick of "sanguine pastel" and lead for a lead holder; square semi-oil stick and two sticks, rectangular and square in that order.

Sanguine sticks

The most commonly used sanguine sticks are the square ones, which are exactly the same shape and size as conventional hard pastels. This is the classic presentation originally introduced by Conté and adopted by many other manufacturers (especially Talens and Faber-Castell).

The differences between two different brand sanguine colors are pronounced, especially if we alternate lines made with dry and oil leads.

Sanguine provides the best results in figure drawing, especially for drawing nudes. Work by Ramón Noé.

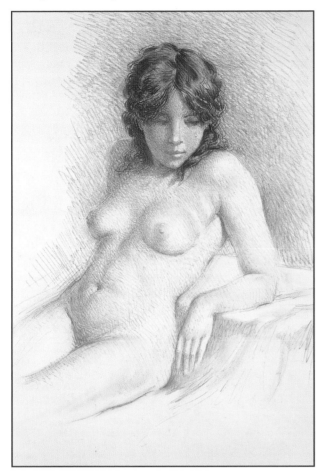

Sharpening sanguine pencils

Sanguine pencils, leads, and sticks seem to be designed for drawing with thick lines, but with some time, a blade, and a little bit of patience the lead of a sanguine pencil can be sharpened to a sharp point. Leaving a good portion of the lead exposed will make sharpening easier, since due to its softness the tip wears out easily. A metal lead protective cap helps preserve the tip.

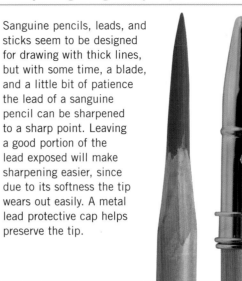

Sanguine pencils

Most of these are a variation of pastel pencils: a pigment lead bound with clay inserted in a cedar casing. However, nowadays, the different brands introduce other variations that are in line with the latest trends in the general production of pencils: mixed leads, watercolor pencils, and oil pencils. The common denominator of all of them is the red color, lighter or darker, of its line, which continues to be the alternative color for traditional artistic drawing, after graphite gray and charcoal black.

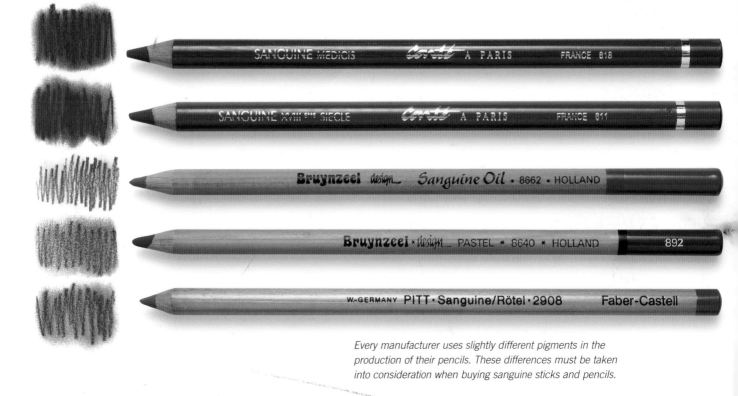

Every manufacturer uses slightly different pigments in the production of their pencils. These differences must be taken into consideration when buying sanguine sticks and pencils.

Chalk pencils and sticks

According to geology, chalk is a white or gray lime rock formed during the Cretaceous period. It has a very fine grain that leaves a mark when rubbed against a hard surface. Chalk has been used for drawing since ancient times. The natural color of the lime rocks used in the old days to draw varied quite a bit and dark earthy tones similar to the ones known today as sepia color, were not unusual. Nowadays, the word chalk is used to refer to square sticks of hard pastel, and in particular to the series of colors in pencil, lead, or stick form of dark earthy tones that are used for drawing chiaroscuro the traditional way.

Chalk assortments

Conté, Creatacolor, and Faber-Castell are the three large brands that produce special assortments of chalk in their sanguine, sepia, white, and black varieties. These assortments include pencils of various qualities and hardness as well as sticks of different intermediate tones.

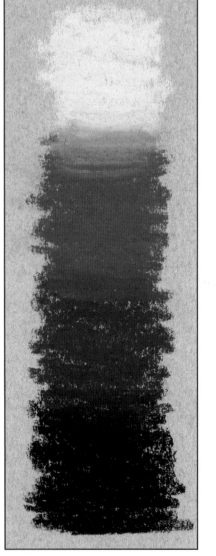

Gradation with a series of chalks.

Assortments of chalk pencils and sticks of the Faber-Castell brand.

Sepia colored pencils and sticks

Sepia color comes originally from the bladder of a mollusk and its use is traditionally limited to ink drawing. By default, this name is also applied to the pencil leads that are similar in color to that original sepia, but which are in reality made with a natural pigment from the iron oxide family (generally, a natural or burnt earth tone). Like sanguine (with which it is usually combined in drawings that are slightly colored) it is available in pencil, lead, and stick forms.

Pencil, lead for lead holder, and two sticks of sepia color chalk of different thicknesses.

Conté PARIS 2440 - 81

Conté A PARIS 2454

Bruynzeel design Sepia · 8666 · HOLLAND Light

White chalk

In reality this consists of a white color that no longer originates in lime but is made of white pigments (titanium oxide, generally) bound with clay and, depending on the variety, a small amount of powdered pumice. It is used to highlight charcoal drawings and is also combined with other chalks (sanguine and sepia mainly). In this context, white chalk and white pastel almost mean the same thing.

All chalks can be mixed with each other. White chalk is an essential complement to create harmony.

From left to right: white chalk leads and sticks, white chalk pencil, white pastel pencil, and white chalk pencil.

Undiffused white highlights.

Diffused white highlights.

Brown and gray ranges

Chalk sticks are available to the artist in traditional color assortments, but expanded in their intermediate colors: a range of grays between white and black chalk and sepia tones between sanguine and black. This increases the options and allows the selection of a particular color that best suits the artist's needs.

A range of gray chalks and a range of chalks in earth tones that go from sepia color to black. A white and a sanguine color chalk are added to the latter.

Charcoal

This is probably the oldest drawing tool. It is also the most immediate: a piece of charred wood that leaves black marks on the support. Modern charcoal sticks are vines or twigs burnt in a slow process to make sure that the entire piece burns evenly on the surface of the wood as well as inside of it. The branches should not have knots, but should be completely smooth to avoid hard particles that could scratch the support. The line, almost completely black, should be soft and dense without any gaps.

Quality

The natural origin of charcoal does not allow for great variations in quality according to brands. However, the selection of wood and the straighter branches and special attention paid to the manufacturing process set the best quality charcoal apart; Winsor & Newton, for example, offers as many as four different grades of hardness derived from the different combustion times. To this effect it is important to mention the square charcoal bars, produced by this same manufacturer, in which the exterior (harder) layers have been removed to allow for smooth drawing.

Almost any piece of natural charcoal can leave marks on a surface. Charcoal is obtained from a soft wood, with hardly any knots, that has been burned slowly.

Charcoal should be blended in such a way that the particles do not scratch the paper.

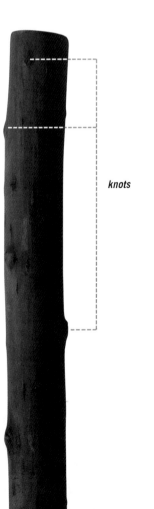

knots

Charcoal sticks should not have any knots on their surface because the hard particles contained in knots could scratch the paper.

The line made by charcoal should be even, continuous, and soft; it should not scratch the paper or create gaps. Shown in the illustration is a line made with a charred vine and another one with an oak branch.

Thickness

Charcoal is available in very different thicknesses depending on the diameter of the branches used in its production. From small sticks measuring 1/8 inch (3 or 4 mm) to bars .80 inches (2 cm) in diameter. The diameter determines the width of the line, although it is possible to draw thin lines with thick sticks by drawing with the edge formed on the tip that comes from rubbing against the support.

Charcoal pieces and charcoal powder

Some manufacturers provide thick pieces of charcoal (irregular cuts from willow trunks) that are useful when working with large pieces and for shading large areas. It can also be purchased in powder form, which is used by many artists for shading by applying to the paper with cotton. Charcoal pieces that are too small can be ground in a coffee grinder for use in this manner.

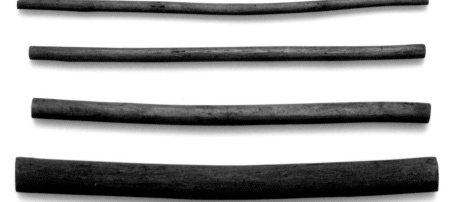

Charcoal sticks are available in different thicknesses, according to the size of the vines used in their production.

Powder charcoal is used in the shading of large drawings.

Box of very thick charcoal sticks.

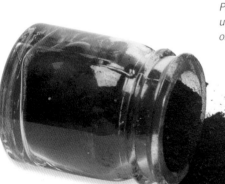

Charcoal should be able to be erased completely.

Charcoal adherence

Charcoal should not adhere to the surface of the paper at all because it is a completely dry substance free of any type of glue, adhesive, or binder. Upon erasing, it should come off completely without leaving any traces or marks. The texture of the paper retains the charcoal particles; later, fixative spray can make this temporary adhesion permanent.

Compressed charcoal

Any other variety of charcoal that is not a piece of charred wood is a compound of powdered charcoal (or black pigment) and a binder. Nowadays, there are many varieties of compressed charcoal found in pencil, lead, or stick formats. The components can vary greatly and can include pigments, soot, clay, or graphite. In many cases, they do not have any charcoal per se, which is why they are closer to pastels than to charcoal. The basic difference lies in the greater density and stability of the line (the presence of the binder adheres it to the paper) and on the greater hardness and evenness of the leads and sticks.

Charcoal pencils

Their predecessor is the "black stone" or "Italian stone," a black claylike stone that can be easily cut and sharpened that was used as a drawing tool during the entire Renaissance period and well into the 19th century. The Conté brand manufactures charcoal pencils with this traditional name. Nowadays, compressed charcoal is being substituted little by little by charcoal mixed with graphite, with soot, or with a pigment to make sharpening easier and to create different color variations.

Sold as leads or sticks, compressed charcoal contains a specific proportion of clay and in the denser color varieties, pigments and soot.

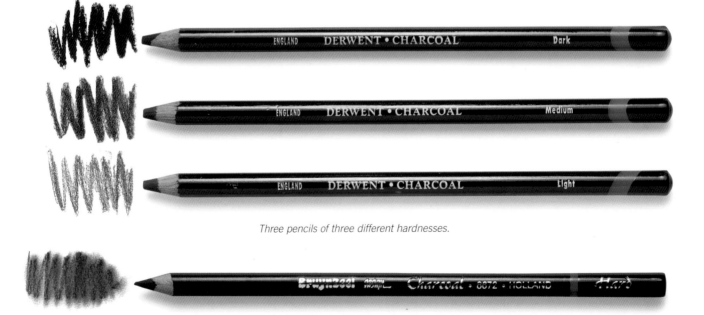

"Black stone" is the predecessor of the modern charcoal pencil. The French brand Conté, pioneer in the production of these tools, produces a variety with that name.

Three pencils of three different hardnesses.

Charcoal pencils with dry (above) and oil leads.

Conté pencil

Conté was the first manufacturer to produce charcoal pencils and sticks bound with clay and graphite. These components give the line a greater stability and blackness. They make the charcoal oilier and allow for a gradation of hardness by varying the amount of clay. For many years it was the only brand that supplied the market with these tools. Nowadays, almost every large manufacturer has varieties and versions of the same concept.

Three different varieties of charcoal pencils with different line intensities.

Leads and sticks

These can be round or square. They are usually oilier than pencils due to the charge of graphite they hold. Their intense and velvety line adheres very well to the paper and it is difficult to erase. Most manufacturers have sticks available in three of four different grades of hardness.

Oil pencils

Originally designed for making lithographs, these pencils are used by some artists for sketching due to their strong (permanent) line and their easy "sharpening" system: the sheath of the pencil is in fact a thick layer of paper wrapped around the lead; this casing can be unwrapped by pulling a string as the lead wears down.

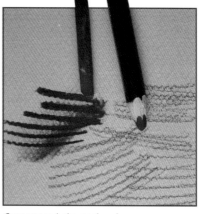

Compressed charcoal makes a more precise line than charcoal alone.

Sticks and leads of compressed charcoal.

This drawing has been made with a charcoal pencil (shading) and a stick of compressed charcoal (contours).

Pastel sticks

Pastels are basically made of pure pigment lightly bound with an adhesive gum that makes them hard enough to use.

Soft pastels offer the most extensive range of colors of any artistic material.

Pastel sticks are pure pigment bound in low adhesion gum (generally methylcellulose) with a minimum of additives or charges. It is the purest of the painting techniques since there is no vehicle or medium whatsoever between the color and the support; this also means that it needs an external fixative. Pastels are very stable, they do not darken or turn yellow and do not suffer alterations chemically. They are, however, sensitive to excessive light and can lose color with time after being exposed to lighting that is too direct and bright. Pastel paints are completely opaque and have good covering power, neither the support nor the colors over which they are applied are visible.

Soft pastels

Soft pastels crumble easily when in use, leaving bright areas of color on the paper. This is due to the low amount of binder used in manufacturing, and to the greater proportion of pigments. They have a characteristic round shape and they are available in very extensive and complete varieties. Practically all manufacturers include charges of white chalk or a similar product to make the colors opaque. Only one or two artisan manufacturers, which are a minority, offer sticks of colors that are almost pure, which in many cases tend to be transparent (when the original pigment is transparent).

Hard pastels

Hard pastels are available in thinner sticks that are generally square in shape. Their greater hardness is due to the fact that in production they are combined with clay and lightly cooked. This hardness makes them suitable for color work: they can be sharpened and the edges make it possible to draw lines that would be too thin and precise for any other traditional pastel. Their hardness makes the delivery of the color on the support low and it does not allow for the effects of great impact and color saturation typical of classic pastels.

Extra soft pastels

In principal, the whiteness of a pastel is a sign of quality because it indicates a superior presence of pigment and its maximum delivery in each application on the support.

Obviously, this also means a higher price. Sennelier provides large pastels in a very wide range that has all of these characteristics. Among artisan manufacturers of superior quality the English brand Unison (which produces 350 different colors) stands out and the very exclusive and very expensive French brand Henri Roché (which supplied pastels to Edgar Degas), that nowadays produces 700 colors but that reached 1,650 during the 1930s.

fine-grain paper

heavy-grain paper

sandpaper

Pastels and supports

The texture of the support radically determines the pictorial effect of the pastel. Highly textured supports retain more pigment but have a more open surface pattern. Medium textured papers balance pigmentation and smoothness of color. Thin sandpapers combine smoothness and color retention.

Comparison between an extra large pastel stick and a conventional stick.

a

b

Preserving pastels

Every pastel work should be preserved with a fixative so the pigment is stabilized on the support. The fixative can be applied at an intermediate phase of the work if the colors used are very saturated: this preservation increases the adherence to the support and prevents new applications from smearing the colors previously applied.

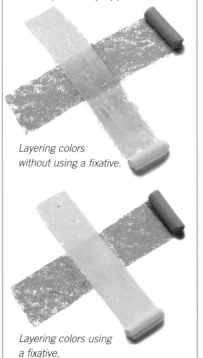

Layering colors without using a fixative.

Layering colors using a fixative.

*In this work the artist has used sticks of soft pastels to apply the color of the background (**a**), hard pastels for the details of the figure's head (**b**), and compressed charcoal to draw the coat (**c**).*

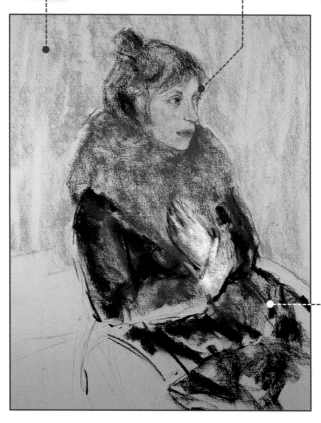

c

Soft pastels have greater quality and color saturation, both of which are readily visible in works created with them.
Piece by Mary Franquet.

Assortments and ranges of pastels

Almost every pastel manufacturer provides different assortments as well as individual sticks of soft pastels and hard pastels. The best results with pastel paints are achieved if colors are not mixed together; for this reason, pastel artists always purchase a very large selection of colors in boxed assortments or individually. Specialized manufacturers usually produce as many as five sticks of each color (the color without any mixtures, two tones darkened with more color, and two tones lightened with white). This increases the options and makes it possible to get as close as possible to the desired color.

Color ranges

Large manufacturers offer very wide color ranges because they combine each pigment with light or dark charges (white, black, or color pigments) that expand the selection. So, as many as five different colors are derived from a single pigment: the one from the pigment itself, two darkened colors and two lightened colors. On the other hand, the basic range for general work can have about 25 colors of pigments without any mixtures.

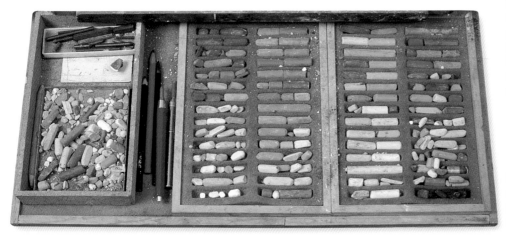

Box of a professional pastel artist who has collected an assortment of all the pastels, hard and soft, that best adapt to his or her way of working.

Basic pastel range of medium hardness. Their selection is smaller than that of common soft pastels.

| darkened colors | color of the pigment | lightened colors |

Sufficient assortment of colors for general work.

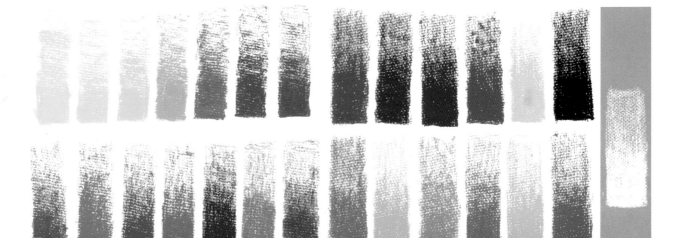

Ranges of soft pastels

Soft pastels are manufactured by most of the brands. One of the widest assortments is offered by Sennelier, a prestigious French manufacturer that sells boxes of 525 different colors divided among four stacked trays. This same company has smaller assortments of 25 to 250 colors available. Some of these colors (the most commonly used) are also available in extra large sizes. The brand Talens Rembrandt produces a wide assortment of 225 colors, as well as selections that include between 15 and 150 colors. The brand Schmincke offers selections of up to 100 colors. Another large assortment of pastel colors is available from the Lefranc-Bourgeois house, which has a range of 300 colors called Quentin la Tour. Other considerable selections are the ones from the English manufacturers of Rowney and Windsor & Newton.

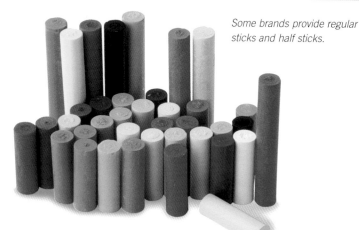

Some brands provide regular sticks and half sticks.

Ranges of hard pastels

These have been introduced more recently than the traditional soft pastels. In general, this variety is derived from the generic products manufactured by the big brands of drawing material (Faber-Castell, Conté, Caran d'Ache, Cretacolor, etc.), especially of sticks of white or color chalk. Therefore, these manufacturers are the ones that make a sufficiently wide assortment of harder pastel sticks, that some continue calling colored chalks, available to the public.

Stick sizes

Some pastel artists cut the pastel sticks in half and then store one of those halves clean in a separate box. Some manufacturers already provide assortments in half sticks, which are cheaper than the full-size ones.

Box of hard pastels by Faber-Castell, which contains all the colors that the company manufactures in this modality

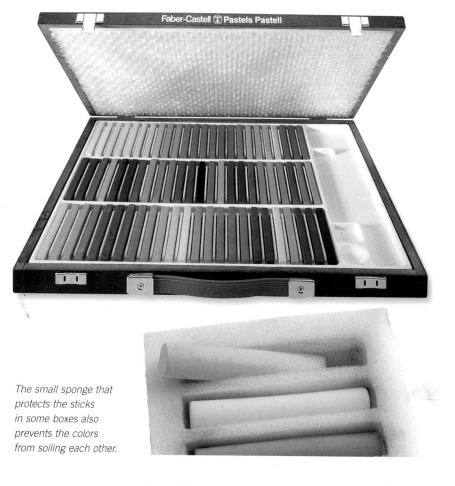

Boxes

There are empty boxes available for purchase that are especially designed for pastels. These boxes contain a screen inside that allows the pastel powder and smaller pieces to fall to the bottom, which helps keep the compartments that contain the sticks themselves clean.

The small sponge that protects the sticks in some boxes also prevents the colors from soiling each other.

Oil pastels

Oil pastels include all the color sticks whose binders are waxes and oils. Although both stem from the same base, wax color sticks tend to be associated with schoolwork, while oil pastels are designed for work by professional artists. However, nowadays, both varieties offer very high quality assortments that can be used by artists for all of the work that requires bright and liberal colors. Their origin dates back to the 1920s when a Japanese teacher, Kanae Yamamoto, produced for the first time wax color sticks for schoolwork. In 1924, the viscosity and pigment charge improved through a mixture of paraffin, stearic acid, and coconut oil, which thus created modern wax paints.

Color waxes

These are sticks of pigment bound with paraffin, which allows color to be easily spread. They are soluble in organic solvents (essence of turpentine, mineral spirits, etc.), or in vegetable oils, and they melt with heat. The color surfaces are transparent and bright and mixing colors is difficult unless they are diluted. Color waxes were introduced in the European market in 1965 through Caran c'Ache, which is the manufacturer that provides the largest and most diverse assortments. The use of polyethylene as a binder has improved the quality of the product. Among the new varieties are the watercolor waxes made with a water-soluble binder called glycol.

Oil pastels are used the same way as conventional pastels.

*School (**a**, **b**) and professional grade (**c**, **d**). waxes. Oil pastel sticks in different sizes and qualities (**e**, **f**, **g**) and oil colors in stick form (**h**, **i**).*

a b c d e f g h i

In watercolors, the white wax helps create reserves.

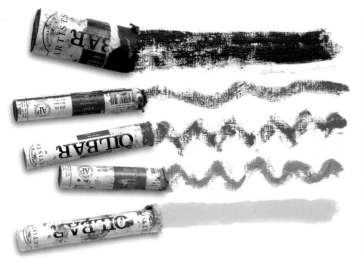

White wax

This is used not only as an additional color but also as a medium for blending colors together: rubbing over them with the white causes the transition from one color to another to be softened and evened out. It is also a medium greatly used by some watercolor artists to create reserves (unpainted areas on the paper), quickly and expeditiously: the wax repels the water-based color and it cannot cover the lines.

Oil pastel lines are very dense and pasty.

Oil pastels

The success in Western countries of Japanese oil pastel sticks, still used by children, piqued Pablo Picasso's interest in this medium and he convinced the company Sennelier to develop high-quality oil pastels. Sennelier produced the first line of oil pastels in 1947. Years later Talens, Caran d'Ache, Grumbacher, and Winsor & Newton, among others, followed. Oil pastels include wax and inert oils as binders, which provide great adherence to almost any surface and prevent the colors from turning yellow. Some varieties (oils in stick) incorporate drying oils to achieve complete drying; this has a drawback in that the color also ends up drying out in the stick unless it is put away after each use. The large amounts of oil binders contained in them prevent the colors from cracking.

Special effects

Waxes lend themselves to certain "special" effects that tend to be within the repertoire of school projects, although they are also perfectly applicable to professional work. The most efficient of all is layering an area of light color over a darker one (or vice versa) and then scratching the surface to expose the base color.

Lead holders

Graphite, compressed charcoal, and chalk leads and sticks can be inserted into a lead holder: these are metal or plastic tubes that keep the lead concealed inside its barrel or leave one of the ends exposed. Modern lead holders derive from the charcoal and chalk lengtheners and holders used by artists since the Renaissance. Nowadays, retractable tip lead holders, some with multiple leads, are a vital tool for technical drawing and a writing instrument of common use. Lead holders for art purposes conform to most of the stick and lead sizes available on the market.

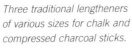

—————— *lead*

———— *lead grip*

————— *body*

Three traditional lengtheners of various sizes for chalk and compressed charcoal sticks.

Lead holder for sticks measuring 3/16 and 5/16 inches (4 and 7 mm). The lead grip conforms to thicknesses found in the previous range.

Two lead holders with tips that can be sharpened in the same way as conventional graphite pencils.

Lengtheners

Since ancient times, artists have used special shafts to comfortably hold and handle pieces of charcoal or chalk in order to work on their drawings. Those tools consisted of reeds open on one end where the piece of mineral was inserted and held in place with a ring. This same system is used in modern metal designs. These are light and very useful devices designed to use up nubs of chalk, compressed charcoal, and graphite in stick form. Once inserted, these pieces can be sharpened and used comfortably.

————— *push button*

Multiple charge lead holders

These can store several thin graphite leads. When one of them wears down completely a new lead is released by simply pressing the push button. Normally, these are used for writing and for small drawings. Most of them include a small eraser concealed under the push button. Graphite and color leads are sold in small tubes.

Mechanical pencils

These are lead holders that hold multiple calibrated leads, that is, of standard diameters ranging between 0.3 and 1mm thick. Because the leads are so thin they do not require sharpening. Each variety of this type of lead is available in different degrees of hardness. This combination of factors makes mechanical pencils very useful instruments for precision drawing.

Lead holders with color leads for technical drawings that involve color coding.

Lead holders for leads and sticks

From a thickness of 1/24 inch (2 mm) and up, lead holders always carry a single charge, that is, they hold a single lead that needs to be replaced when it wears out. There are suitable models available for almost any thickness of lead or graphite stick, chalk or compressed charcoal. Some of them can hold leads almost 5/8 inch (15 mm) thick. They make it possible to use the sticks to the very end and are commonly used for sketches and for work that does not require changing instruments.

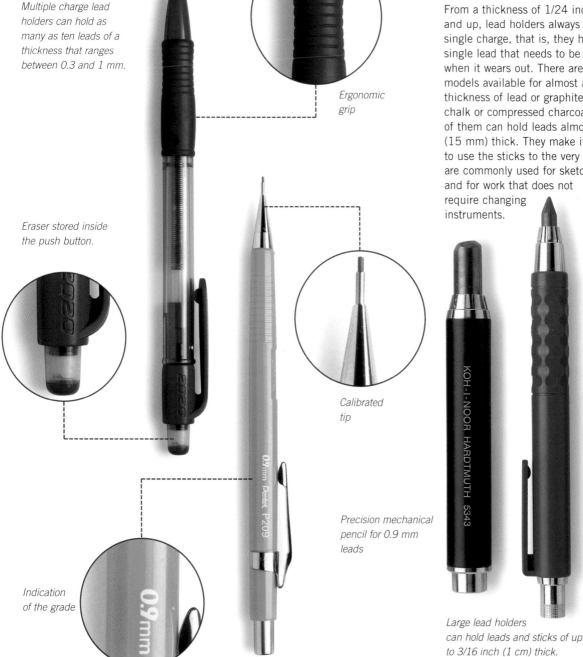

Multiple charge lead holders can hold as many as ten leads of a thickness that ranges between 0.3 and 1 mm.

Ergonomic grip

Eraser stored inside the push button.

Calibrated tip

Precision mechanical pencil for 0.9 mm leads

Indication of the grade

Large lead holders can hold leads and sticks of up to 3/16 inch (1 cm) thick.

Pens

As a drawing medium, ink can be used in different ways depending on the instrument with which it is applied. The most common applicator is the nib pen, but a reed pen, a brush, or conventional writing pens can also be used for drawing. Depending on which instrument is used, the results can vary from the most meticulous and detailed approach to spontaneous color washes and graphic effects. Ink used in a writing pen is the most direct and clean media, very suitable for sketching, taking notes, and making studies from life models. The thin lines make it possible to work in smaller formats than is customary with other types of media.

flat, or channeled tips are designed for calligraphy. The thickness of the lines made with nib pens does not vary much. Applying pressure on the pen makes the tip open and the lines become somewhat thicker. These small variations are sufficient to highlight and to give a drawing some character. Naturally, nib pens need to be recharged constantly by dipping them in an inkwell, which makes it possible to control the amount of ink and the length of time that each charge lasts.

Drawing with nib pens is based on a method of crosshatching with lines of different thicknesses. Work by David Sanmiguel

Nib pens

The classic metal nib (invented in Great Britain at the end of the 18th century) is sold individually and can be inserted into a plastic or wood handle. Nibs come in many different shapes, but the most suitable ones for drawing are the ones that have a straight or oval tip because round,

Goose feathers are the precursor of modern drawing and writing pens.

Series of special Joseph Guillot drawing nibs.

Different varieties of Brause drawing nibs. From left to right: five drawing nibs, three calligraphy round tip nibs, three slanted nibs, and three for extra-thick lines.

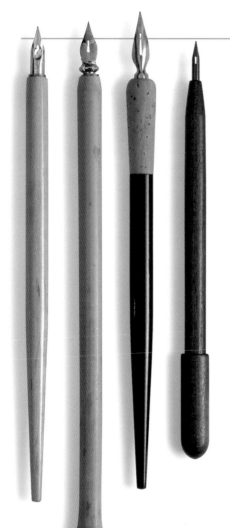

The three pens on the left are inserted into handles and are removable. The one on the right forms a solid piece with the handle and has a capsule that protects the tip.

Some types of handles have a lever that secures and immobilizes the nib.

Reed pens

Dry reeds cut at an angle on one end are good tools for ink drawing. The most sophisticated ones have a metal tab on its lower part that makes charging the ink easier. The lines drawn with a reed pen allow for some adjustment, depending on the side of the tip that touches the paper. By holding the reed as if it were a fountain pen the lines drawn are heavy and continuous and can show variations depending on the pressure applied. Much thinner lines can be drawn by holding the tip at an angle.

Lines made with reed pens are very uneven and are suitable for sketching and for quick and spontaneous drawing.

Some reed pens have a metal tab that makes charging the ink easier.

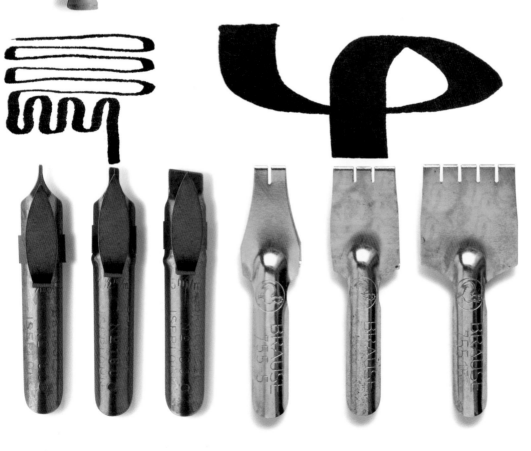

Fountain pens, ballpoints, and fine points

These are considered writing tools but are also used for drawing. They hold the ink inside; the mechanism of their tips and the type of ink they use sets them apart from each other. The pens generally make thin lines and are usually used for linear drawing.

Fountain pens

Invented in 1850, the fountain pen was the main writing instrument until the appearance of the ballpoint. They were used by many artists as a substitute for traditional nib pens, although the fact that the thickness of the line doesn't change regardless of the pressure applied is a drawback. Nowadays, fountain pens have rechargeable inkwells.

Ballpoints and rollerballs

Ballpoints are known worldwide by the name of *Biros*, after their inventor, the Hungarian Lazlo Biro, who introduced this new mechanism in 1938. They have a small ball on their conical tips that when rolled release ink on the paper. The ink is oily and dries on the paper without penetrating it. The charge of ink lasts a long time and the lines are susceptible, to a certain degree, to the pressure applied by the hand.

Rollerballs were developed from ballpoints with the intention of combining the advantages of the latter with the smoothness of the line of fountain pens. Their mechanism also incorporates a ball inserted at the end of a conical tip. The main difference with ballpoints is that the ink used by rollerball pens is water based and much more fluid; this allows for a much softer and lighter manipulation and makes a thicker line. The ink, normally pigmented, is brighter in color and penetrates into the paper's fibers, which makes it more permanent. The ink delivery of rollerballs is greater than in ballpoints and they run out of ink much faster.

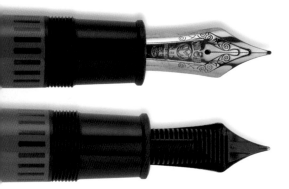

The nib of modern high-end fountain pens is a sophisticated mechanical piece that is gold or iridium filled to prevent the corrosion produced by the ink and to ensure maximum durability.

There are many models of plastic fountain pens available that are suitable for drawing.

From left to right: conventional pen, gel rollerball, and rollerball with a water-based ink.

Gel rollerballs

These are the latest in writing tools. The ink is substituted by a more or less fluid gel, which makes very light lines. The gels are available in many different colors including metallic, soft, iridescent, phosphorescent tones, and many more. The gel does not penetrate the paper but rather dries quickly on the surface.

Metallic color gel rollerballs.

Fine-point markers

Some markers are characterized by their round point (like that of a needle); the lines are very light and more precise than the ones of common roller tips. Also, they are thinner and that is the reason for their name, fine points. Their mechanism is similar to that of markers and their tips are very precisely calibrated between 0.2 and 1 mm wide.

Fine points are precise instruments: their line has a stable thickness despite the pressure or angle on the paper.

Many fine-point marker models are sold in series of an assortment of widths. Each brand uses different inks, which are interesting to try out.

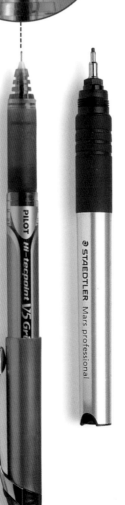

Nylon fine points of the Faber-Castell brand, in sanguine color and standard widths. The series also includes a brush-tip marker.

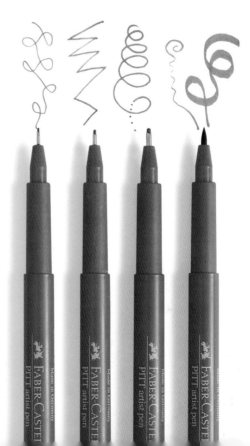

Markers

Working with markers is the latest trend in drawing techniques. They are especially suitable for illustration or marketing projects that require clear and sharp colors, clean lines, and a quality that is easily transferable to photographic or to photomechanic techniques. This does not mean that markers cannot be used in more creative and artistic projects: the wide variety available on the market makes all styles and approaches possible.

A series of water-based school markers.

Composition

Markers consist of a tip or head, which was originally made of felt but presently is made of polyester covered with micro pores that make it possible for the ink to travel from the interior well to the tip. The marker's well contains a wad of felt soaked in ink that touches the tip: as a result of the capillary effect the ink ascends to the tip while writing or drawing.

A marker disassembled.

drawing, marking and writing
edding 3000

Characteristics

Markers can be used to make color sketches faster than any other drawing medium. The ink dries quickly, the lines can be completely controlled, and large surfaces can be colored cleanly and evenly. Since the ink is delivered automatically there is no need for any additional material or equipment. The colors can be layered and superimposed almost instantly, since they do not bleed or change with time. The finish varies depending on the ink, but it is usually opaque or semi-opaque, with almost perfect, even tones and visible color luminosity.

Water-based opaque markers with good covering power.

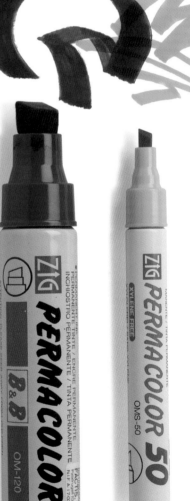

Alcohol-based markers with thick and extra-thick felt tips.

Alcohol-based markers

These are the most commonly used by drawing artists. The ink is usually xylem, which evaporates rapidly (fast drying ink). Once dry, the color of these markers is indelible and can be layered with other colors without mixing together or bleeding. The colors tend to be quite transparent, which is why these markers work best when used on white surfaces that do not detract from the color. The colors that are available vary according to the manufacturer: the American brand AD Marker offers 200 colors; the Danish Edding has 80; the English Magic Marker produces 123 colors; the French Mecanorama 116 colors; the American Pantone 500 colors; and the Danish Stabilo 50.

Double-ended Letraset markers, and their alcohol-based rechargeable ink.

Water-based markers

Water-based markers are usually school grade. The lines take longer to dry and some colors change others when they are layered. Some manufacturers produce water-based markers that have a charge of pigment that is similar to gouache, which makes the color completely opaque and gives excellent results in work that requires blocks of solid, even, and homogenous color.

Nylon-tip markers and metallic color ink.

Double-ended, alcohol-based markers from the Kuretake brand.

This marker from the Kuretake Pilot brand has a retractable semi-solid bar of gel that rubs against the paper.

Brushes

A good brush can hold in its tip a large amount of water or diluted paint (in the cases of watercolor brushes), or thick paste (in the case of oils or acrylic paints), holding it that way until the moment of its application on the support. During the brushstroke, the delivery of paint is continuous and even and the tip of the brush, in round watercolor brushes, should be able to make very thin lines. The tip and the shape of the hair must return to its original position immediately after each brushstroke.

All brushes consist of a handle, a ferrule, and the bristles.

-------- *bristles*

-------- *ferrule*

-------- *handle*

16

Escoda 4160 SPAIN

The handle

The handle is usually made of wood (although it can also be made of resin or reed, in the case of Oriental brushes) and traditionally is longer in oil painting brushes than in those for water-based techniques. However, the tendency is to standardize the length and make them all long. In high-quality brushes, the wood is protected by several layers of nitrocellulose varnish and the manufacturer's brand as well as other information, especially the number that identifies its size, is stamped on the surface. Watercolor brushes are usually painted in various colors while oil brushes are made of varnished wood.

Chromed and gold color ferrules in different sizes.

From left to right: round sable and bristle brushes, and flat brush made of synthetic fibers.

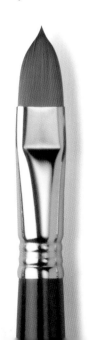

The ferrule

The ferrule is a circular chromed clamp with a conical shape that holds the bristles and binds them to the handle. The metal ferrule is attached to a groove in the wood handle. The bristles are attached to the ferrule at the base with a very solid resin glue. The ferrule determines the thickness and the shape of the bristles. To create brushes with flat bristles, the ferrule is pressed flat at its upper end.

The bristles

The bristles are made of hair or synthetic fibers bound to the inside of the ferrule with a very durable adhesive. The bristles can be round, pointy, straight, slanted, fan-shaped, etc. One third of the length of the bristles is attached to the inside of the ferrule with special adhesives.

Characteristics of the hair

Three distinct areas can be identified in the hair of a brush: the tip, the body, and the root.

The tip is the end of the hair, the thinner part, the part that is going to allow the brush to aim perfectly and to provide maximum precision while painting. In bristle brushes (the hair from a hog) the tip ends in two or three points, which gives it a certain degree of smoothness when used. The tips in synthetic fibers are created with high precision mechanical finishes.

The body is the central part of the hair or bristles. It holds the liquid, thanks to its textured surface, and transports the liquid to the tip when the artist is painting. It also determines the ability of the hair (the spring) to recover from the brush-stroke when working with oils.

The root is the base of the hair, the part that is attached to the skin of the animal, obtained by shearing or pulling it, once the animal has been sacrificed for human consumption. It is the part that will remain inside the ferrule so the adhesive can hold the hair in place permanently.

tip

Two-colored lacquered handle of a watercolor brush.

Varnished handle of an oil paint brush.

head

Carved handle of a high-quality sable-hair brush.

root

Hair and procedure

The oil painting brush must retain the paint and apply it smoothly. The same can be said of acrylic brushes. In both cases the hair of the brush should be strong and flexible, stiffer than the hair in watercolor brushes. The ideal hair is hog bristle, although nowadays there are synthetic alternatives.

The watercolor brush should hold an abundant charge of paint and deliver it gradually. In addition, its tip should be perfect and be able to recover its shape as soon as the hair is lifted from the paper. Kolinsky sable hair perfectly emodies all of these characteristics.

Brushes for watercolor painting

Natural hair brushes

The best quality natural hair for watercolor brushes comes from the tail of the Kolinsky or Tajmyr sable, which inhabits the northernmost part of Siberia. Its very delicate tip, imperceptible to the naked eye, ensures a perfect brush tip; its body is strong, giving it a precise spring (it recovers its shape immediately after every brushstroke) and a great ability for holding diluted paint.

Other natural fine hairs common in watercolor brushes and more affordable are mongoose, which is characterized by its yellow and dark, almost black, bands of color; the ox ear hair, which is reddish brown in color; and weasel hair, which is black and strong.

Other types of natural hair that are not commonly used by watercolor artists, either for their lack of spring or their excessive texture, are squirrel hair, badger hair, pony hair, and goat hair.

Squirrel-hair brush.

Synthetic brushes

Synthetic hairs or fibers are monofilaments of polyamide designed specifically for artistic work. They have been produced in Japan since 1970. The fibers mimic closely the conical shape of the animal's hair, the point of the bristles, as well as the color of the sable, badger, etc. Although they cannot hold the same amount of liquid or maintain their shape after continuous use, the quality and price relationship makes them very attractive tools for any professional. In general, watercolor artists use synthetic brushes in their flat square hair varieties. No matter the hair used, synthetic or natural, watercolor brushes should be washed only with water after every session.

natural hair *synthetic hair*

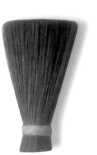

Kolynsky sable **ox ear** **mongoose** **toray** **sable imitation toray** **takatsu**

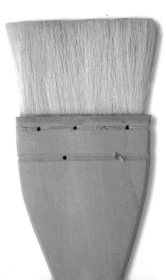

Common selection of brushes in the repertoire of a watercolor artist. From left to right, round sable brush, round ox ear brush, thick round pony hair brush, flat synthetic hair brush, and goat hair hake brush.

Hair shape

The most common shape of the tip of a watercolor brush is round: this makes it possible to hold the greatest amount of paint and is suitable for making thin lines. Many types of different lines and colors can be made depending on the pressure applied on the support. Flat hair and square (or hake) brushes are used to spread paint over large areas and are always present in the repertoire of professionals, especially in medium and large sizes. Among this variety are the bright (flat and with rounded edges) and filbert (flat with a pointed tip) brushes; both make the characteristic lines and strokes of their shape; they are not as commonly used as the round and square flats.

square brush

round brush

filbert brush

bright brush

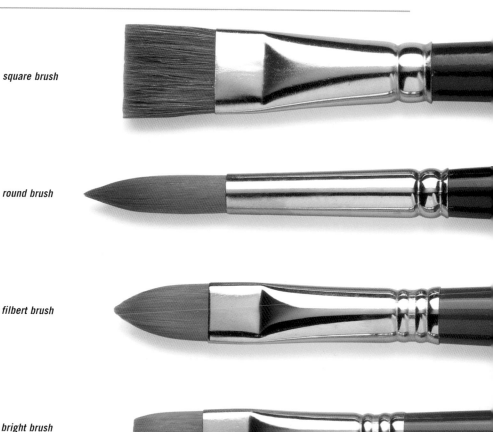

Brush sizes

A number stamped on the handle indicates the size of the brush. This code does not follow any standards and every manufacturer markets different sizes with different numbering systems. As an example of the range of sizes it is worth mentioning the series of high quality, round watercolor brushes from the manufacturer Escoda, which includes a total of 18 sizes. The smallest is number 5/0 whose hair has a diameter of 1/20 inch (0.5 mm); the largest of them is number 24 which is 3/4 inch (17 mm) in diameter. The numbering system of this series beginning with 1 follows, like almost all brush series, a progression of multiples of 2. Watercolor artists normally use just the intermediate or small sizes because these brushes are expensive; for larger sizes they usually choose other brushes with natural or synthetic hair.

Complete series of Kolinsky sable-hair brushes.

Brushes for oil painting

Natural hair brushes

The density and creaminess of oil paint requires a brush with robust hair. It is not so important that the bristles can or cannot hold a large amount of diluted color, but they must be stiff enough to transport a lot of paint from the palette to the support, and able to spread and model it with some flexibility. The natural hair that best combines all these qualities is hog bristle, specifically white Chungking hog (a Chinese hog with long hair). It is taken from the back of slaughtered hogs and is characterized by a prominent root and thick body. In hog brushes the bristle ends in two or three points, which gives it a certain amount of softness and improves its ability to hold paint.

Since there are many styles of oil painting, including delicate work with paint that is very diluted in oil, many painters use fine hair watercolor brushes, like squirrel, badger, and even sable.

white Chungking bristles *synthetic Teijin fibers*

Synthetic hair brushes

Synthetic fibers have a rigidity that is appropriate for oil painting and they are more resistant to turpentine and solvents than natural hair. They have been greatly perfected since the appearance of the first Toray fibers. In addition to Toray, today brushes for oils are made using thick filaments of Tekady and Teijin fibers. Since maintaining a perfect point is not as important for oil painting as in watercolor, synthetic fiber brushes are an option for these artists.

A set of brushes for oil painting, consisting of medium round and flat white hog brushes, small synthetic hair brushes, and wide brushes with synthetic hair and hog bristles.

Brush shapes

The shapes of brushes for oil painting are the same as watercolor brushes: round, square, bright, and filbert. But unlike watercolor artists, oil painters mainly use square brushes because they tend to apply the color by pressing it on to the support rather than dragging it across, and generally the brushwork is more a matter of dabbing than applying long brushstrokes.

Brush sizes

Brushes for oil painting tend to be larger than those used for watercolor. A complete set of flat brushes for oil (numbers 0 through 32) can include 18 different sizes, from 1/12 inch (2 mm) to 1-3/4 inch (45 mm).

In addition to this, artists use wide brushes that can be as large as 6-3/4 inches (170 mm). Artists should have a large number of medium-size, white hog bristle brushes, brushes with synthetic or lesser quality hog bristles, and a few small brushes of sable or other natural hair.

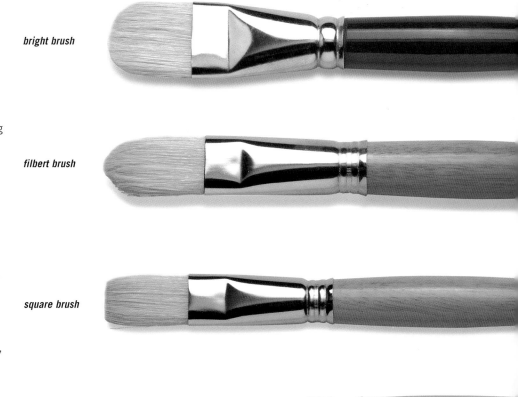

bright brush

filbert brush

square brush

round brush

Cleaning and caring for brushes

Brushes for oil painting should be cleaned after every session. First the excess paint should be removed from the bristles using a rag or piece of absorbent paper. Then the bristles should be soaked in solvent to remove as much paint as possible.

Finally, the bristles should be washed with liquid or bar soap.

Washing should be repeated until no more paint can be seen in the foamy soap.

Other types of brushes

Pocket brushes

Designed for making onsite watercolor sketches, pocket brushes have a removable handle that is placed over the brush end to protect it. When it is closed the brush is somewhat smaller than a ballpoint pen. The watercolor boxes used with these brushes are also small and the sketches made with this equipment are necessarily small in size.

pocket brushes

Chinese brushes

These are made in both China and Japan. Their hair is much softer than that of Western brushes, and they are used for techniques based on a very fluid brushstroke.

Chinese brushes

Fan brushes

The bristles on these brushes are very flat and the hair is arranged in the shape of a butterfly wing. They are used for cleaning lint and dust from drawings created by erasing. Some pastel artists use them for blending delicate areas of the work. They are not of much use for any other painting techniques. These brushes are usually made with hog, badger, or synthetic hair.

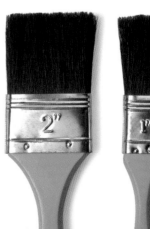

fan brushes

decorating brushes

Stenciling brushes

These round brushes with flat heads are used to apply color by dabbing through stencils rather than using brushstrokes. They are used for making decorative borders and ornamental designs.

Using a stencil.

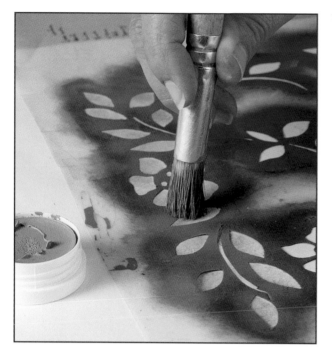

stenciling brushes

Rubber-tipped brushes

Instead of bristles, these brushes have a very flexible rubber point. They come in different sizes and shapes (conical, wedge, trapezoid, etc.). Their introduction at the end of the 1980's did not cause much enthusiasm, but their usefulness in creating oil and acrylic works in impasto cannot be denied. The "brushstrokes" vary according to the shape of the point.

The marks made by a rubber-tipped brush are smoother than that of normal brushes. They are used to create textures.

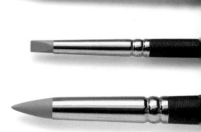

rubber-tipped brushes

Decorating brushes

These brushes are not usually recommended for artistic painting, but their low prices make them appealing when it comes to painting large format work, or work where the texture is very pronounced. In such cases, when the artistic effect does not depend on a particularly careful or traditional finish, the use of these brushes with poorly glued and roughly finished bristles is justified.

extra-wide decorating brushes

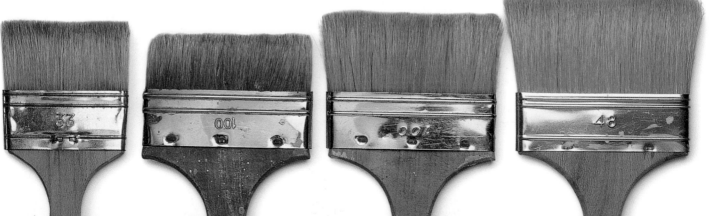

Spatulas

Spatulas are indispensable tools for manipulating paint—spreading it, applying it, and retouching it—and also for cleaning palettes and scraping off excess paint. Generally, they are useful tools for the heavier media like acrylics and oil. The spatula has an important and distinguished role in the practice of oil painting. This is practically a separate genre that has many followers.

Spatulas can be used to spread large amounts of undiluted paint on works that require thick, heavy impastos.

Palette knives

These are long narrow spatulas made of a flexible blade with dull edges, and a handle. The length of the blade varies from 2 to 8 inches (5 to 20 cm). Normally they are used for dragging paint and scraping it off the canvas or the palette. They are also useful as a tool for applying color, especially for covering backgrounds and applying preparations to fabric, wood, and cardboard supports. They are very useful for manipulating pigments, for extracting them from containers, and mixing them with a binder or agglutinate.

Palette knives of different sizes. The shape of the blade determines its use: the angled tips are for scraping, while those with round tips are for spreading paint.

Trowel spatulas

These have the same shape as the trowels used by masons; a triangular blade attached to a wooden handle with an angled steel rod. They are available in very different sizes and are a little less flexible than palette knives. They are the best spatulas for working with paint on a support. They can hold quite a bit of paint and can be used to make many different kinds of marks on the canvas.

Trowel spatulas are used for making impasto paintings.

palette knives

trowel spatulas

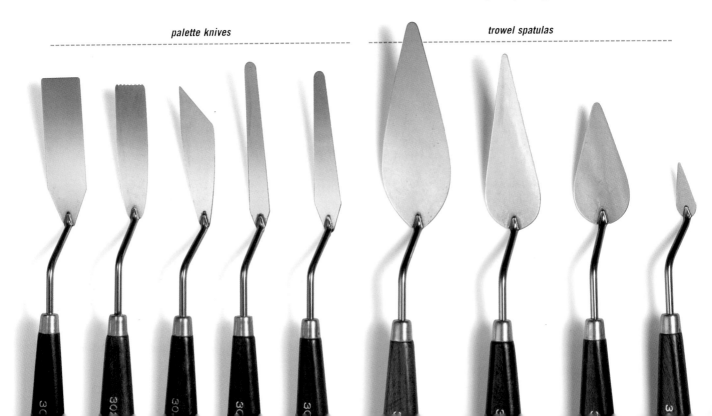

Scraper and putty knife

These are more robust and less flexible than those used in fine arts. They consist of a straight or triangular blade directly inserted into a wooden handle. They come in different widths, and are useful for preparing supports and working on large format paintings. They must be used with care, because the edges can damage, scrape, and even perforate the support. They can hold a lot of paint, and as scrapers they are very useful for cleaning palettes.

Scrapers and putty knives are heavier and larger than those used for painting, and they are less flexible. They are used to create textured backgrounds and for cleanup.

Cleaning spatulas

At the end of every work session it is a good idea to clean the part of the palette reserved for mixing. There are long and flexible palette knives for this, which can be used to scrape off leftover paint. Many artists save this paint (which is a dirty gray, the result of mixing many different colors) in containers for use as a neutral base in future works.

Plastic spatulas

These are a very inexpensive option for manipulating pigment and small-scale work. They come in the same shapes as conventional spatulas, and while they are somewhat more flexible, they are also more fragile.

More fragile than conventional spatulas, plastic spatulas will not rust and therefore are useful for working with pigments.

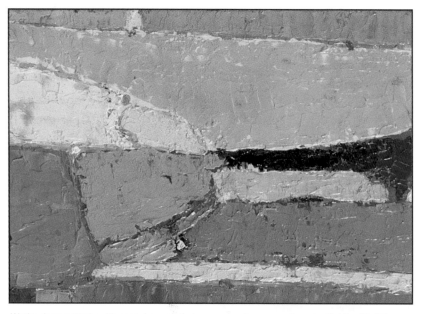

Works done entirely with spatulas usually have a simple approach and a finish with little detail and shading.

Pigments

From the beginning of time, artists have been able to find the coloring media needed for their work among the pigments found nearby. Pigments are powders with a particular chemical composition (organic and inorganic) that are used for manufacturing paint of all kinds, whether industrial or artistic. The artistic paints constitute a very small amount of all manufactured paints, but they are the most refined and require the greatest purity and quality.

Inorganic pigments

Pigments are divided into two large families: the inorganic and the organic. Each can be either natural or synthetic. Among the natural inorganic pigments are all the earth tones (siennas, reds, ochres, slate grays); and the mineral pigments, which are less common (vermillion, malachite green, etc.). The artificial inorganic pigments are products of laboratories, although some have been around almost as long as the natural ones, as for example, Naples Yellow.

Organic pigments

These can be of vegetable or animal origin. There are only a handful of them, but dating back to prehistory, they have stood the test of time. Ivory Black, for example, is made from burning bones and Indian Yellow is obtained from cow urine. The synthetic organic pigments appeared in the 19th century, and although in the beginning they tended to be too light, advances in chemistry have improved to the point that today the great majority of pigments are products of the laboratory.

The artist can bind, or agglutinate, his or her own powdered pigments. This could be an actual palette for a painter.

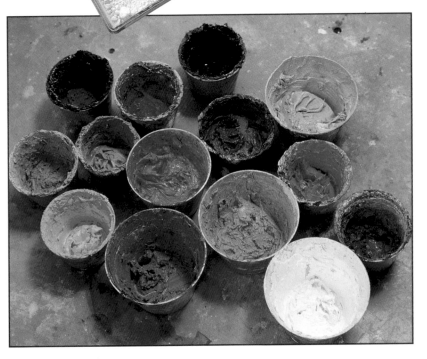

Containers with agglutinated pigments ready for use. Painters can buy pigments in art supply stores and make their own paint with recipes that best match their style of painting.

Jars of pigments for artistic paint sold by (from left to right) Bolckx, Old Holland, Maimeri, and Barna Art.

Pigment codes

On the label of a stick or container of paint (watercolor, oil, pastel, acrylic) there is, among other information, a color denomination (Lemon Yellow, Scarlet Red, Manganese Blue, etc.) and also a code that indicates the pigment used in its manufacture. This code consists of two letters and a number; the letters can be Pw (white pigment), Pr (green pigment), Py (yellow pigment), Po (orange pigment), Pg (green pigment), Pb (blue pigment), Pv (violet pigment), PBr (brown pigment), and Pbk (black pigment). The numbers that follow indicate the particular type of pigment for each color.

Pigment and paint

Paint can be made from a single pigment or from several. The pigments have names like *chrome oxide cobalt* (used for making some blue paints), *beta quinachridone* (for manufacturing scarlet red), and *copper phthalo-cyanine chlorate* (in some green paints), among many others. Nearly all can be bought in powder form for artists to make their own colors.

The color charts from different paint manufacturers are made with agglutinated pigments. This could be an "original" color chart.

After being agglutinated the pigments acquire the creamy consistency that we are used to seeing.

Blue and violet colors

The most commonly used blues and violets

Here is a list of the codes for the most common blue and violet pigments, plus a comment on a small selection of five blue colors and one violet, which form the basic core of blues and violets used by artists. Keep in mind that mauve and purple tones are almost without exception a result of color combinations. Having these all handy makes it easier to create other blues through mixtures.

BLUE PAINTS

PB 29 **Ultramarine Blue**
PB 27 **Prussian Blue**
PB 28 **Cobalt Blue**
PB 74 **Dark Cobalt Blue**
PB 36 **Turquoise Cobalt Blue**
PB 15 **Phthalo Blue**
PB 17 **Cyan Phthalo Blue**
PB 16 **Turquoise Phthalo Blue**
PB 35, PB 36 **Cerulean Blue**

VIOLET PAINTS

PV 23 **Dioxazine Violet**
PV 15 **Ultramarine Violet**
PV 49 **Cobalt Violet**
PV 14 **Dark Cobalt Violet**
PV 16 **Manganese Violet**

Since most blue colors are dark pigments, they provide many different shades when they are mixed with different proportions of white (or are diluted with water in watercolor painting).

The undertones of blues

Each one of the blues that are shown in this page has its own chromatic tendency: either closer to red or closer to green. Among all of these colors the one closest to red is, of course, violet. Among the true blues, Ultramarine Blue has the greatest reddish tendency followed by Cobalt Blue, which is halfway between red and green. Cerulean Blue, lighter than cobalt, has a similar intermediate tendency. Phthalo Blue has a slight greenish tendency and Prussian Blue leans definitely toward green.

cobalt

ultramarine

violet

red

cerulean

phthalo

Prussian

green

Phthalocyanine Blues

These are paints made from organic pigments (synthetic) that were introduced relatively recently. They are very brilliant, transparent, and have a high tinting strength. Some artists, however, consider the color of these blues a little too artificial, "electric."

Ultramarine Blue

This is the blue that is most commonly used by artists: slightly violet, with a dark and rich tone. This paint has extraordinary tinting strength, which produces very brilliant and bright blues when it is lightened with white. Mixed with other colors it provides very good grays. Its incredible chromatic strength is visible in the professional grade soft pastel sticks.

Cerulean Blue

This blue has a very slight green undertone and it is the lightest and closest blue to the first cyan. Its tone is the closest to "sky blue." Its color is transparent, delicate, and very much favored by watercolorists. In oil painting, this color is not used very often because it is easy to mix very similar colors by combining Cobalt Blue and Ultramarine Blue with white.

Cobalt Blue

This is a medium blue (between violet and green). It has a sky blue tendency when diluted or lightened with white. Although it can be more solid and have more covering power in opaque techniques than ultramarine blue, its influence in mixtures is much lower.

Dioxazine Violet

Sometimes sold under the label of "permanent violet," this is a very solid paint with good covering power and it is an exceptionally robust violet. Its tone is practically halfway between red and blue; it is very dark, and mixing with water or with white will render many very beautiful mauve tones.

Prussian Blue

This one is a cold and metallic blue with a greenish undertone. Used in pure form or diluted with water (watercolors) its tone is very deep and beautiful; mixing with white creates a wide range of tones that are somewhat starchy. It tends to muddy oil and acrylic mixtures. This tint can vary considerably depending on the brand.

watercolor samples

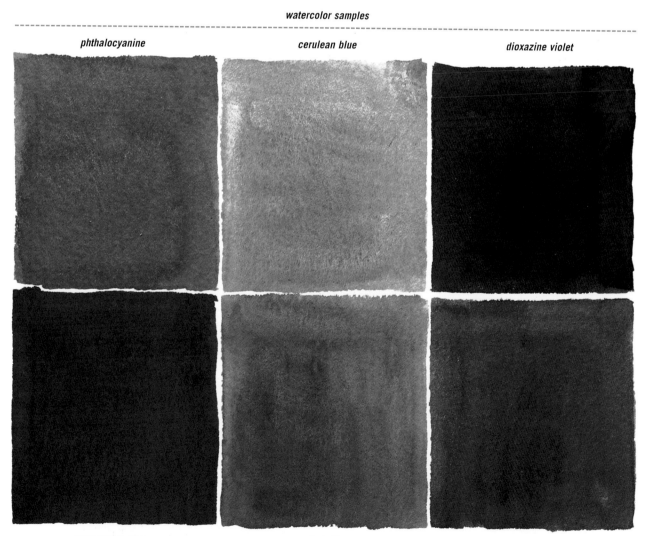

phthalocyanine

cerulean blue

dioxazine violet

ultramarine blue

cobalt blue

Prussian blue

Green colors

The most common greens on the palette

The great majority of green paints are made of phthalocyanine pigments. They have a clean green tone that is powerful and solid, halfway between yellow and blue. Traditional greens like Emerald, Hooker, and Olive Green are the result of several pigment combinations that vary according to the manufacturer. The codes listed here are the most common ones; however, some colors with the same name can be obtained with different combinations of pigments, and different codes can refer to pigments with a very similar color and composition.

GREEN PAINTS

PG 36 **Phthalocyanine Green**
PG 36 + PY 110 **Hooker Green**
PG 17 **Chromium Oxide Green** (Olive Green)
PG 7 + PY 3 **Permanent Green**
PG 18 **Emerald Green** (Viridian Green)
PG 50 **Cobalt Green**
PG 23 **Green Earth**
PG7 + PY 42 **Sap green**

Due to their nature, greens adapt perfectly to colorist painting techniques and to painting with values: they offer more possibilities for chiaroscuro than most other colors (they can be darkened without losing their tone) and some of their shades are comparable to the most brilliant colors of the palette in terms of brightness and intensity.

The four most commonly used greens in oil painting. From left to right and from top to bottom: Cobalt Green, Permanent Green, Emerald Green, and Sap Green.

Phthalocyanine Green

Made with organic pigments that have been introduced relatively recently, this is a cool green that has a brilliant and solid color with a bluish undertone. It has good covering power and it can create clean mixtures in any technique. It is very useful on the palette, because most of the traditional greens tend to get muddied when mixed with other colors.

Permanent Green

A green with a "standard" tone, made with different mixtures of phthalocyanine pigment. A bright and clean tone although somewhat artificial, as it is the case for all the colors based on these pigments. With a yellow undertone, it is extremely useful on the palette with any pictorial technique due to the brightness and variety of colors that can be created with the mixtures.

Hooker Green

This is a classic on the watercolorist's palette. There is no equivalent color in any of the other techniques. This is a deep green with a yellow undertone, made with mixtures of several pigments (greens and yellows or blues and yellows). A very natural color when used in its pure form, it tends to muddy the mixtures in which it is used.

Emerald Green

In continental Europe Emerald Green is the name given to the color known as Viridian in the Anglo-Saxon world. It is a classic on the palette of every artist. It has a bluish, deep, and transparent tone. In mixtures, it produces tones that are complex and interesting.

Chromium Oxide Green

This is an opaque color that is somewhat earthy, and has very good covering power. It is the most solid and permanent of all the greens. Its tone is somewhat muted and it is widely used in pastel painting. It dominates in almost all mixtures and it quickly turns them gray, but it can produce very interesting olive color tones.

Cobalt Green

Like Chromium Green, this color has an earthy appearance, but it is yellowish and lighter. This is a very natural green color that loses its luster in mixtures. It is used directly as a neutral tone within the family of the greens. Cobalt Green is often used, almost without being mixed, in oil painting, especially by landscape artists who wish to diversify the green tones as much as possible.

watercolor samples

phthalocyanine green *Hooker green* *chromium oxide green*

permanent green *emerald green* *cobalt green*

Red colors

Most common red paints

Nothing on the palette can match the chromatic impact of red. Because of the wide range of reds available—spanning from orange to violet—we recommend having two or three on hand. The most widely used of all is Cadmium Red, a solid and opaque color that has good covering power.

Naphthol Red, and especially the very brilliant Quinacridone Red, are recommended as substitutes or complements. In this list there are a couple of Quinacridone Reds with the same code; they are pigments that come from different providers.

RED PAINTS

PR 112 **Permanent Red** (Naphthol Red)
PV 19 **Quinacridone Pink**
PV 19 **Quinacridone Magenta**
PO 20 **Orange Cadmium Red**
PR 108 **Medium Cadmium Red**
PR 264 **Carmine** (Pyrrole Red)
PR 188 **Scarlet Lake** (Naphthol Scarlet)

Reds are the warmest colors of the artist's palette. In this painting we can clearly see how they stand out in visual proximity against the rest of the colors.

The red pigments are common to all pictorial techniques.

These are the reds that are most commonly used by the oil painter. From left to right: Permanent Red, Medium Cadmium Red, Dark Red, Crimson (Pyrrole Red), Quinacridone Carmine (somewhat earthier than the previous one), and Quinacridone Pink.

Permanent Red (Naphthol Red)

Somewhat similar in tone to the old Vermilion (a color that is no longer produced due to its low stability), this color is a solid and brilliant intermediate red, very good for any mixture, especially with yellows and blues. Its clean tone makes it especially suitable for use in the pure form.

Orange Cadmium Red

Like all the cadmiums, this is an intense color, very solid and with good covering power. It clearly stands out in all mixtures with yellows and it is very interesting as a complement with other reds in shading.

Quinacridone Pink

A transparent and brilliant pink, this is suitable for using unmixed or in mixtures with blues, which produce interesting violets. Also, it is very good for creating clean, light, and very brilliant pinks. Like all the reds based on the quinacridone pigments, this pink results in very delicate tones (pinks with a mauve undertone).

Medium Cadmium Red

This is perhaps the red most commonly used by painters because of its chromatic impact and its solidity. It is very opaque and has good covering power, but it is less brilliant than other intermediate reds. It has almost no drawbacks, only the muddy results that it may produce because of its characteristics: pinks turn out somewhat earthy looking and violets a little subdued.

Quinacridone Magenta

This is a dark red with a violet under-tone that produces several brilliant reds when mixed with yellow, as well as orange colorations. Numerous shades of violet result when it is combined with blues. This great chromatic versatility makes it very useful in all the painting media. In its pure form it provides a deep, velvety, and saturated tint that has great covering power.

Carmine (Pyrrole Red)

This is very similar to the classic Madder Carmine (a color that is hardly produced due to its low stability). Pyrrole Red is the ideal carmine; it produces wonderful oranges and excellent pink tones that are very lively and brilliant.

watercolor samples

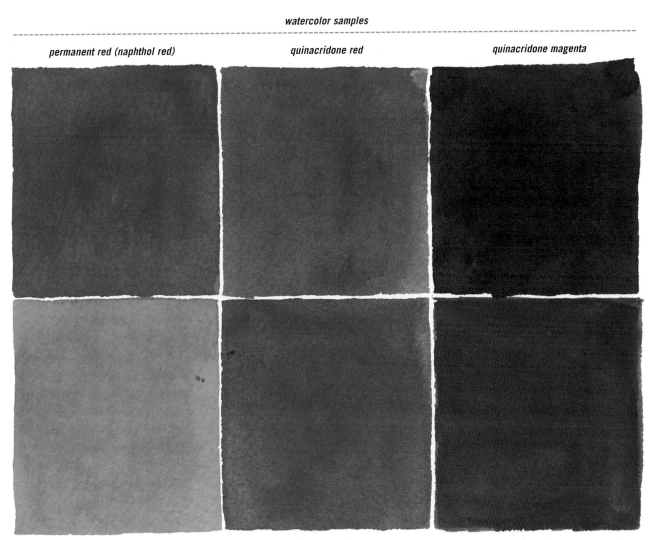

permanent red (naphthol red) *quinacridone red* *quinacridone magenta*

orange cadmium red *medium cadmium red* *carmine (pyrrole red)*

Crimsons and purples: the magentas

A selection of magentas

Crimson and purple colors, or magentas as they are known today, are the most modern colors of the entire palette. They were practically unknown in the old days because there are hardly any inorganic pigments of this color and the organic alternatives are very volatile because they lose their color quickly. Advances in modern chemistry have given the artist a good number of extraordinarily vibrant and brilliant colors that are very useful for creating mauve and violets (when combined with blues) and bright pinks when mixed with white.

CRIMSON PAINTS

PW 4, PW 6, PR 23 **Medium Pink**
PV 14 **Cobalt Violet**
PR 122 **Quinacridone Magenta**
NR 9 **Madder Pink**
PR 122 **Quinacridone Pink**
PR 83 **Alizarin Carmine**

The colors purple and magenta are the newest additions to the artist's palette. They are very bright, attractive, and brilliant.

The vitality of the pinks and the magentas becomes especially noticeable when they are used in watercolor paintings that emphasize their transparency and brilliancy.

Magentas and crimsons have great chromatic impact and can stand out even in combination with other vibrant colors, as seen in this portrait. Work by Dolors Raich.

Medium Pink

This color is made from mixtures of other pigments, particularly Napthol Crimson and two white pigments. It is a very warm and attractive color, but not very lightfast when used with watercolors. It is rarely sold under this name in other media.

Madder Pink

Manufactured from one of the oldest known pigments obtained from the plant *Rubia Tinctorum*, Pink Madder is considered too prone to fading by today's high standards. However, its very light and natural magenta tone continues to captivate many painters who wish to work with the same colors that were used by the old masters.

Cobalt Violet

This is a delicious color: luminous, transparent, and halfway between Magenta and Red Violet. It is ideal for using alone or for creating delicate reds and violets, depending on whether it is mixed with medium reds or blues. It is very popular with oil painters who want clean violet colors.

Quinacridone Magenta

Traditionally Magenta has not been a very lightfast color; nowadays, the Quinacridone Red pigments can make a bright, deep, and very stable Magenta. It is a very versatile color for mixing with yellows, reds, and blues to create clean and clear tones.

Quinacridone Pink

This color is based on Quinacridone Red pigments. It is a clean and bright reddish purple. Like all the quinacridone colors it can make very clean and diverse color mixes. It could be the most useful red violet color on any painter's palette.

Alizarin Carmine

This was the most intense red on the artist's palette during the 18th and 19th centuries. (Turner used it constantly). It is the most "Magenta" of the traditional reds. Today, many manufacturers tend to replace it with the more practical Quinacridone Magentas. It has a dark, velvety red color, but does not mix as cleanly as the Quinacridone Reds.

watercolor samples

medium pink *cobalt violet* *quinacridone pink*

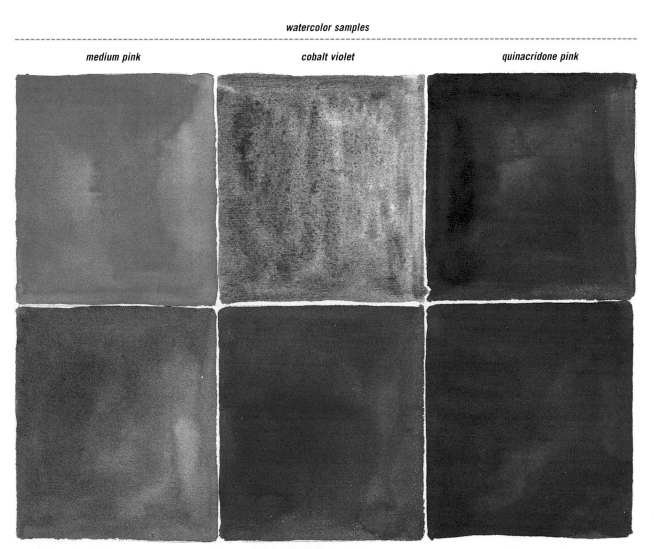

Madder pink *quinacridone magenta* *Alizarin carmine*

Yellow colors

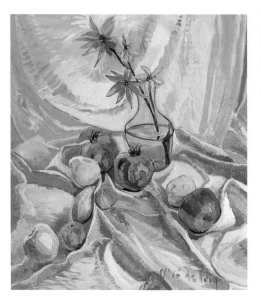

Yellows mixed with a bit of black make very complex greenish grays that are very useful for atmospheric effects.

A selection of yellow colors

These are the brightest, warmest, and most vibrant colors on the painter's palette. Yellow paints are manufactured from approximately a dozen different pigments, and by adding various combinations of other pigments a considerable range of colors, called by an assortment of names, can be created. The six paints shown here can be reduced to two or even one; any one of them has all the possible characteristics of a quality color. If you do decide to opt for only one of them, we recommend for practical purposes, Hansa or Azo Lemon Yellow.

Orange colors

Although orange is easy to create with simple mixtures, it is worth including an orange color on the palette to have direct access to a warm, saturated color. The most commonly used orange is the Cadmium Orange pigment (PO 20), solid and covering like all Cadmium colors, and somewhat earthy and dominant in mixtures. Another more delicate alternative is Pyrrole Orange (PO 73), which has a reddish tendency. It is usually mixed with Azo Yellow pigments and sold under the name of Transparent Orange.

YELLOW PAINTS

PY 3 **Lemon Yellow** (Hansa Yellow)
PY 153 **Indian Yellow**
PY 35 **Medium Cadmium Yellow**
PY 35 **Light Cadmium Yellow**
PY 97 **Permanent Yellow** (Hansa Medium)
PY 37 **Dark Cadmium Yellow**
PY 175 **Permanent Yellow**
(Benzimida Yellow)

The yellows and oranges are the most vibrant colors on the painter's palette. Work by Esther Olivé de Puig.

Yellow colors commonly used for oil painting. From left to right and top to bottom: Light Hansa Yellow, Cadmium Lemon Yellow and Medium Cadmium Yellow, Dark Hansa Yellow, Benzimida (halfway between Lemon Yellow and Red), and Cadmium Red Orange.

Lemon Yellow (Lemon Hansa)

This is a bright color but not very solid. Lemon Yellow is the best vehicle for mixing with other colors. Many painters consider it the standard yellow upon which they base their mixes using the color theory (primaries, secondaries, etc.). Used unmixed, it is the most intense yellow on the palette.

Indian Yellow

The color that originally had this name is rarely made, however the colors substituted for it are very attractive because of their orange undertones and extraordinary warmth and delicacy. It is not very strong in mixtures and is very transparent. It is a favorite of watercolorists, but little used by painters in other media.

Medium Cadmium Yellow

Like all Cadmium colors, the yellows from this group are very solid and strong in mixtures. This is an opaque color that borders on orange. Many painters of acrylics and watercolors use it as their standard yellow, but it does not make very clean mixtures when combined with colors that are far from its chromatic group.

Light Cadmium Yellow

Very near lemon yellow, this is a solid and opaque color that mixes well with reds and greens. This color is much used by oil painters as a basic yellow in mixtures.

Permanent Yellow
(Hansa Medium)

This is a warm color, although not as strong as the Cadmiums. It is especially used by watercolorists, who often make washes using pure colors. They are able to discern the quality of the color and use it without mixing.

Dark Cadmium Yellow

This yellow shows up on the palettes of artists that work in several painting media. Like all the Cadmiums, it is solid and practical, and works well alone and in mixtures.

watercolor samples

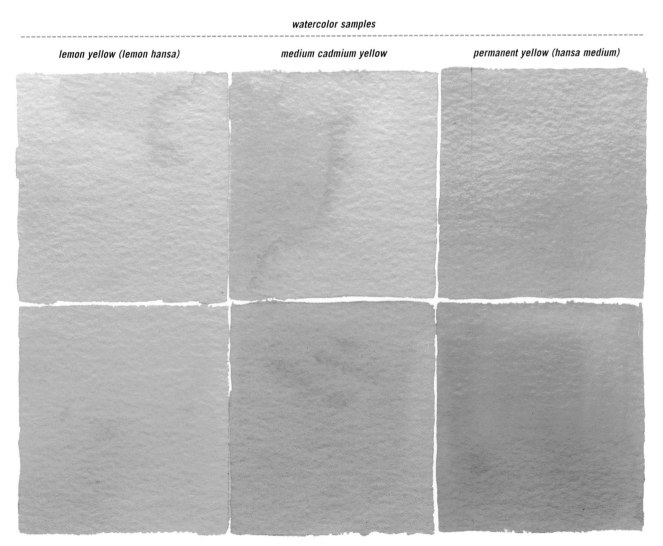

lemon yellow (lemon hansa) *medium cadmium yellow* *permanent yellow (hansa medium)*

Indian yellow *light cadmium yellow* *dark cadmium yellow*

Earth colors

A selection of earth tones

Earth colors are not only the oldest pigments but also the easiest to obtain. Traditionally, they were made from natural mineral powders (most of them from Italian mines); rich in iron oxide, they are mostly reddish, orangish, and yellowish in color. These are solid and very stable paints that should always be present on the painter's palette in a greater or lesser amount. Nowadays, the large chemical industries make synthetic pigments.

These paints are often sold under names such as Mars yellow, Mars red, Mars violet, etc. They all have the same PBr 7 code.

Raw Sienna is a yellow-brown pigment that becomes a clean and transparent chestnut color when burnt. The irreplaceable color is called Burnt Sienna.

EARTH COLORS

PBr 7 **Transparent Golden Ochre**
PBr 7 **Burnt Sienna**
PBr 7 **Raw Sienna**
PBr 7 **Iron Oxide Red** (English Red)
PBr 7 **Raw Umber**
PBr 7 **Burnt Umber**

Earth tones are the most harmonious and subdued of all the colors that can be found on the artist's palette.

Earth colors form a chromatic family of their own, from which multiple color harmonies can be derived. Work by David Sanmiguel.

The most commonly employed oil paints of the earth tone family. From left to right and from top to bottom: Burnt Sienna, Raw Sienna, Yellow Ochre, Raw Umber, Burnt Umber, and English Red.

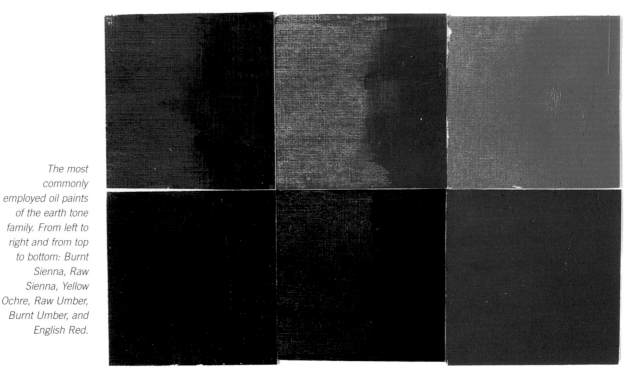

Transparent Golden Ochre

This is a transparent and very beautiful color, especially when used in water-color painting. It loses almost all its charm when used in combination with other colors; it is not very powerful and it is almost unnoticeable in mixtures. Used in pure form it can be one of the most beautiful and warmest colors on the palette.

Iron Oxide Red (English Red)

This red is very solid and opaque with good covering power. Its low brilliancy makes it difficult to use with other reds, next to which it always looks like a subdued brown. However, in combination with other earth tones, mainly ochre, it is very attractive. In oil painting, its opacity becomes even more apparant and it could be considered the most opaque of all the colors on the oil painter's palette.

Burnt Sienna

This one is irreplaceable. Its transparent chestnut color is very attractive whether mixed with another color or not. It produces very interesting ranges of warm grays when mixed with blues, and deep and warm browns when combined with reds.

Raw Sienna

This is very dark and has a greenish undertone. It is a perfect color for mixing complex grays and also for creating olive tone greens. It tends to look dull when used alone in raw form, but with yellows and the other earth tones it produces very warm and serene harmonies.

Raw Umber

Raw umber is a very transparent color and not very strong; it has an ochre undertone and it can sometimes be mistaken for that color. It is usually found on the palette of watercolorists, who are always fond of transparent colors, even though this one has low brilliancy.

Burnt Umber

This is almost like a standard brown. It is a very common color on all palettes. Because of its rich and deep yet lively tone, it can be used by itself or mixed with the ochres and yellows. Its chestnut color becomes even deeper and stands out more in oil paints.

watercolor samples

transparent golden ochre *burnt sienna* *raw sienna*

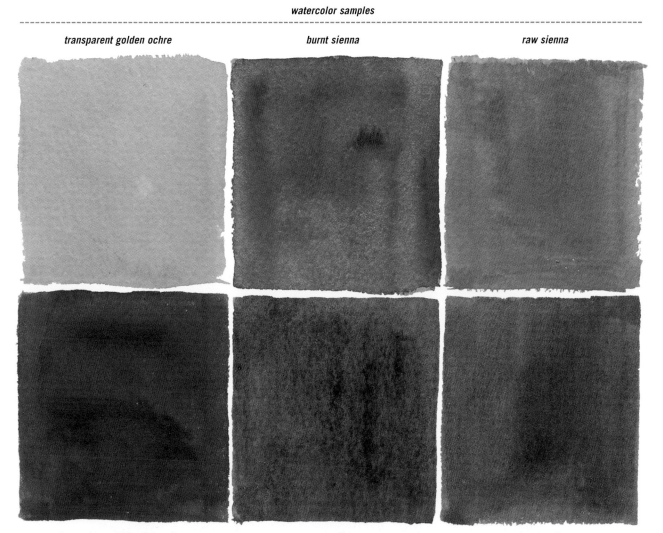

iron oxide red (English red) *raw umber* *burnt umber*

Whites, grays, and blacks

For artists, the grays are colors in their own right and form a very wide chromatic family. Except in the case of painters who have a completely colorist approach to their work, the grays are used by artists to create the foundation of every good harmony—they make it possible to balance out and coordinate the contrasts between saturated tints. When speaking of grays, we should first mention the whites and blacks. The most commonly used nowadays are Titanium White and Ivory Black. These pigments are used in pure form or mixed with others to create all the colors required by the artist.

Gray paints are produced especially for watercolors; the most important among them are Payne's Gray, which is very cool and dark, and Davy Gray, with a greenish undertone.

WHITES, GRAYS, AND BLACKS

PBk 19 + PBk 4 + PBK 6 **Davy's Gray**
PBk 6 + PB29 **Payne's Gray**
PBk 6 + PBk 15 + PBk 19 **Neutral Gray**
PBk 6 **Smoke Black**
PBk 8 **Charcoal Black** (Vine Black)
PBk 9 **Ivory Black**
PBk 6 PB 60 **Indigo**
PBk 11 **Mars Black**
PW 4 **China White** (or Zinc White)
PW 6 **Titanium White**

The three most commonly used black colors in oil painting. From left to right: Ivory Black (the most universal), Smoke Black, and Mars Black (Iron Oxide).

Three white oil paints. From left to right: Titanium White, Lead White (in reality, it is a mixture of titanium and zinc), and Zinc White.

Each white, black, and gray color has a warm or cool blue, green, or red undertone, etc. This is evident when they are juxtaposed and mixed together.

Davy's Gray

This paint is obtained from mixing other pigments where black lime, zinc oxide, and charcoal black are included. This is a delicate gray, with a very transparent green undertone that is sold exclusively in watercolor form. It is suitable for use in pure form, because it quickly loses its qualities in mixtures.

Payne's Gray

Another mixed gray for watercolor painting. A very dark color with a powerful and bluish tone. Sometimes, it can substitute for black. It is dominant in mixtures and can provide a very wide range of intermediate tones and cool and transparent grays.

Neutral Gray

This incorporates several pigments to give a tone that is almost completely black with a violet undertone. Like Payne's Gray, it provides a very wide range of intermediate tones when diluted with water (again, this is a gray that is only available for watercolors).

Lamp Black

This transparent and warm black is made from soot. It lacks the saturation required to be considered a true black. Its intermediate tone makes it an ideal paint for adding subtle and complex transparency effects.

It is used more in oil painting than in watercolor painting and loses its characteristics when mixed with other colors.

Charcoal Black

Darker than the previous one, this black (traditionally known as Vine Black) is obtained from charred vines. It is a beautiful color, somewhat transparent, cool and full of life. Its tonality is very susceptible to the level of solution (with water in the case of watercolors and solvent with oils).

Ivory Black

This black is the one most commonly used by painters. Its tone is rich and saturated and it is very dense and opaque. It is a color that lends itself to all uses, irreplaceable on the artist's palette with any technique. Almost every oil painter uses it as a standard black due to its opacity, evenness, and quick drying time (in the case of oil paints).

watercolor samples

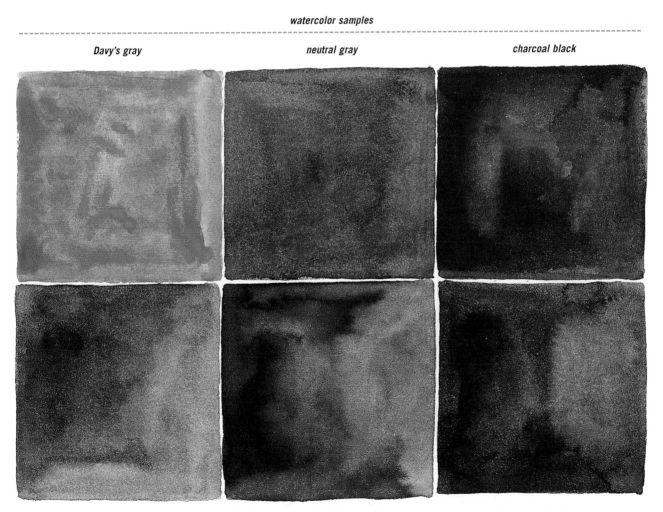

Davy's gray *neutral gray* *charcoal black*

Payne's gray *lamp black* *ivory black*

Oil paints

Oil paints are pigments bound with oils, that give them a richness and tackiness that cannot be found in any other pictorial technique. The binder is a drying oil, that is, an oil that absorbs oxygen from the atmosphere when applied in thin layers, and polymerizes (dries out) forming a flexible and resistant layer. The quality of the pigments and of the oil affects everything.

Oil paints are pigments bound with linseed oil. It can be diluted with organic solvents derived from resins or from petroleum.

Oils

Linseed, walnut, and sesame are some of the many oils used throughout history to make paints.

Nowadays, manufacturers use linseed oil for most of their colors due to its intrinsic characteristics and availability. The best linseed oil and the quickest to dry is obtained from cold-pressed flax seeds, but a good many manufacturers use hot-pressed oils because they are easier to acquire.

Oil, when added to oil paints, dilutes the paint without separating the pigments and gives the paint moderate fluidity, unlike turpentine (left), which can separate the pigment particles.

Darkening of the oil

The golden tone of linseed oil darkens when deprived of light and lightens again when exposed to light. This is equally true for liquid or dry oil, and is why paint that is stored in a dark place for a long time will inevitably darken. Some artists that make their own paints leave the oil exposed to light and air for a while so it thickens and lightens, thus reducing to a minimum the risk of the oil turning yellow (visible in light blue tones).

Alkyd paints and water-based oils

Alkyd paints (bound with a drying resin) act like oil paints, but they dry faster. They can be mixed with the latter and their characteristics are almost identical, although they have less body. Water-based oils are a variety introduced in the market only recently. They act like acrylic paints or like oil paints, depending on whether they are mixed with one or the other. They can be diluted in water and dry fast.

Shown here are three tubes of water-based oils. On the right, a tube of alkyd paint.

1

2

Drying time of oils

Oil paints dry very slowly. A thick impasto can take weeks before it is completely dry. Upon drying, the paint contracts slightly. This is why the surface cracks when the paint used is very diluted (quick-drying) and applied over an area of heavy paint that appears to be, but is not yet, dry. These inconveniences are the flip side of the major advantages of a slow drying time: the colors from one session do not cover but become mixed with those of previous painting sessions, resulting in multiple unexpected tones of great quality.

Making paint

Artists can make their own oil paints. First, a small heap of pigment is placed in the center of the surface used as a base. Then, the oil is poured inside a little depression made in the middle of this pigment heap. Purified linseed oil is the most suitable oil for making paints. We recommend using as little oil as possible because its ability to bind pigments is greater than it may appear at first glance. (**1**).

Then, the oil and the pigment are mixed together with the pestle, using continuous circular motions (**2**). This is done until the paint is evenly mixed (**3**). Finally, the pigment is scraped up with a palette knife and stored in tin cans, available in art supply stores (**4**).

3

4

Oil paints: containers

Oil paints are sold in tin or plastic tubes with screw caps, in four or five sizes, and in different qualities depending on the rarity of the pigments used. These three sizes correspond to 1.25, 4, and 6.75 oz. (37, 120, and 200 ml) tubes respectively. The most common approach is to choose a medium size for all the colors, except for white, which should be purchased in a larger size. One pint (one half liter) cans are also available and are used by artists that like to work with heavy impastos.

Assortments and choices

The paints mentioned here are the classics, the ones whose quality has been proven, and are resistant and permanent. Manufacturers produce many more. Some of the names used are: House Blue, Antioch Green, Brueghel Red, Coral, etc.

The characteristics of each color (their solidity, transparency, and stability) are specified on the color charts provided by the manufacturers. The best charts have a chip of the color painted directly on them to avoid confusion when selecting the color.

Paint tubes have a lot of information on them about the characteristics of the paint held inside. The basic information always includes the code of the pigment and the type of oil involved.

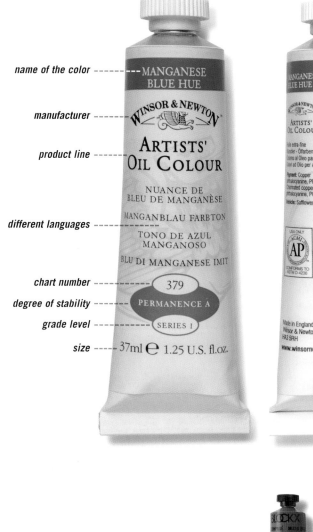

name of the color ---- MANGANESE BLUE HUE

manufacturer ---- WINSOR & NEWTON

product line ---- ARTISTS' OIL COLOUR

NUANCE DE BLEU DE MANGANÈSE

different languages ---- MANGANBLAU FARBTON
TONO DE AZUL MANGANOSO
BLU DI MANGANESE IMIT

chart number ---- 379

degree of stability ---- PERMANENCE A

grade level ---- SERIES I

size ---- 37ml ℮ 1.25 U.S. fl.oz.

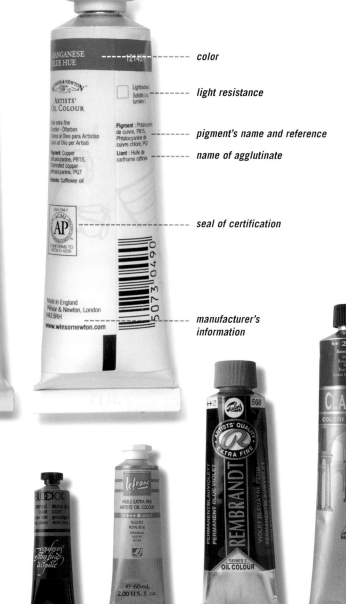

color ---- 12145

light resistance

pigment's name and reference

name of agglutinate

seal of certification

manufacturer's information

Oil paint tubes are sold in three different sizes. The largest sizes are white, black, and the primary colors.

Oil paint charts

These are samples of all of the colors manufactured by a brand. They are a vital reference for the selection of colors. Some of them have an actual sample of the color from the tube and that same color lightened with white: this is very useful to verify the exact tone of the darkest colors. The manufacturers who produce high-end paints supply charts painted by hand to avoid any errors, due to machine impression, between the real color and the one in the chart.

Color charts are an important reference when making a personal selection from a color palette.

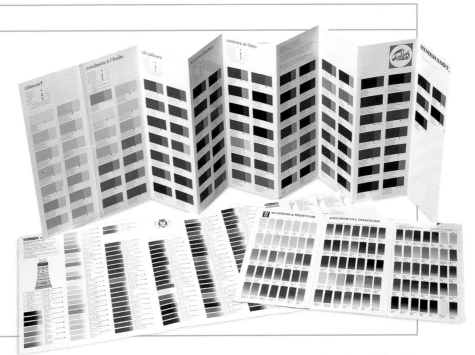

Large box of oil paints produced by the Talens brand.

Boxes

Oil paint boxes form part of the artist's normal equipment. The boxes are sold empty or with a selection of colors, brushes, and solvents, in addition to the palette included. There are very many sizes and qualities available, from school grade boxes to very large, fancy studio boxes made of hardwood. They are useful for carrying the material, however for a studio artist they are not vital. In terms of the color selection included in the boxes, the nature of oil paints lends itself to any type of mixture, no matter how complicated it may be, so a rare color can be obtained by mixing half a dozen basic colors. Basically speaking, the primary colors (blue, yellow, and red) plus a white to make other colors are sufficient, but no artist limits his or her palette that much. Every artist has his own preferences and selects the colors that he thinks he is going to use, whether basic ones for mixing or special ones that are time consuming to mix. The best approach is to develop a personal color selection that responds to the needs of the artist.

space for storing palettes

support for canvas boards

compartments for paints and brushes

side drawer

Watercolors

Watercolor paints are made of organic and inorganic pigments bound with water and gum arabic, in addition to glycerin, honey, and a preservative. Upon drying, the glycerin and honey prevent the surface from cracking when the paint is somewhat thick. The quality of watercolor paints depends directly on the quality of the original pigment used, but also on how the pigment has been ground and agglutinated with the gum arabic and the rest of the substances. This quality is evident basically in two characteristic ways: the stability on the paper, without deteriorating or flaking, and the solidity and resistance to light, without suffering any discoloration.

Brilliance

This characteristic defines the clarity of a color in its maximum saturation (without diluting it in water, as it comes out of the tube). In each family of paints (yellows, reds, greens, and blues, etc.) there are colors with very different brilliance. In watercolor painting, this factor is usually associated to the innate transparency of each color—the greater the transparency the greater the brilliance.

Transparency

The vehicle or binder of watercolor paints (gum arabic) is transparent and this is what gives the colors their wonderful brilliancy. But not all of the paints have the same level of transparency. The quinachridone pigments (oranges, reds, and mauves) and the phthalocyanine (greens and blues) are extraordinarily transparent and brilliant, while the cadmiums (yellows and reds), the ones with chromium (greens and yellows), and the iron oxides (reds and ochres) are, in some degree, opaque. These differences are intrinsic to the pigments and the artist must know them and use them to his advantage.

Watercolor paints are pigments bound with gum arabic. Water is their solvent.

The transparency of the color is maintained almost independently of its saturation, although it will be greater in colors that are more diluted with water.

Tinting power

Some paints stain the paper more thoroughly and withstand washes without vanishing completely. An excess tint could indicate the presence of anilines, very volatile tints that should be avoided all together. Ideally, it should be possible to reduce the color of the stroke until it disappears completely, although, again, this is more feasible with certain colors than with others, which may be an indication of questionable quality.

Other attributes

Depending on the paint, the areas of color can have a grainy texture due to the larger size of the pigment particles. This tends to happen with iron oxide pigments and also with some cadmiums. In other cases, like Ultramarine Blue, a flocculation effect takes place: the pigment particles attract each other and the dry paint acquires a characteristic mottled look.

The most outstanding characteristics of watercolors are their transparency and brilliancy.

Colors like Cadmium Red are more opaque than the rest of the watercolors.

The particles of Ultramarine Blue pigment have formed lumps.

The different natures of the pigments become visible in color mixtures.

Watercolor formats

The main high-quality watercolor brands are: Winsor & Newton, Talens, Blockx, Old Holland, Titán, and Schmincke, among others. Many of them provide the two main watercolor varieties: dry and creamy. Creamy watercolor paints are sold in individual tubes that the watercolorist uses with a palette with wells, and also in various assortments. Watercolor pans are sold in metal boxes that double as palettes. These boxes can have 6, 12, or 24 replaceable pans, because the colors can be purchased separately. In addition to these generic assortments, the best known manufacturers supply many other boxes with a variety of colors and that can incorporate all types of accessories.

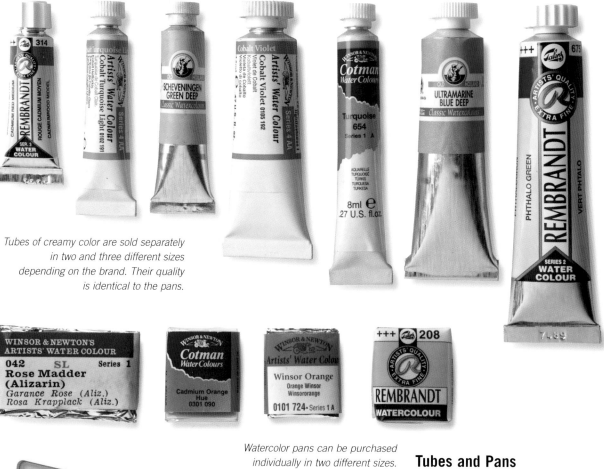

Tubes of creamy color are sold separately in two and three different sizes depending on the brand. Their quality is identical to the pans.

Watercolor pans can be purchased individually in two different sizes.

Tubes and Pans

Quality watercolors are used in the same manner, whether in tube or pan form. The tubes supply large amounts of paint, but they can easily lead to waste. With pans, we always use the right amount of paint, although it is difficult to charge a generous amount of paint from a pan, and the brush suffers every time it rubs against a still-dry cake. Paint in tubes allows one to use any size brush, from small to large, but large brushes cannot be used with small pans. The pans, on the other hand, are compact, comfortable to use, and easy to carry.

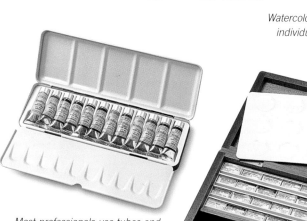

Most professionals use tubes and pans interchangeably. In general, tubes are more appropriate for working in the studio.

Color charts

Winsor & Newton and Schminke charts include between 80 and 100 different colors. They have 14 yellows, 9 reds, 11 blues, 10 greens, and so on. Naturally, it is not necessary to have so many varieties for painting, and every artist chooses those that are most suitable. That is precisely why the color charts are so useful. Each color's level of stability is indicated in all of them, dividing them into those that are most volatile and those that are most stable.

Good quality color charts from water-color manufacturers are painted by hand and each paint chip is real, meaning that it has been painted directly on the chart. This makes it easier to check the real tone of each paint color.

Personalized charts

Some artists make their own color charts using paints that he or she acquires, sometimes out of curiosity. These color charts make it easy to check the color of the paint in different levels of solution, that is, in different saturations, as well as show how the paint looks when it is applied on different papers. These samplers are of great value, because they help the artist in the selection and the use of the color, as well as in the choice of the specific support for each job.

Gouache colors

The good thing about painting with gouache is that it is connected to watercolors both historically as well as technically. The difference between the two, as far as artists are concerned, did not surface until the end of the 18th century. Technically, they both share the same chemical composition, although modern gouache includes certain ingredients that are not present in watercolors. Traditionally, they have been considered as a lesser medium than oils or as an "impure" version of watercolors. However, this way of thinking is now outdated, and most artists do not pay attention to the hierarchy imposed by tradition, especially in what refers to artistic expression.

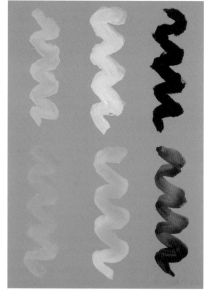

The opacity of gouache depends on the level of solution. They are completely opaque when they come directly out of the can or tube.

dense color

In this color sample we can see the different consistencies of gouache depending on water content, ranging from almost as thick as acrylic paint to almost as transparent as watercolors.

Characteristics

Gouache has the same composition as watercolors and both techniques resemble each other to the point that many consider gouache an opaque watercolor. In modern manufacturing processes, gouache incorporates almost the same binders contained in watercolors: gum arabic mainly, but also Ghatty gum, bone glue, and starches that give body to the paint. The manufacturers add a fungicide to the paint to prevent the starches from promoting fungal growth. In addition to these ingredients, every color incorporates a filler, normally inert white pigments, to achieve the complete opacity of the color.

good covering power

The opacity of gouache makes it possible to layer the colors easily, as long as the bottom layer is completely dry.

transparent color

Varieties

Color gouaches are sold in two typical varieties: tubes and small jars. To the latter we must add a third: dry paint in cakes, especially designed for school use, while the former two are the ones used by professionals. Artists use tubes and small bottles interchangeably. Most of them buy their colors separately, tube by tube or bottle by bottle, as needed.

Assortments

There are three basic formats available: 1.25 oz (37 ml) tubes, 1 oz (30 ml) jars, and 5 oz (150 ml) cans. These cans come with a dropper in the lid to avoid the continuous opening and closing of the can, and are very useful for colors such as white and black, which are used more often than the rest. The colors available in this format are of professional quality. Gouache colors are also available in many school formats, but most of them are of little interest to professional artists.

School-quality boxes with color cakes.

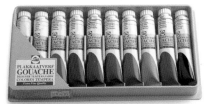

Basic assortment of professional quality gouache paints in tube form.

Direct mixtures and colors

The traditional use of gouache as a medium for graphic designers and illustrators inspired many manufacturers to provide a variety of colors in order to fulfill the illustrators's needs and to give artists direct colors saved from the hassle of involved combinations based on the three basic colors. The arrival of the computer has made this function obsolete.

The homogeneity afforded by mixing gouache colors makes it possible to obtain almost any color range using only the three primary colors plus white (and, eventually, black). But the traditional use of gouache for illustration and design work has made some manufacturers continue to offer a very wide range of colors in cans.

Acrylic paints

The success of acrylic painting as a general technique for any type of artwork becomes obvious when visiting an art supply store. The colors, whether for children's use or for murals, are available in every imaginable shade. Acrylic paints have caught on very quickly and very few artists have not worked with them at some point in their careers. Nowadays, acrylics are as popular as oils, equally so among amateur painters as well as professionals. Acrylics have gained a reputation for being an affordable medium and easy to use, less "dirty" than oils, yet with a finish that is almost identical. And such sentiment is to a certain degree true.

The consistency of undiluted acrylic paints is smoother and lighter than oils. When the paint is diluted the consistency lightens to the point that it becomes similar to gouache diluted in water.

thick color

saturated color

diluted color

Drying and strength

The quick drying time of acrylics does not make them a more fragile or less durable medium than others that are proven strong, like oil paints.

On the contrary: acrylic paints, once dry, are extremely strong and form a hard layer that is waterproof and somewhat flexible, is thus less prone to cracking and more stable than oil paints.

Characteristics

Acrylic paints are pigments bound in synthetic resin: an emulsion of polyvinyl acrylate. This emulsion dries by water evaporation and traps in its molecules the particles of pigment that are suspended, forming a flexible layer that is transparent and very resistant. This elasticity, transparency, and resistance are qualities that characterize acrylic paints and set them apart from other media. However, their most obvious trait is their quick drying time, which is extraordinarily fast compared to oils, which makes working with them much easier in most cases.

consistency of acrylic paints

direct paint *paint diluted with water* *paint diluted with an acrylic medium* *extra thick paint*

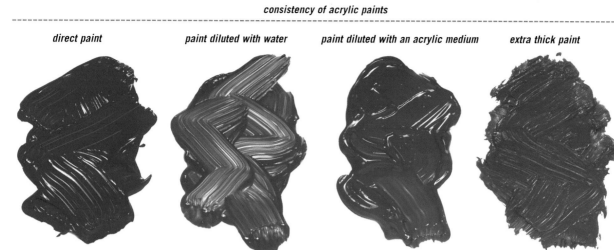

Box with an assortment of commonly used acrylic paints. Normally, there are more paints than those needed for oil painting.

Formats and assortments

Acrylic paints are sold in the same formats as oil paints. There are two basic formats: tubes and cans. The tubes are usually similar in size to oil paints. The cans can be very different styles and sizes: from very small jars with a dispenser to large one gallon (four liter) cans. Every manufacturer provides the market with different formats and prices.

Tubes of acrylic paint.

The ease of use of acrylic paints makes them very appealing for experimenting, which would be difficult to do with any other media. Work by Ramón de Jesús.

Easy to handle

Ease of use, cleanliness, and affordability are the three main reasons why acrylic paints have become one of the most popular media among professional and amateur artists. The cans with dispensers are one example of the clean factors that characterize acrylic paints.

Ink

Ink is one of the traditional drawing media. In the Eastern world, its origin dates back to the year 600 before the modern era. In the Western world the Romans used different versions of black ink, and many of them are still used today for writing and drawing. Nowadays, there are many available variations of the Eastern and Western inks. In addition, the technological advances in the chemical industry have widened the spectrum, introducing color inks and new versions of long forgotten formulas.

India ink

This is the oldest of all inks. It originated in China and its old formula included mixtures of charcoal dust, oils, and gelatin. This ink is soluble in water and therefore its strength can be controlled. Traditional India ink is available in solid sticks that can be diluted by rubbing them on a special dampened stone; this is the way it is used in traditional Chinese and Japanese painting techniques. Most artists use India ink in liquid form, which is made with black charcoal and gum lac; it is insoluble in water when it dries.

These are various samples of inks that have been slightly diluted with water at one end.

India ink

sepia ink

black ink for fountain pens

blue ink for fountain pens

pigmented ink

ink with coloring agents

ink from plant extracts

The results offered by Chinese ink are always highly graphic. Work by David Sanmiguel.

Original Chinese ink is available in solid bars that need to be ground in water on a special smooth black stone to make the ink liquid.

Black Ink

Even though the name of India ink is applied to any type of black ink, the truth is that most of the conventional black inks are made of complex chemical compounds with metal salt bases that incorporate a pigment or ink, which can be of different colors (even white) depending on the substances used to make them.

Opaque black ink from the brand Winsor & Newton.

Ferrogallic ink

Since the Middle Ages this has been the most commonly used ink for writing and drawing, from the codex illustrators on down to Van Gogh. During all these centuries there was no other alternative. Classic painters like Rembrandt, who is the author of this drawing, used ferrogallic ink. This ink is red when applied and turns black after it oxidizes on the paper. Nowadays, it has been replaced by other more stable inks, because ferrogallic ink causes continuous and irreversible corrosion to the paper.

Samples of color inks. The use of coloring agents (of low stability) makes it possible to produce colors that are very bright and luminous.

Colored ink

The composition of colored ink can be the same (or similar) to India ink, but it incorporates coloring agents instead of black pigment; colored pigments would result in uneven consistencies and they would reduce the transparency of the strokes. The colors are indelible but not very permanent, that is, they discolor after prolonged exposure to light. This lack of stability is increased with the transparency of the coloring agents used in the making of the inks. In general, the cleanest and brightest colors are the most susceptible to the color loss with time.

Special palette for color inks. Each ink produces different colors (arranged in various wells) according to the amount of water used in the solution and its mixture with other inks. So, the number of colors available is multiplied without the need for mixing them.

Writing and calligraphy inks

Modern writing inks, which are designed to be used with fountain pens, were developed during the early decades of the 20th century to be fast drying substances with alcohol bases that did not need blotting papers. The pioneer and best known of all of them is Parker *Quink*, very popular nowadays among many artists due to the great variety of tones that result when diluted with water. Calligraphy inks incorporate pigments (opaque) or vegetable inks (transparent) and are available in very many colors.

Calligraphy ink made with plant extracts, from the Swiss brand Abraxas.

Lines made by mixing two different inks (yellow and magenta) in different proportions.

Solvents

The solvent in almost all of the painting techniques like watercolors, gouache, acrylics, inks, etc., is water. The exceptions are oil paints and a few other techniques derived from oils, whose solvent is a distilled vegetable substance or an element derived from petroleum, in other words, an organic solvent. The primary and basic use of solvents is to make the paint more fluid, but they are also very useful for cleaning the brushes, the palette, and other painting tools, as well as hands and clothes when paint gets on them by accident.

Water

Water is the most commonly used solvent in all the pictorial techniques. We recommend avoiding water that is too alkaline or too acidic because it can alter the colors. If water is used as a solvent for India ink, it should be distilled to prevent the pigment from separating.

Water is the solvent for all media except for those that have oil or wax as binders.

Mineral spirits or essence of turpentine dissolves oil-based paints, reducing the body and consistency of the colors and making the paint surface more transparent and fluid.

Turpentine

Nowadays, turpentine or essence of turpentine is the most commonly used solvent by painters. It is the result of distilling the resin of pine trees, which is transparent but slightly yellow, with a strong and penetrating odor (resin smell) that can be unpleasant for some people but aromatic for others. It is harmful if ingested and if a person is exposed to its fumes for an extended period of time, and it will irritate skin. There are many alternatives to turpentine, which is why its use is discouraged.

The essence of turpentine makes the brush slide easily on the support and helps spread the paint comfortably.

Odorless solvents

All of the petroleum distillates can be used as solvents for oil paints. The most commonly used, white spirit, is transparent and odorless. It is less toxic than turpentine and less of an irritant. Mineral spirits are another alternative but they are not problem-free. Products made from orange peels are a more pleasant alternative; they are good solvents and very aromatic, although they are more expensive than the others. However, all of these solvents have a certain level of toxicity and it is important to use them in areas with good ventilation.

Odorless solvents for oil paints tend to be products obtained from distilled petroleum. They are very effective, but their high toxicity requires using them in well-ventilated areas.

Risks

The great majority of solvents are harmful if inhaled and if they come in contact with skin. To minimize these risks, work areas should have good ventilation and the solvents should not be used for cleaning hands; if this is the case, the skin should be rinsed with abundant water and a lotion applied afterwards. Also, it is important to avoid accumulating rags or brushes soaked with solvent because they can cause spontaneous combustion.

All of the organic solvents must indicate whether they are flammable and the health risks involved.

Recycling solvents

Paint and other impurities that soil the solvent end up settling on the bottom of the container (**1**). The used solvent can be recycled by pouring it repeatedly into different containers as the impurities settle on the bottom of the jars (**2**, **3** and **4**). In the end, the liquid will be somewhat tinted and not as strong as the original solvent, but still usable (**5**).

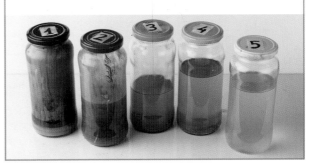

Varnishes

Varnishes protect paintings from pollutants, dust, humidity, and so on. They are made of a resin and a solvent. There are very many different types available, especially if we add the new varieties that manufacturers introduce to the traditional varnishes. There are two main groups: varnishes for

touching up and finishing varnishes. The latter include different varnishes for water techniques, which hardly have any problems like varnishes for oil paints, which can be too glossy or dry up, and therefore do not require special attention.

Varnishes create an insoluble, transparent, and flexible surface that protects finished paintings and emphasizes or minimizes their natural glossiness.

Every varnish has a different tone that makes it more or less transparent. The glossy varnishes are also the most transparent.

Many of the varnishes for traditional finishes (finishing varnishes) turn yellow with time and alter the natural color of the painting. That is why we recommend using reversible varnishes, that is, varnishes that can be removed with a special solvent.

Finishing varnishes

These create a protective film that isolates the layer of paint from the environment. In the case of oil paints, they should be reversible so the painting can be varnished again after a few years. Traditional varnishes are not reversible or reversible only with great difficulty. They should not be applied until all the paint is completely dry (between 4 and 10 months), otherwise the varnish will mix with the oils of the paint and it will become permanent. To avoid this risk there are protective varnishes or first layer varnishes that are applied before the final varnish and act as insulation for the paint.

Varnish for touching up

These are exclusively for oil paints. They are used to adjust specific areas of the painting that lack gloss because the oils have been absorbed by the underlying paint layers or the canvas. Also, touch-up varnish is very useful for giving an even finish to the paint surface after touching up a painting that has been completely dry for a long time. It is applied in very thin layers, preferably with a spray. It takes only a few hours to dry and does not turn yellow. It can be dissolved with turpentine, but the presence of a solvent can affect the paint layer, which should always be completely dry before varnish is applied.

Matte or glossy

Most of the varnishes are available in matte and glossy varieties (traditional varnishes are very shiny) that can be combined until the right level of glossiness is achieved. The natural finish of oil paintings obliges us to use a preliminary glossy varnish before the matte varnish (which includes silica and waxes), if the artist wishes a matte finish.

Varnishes and techniques

Every painting medium can be varnished with a specific product. Almost all of these products are available in matte and glossy varieties, and almost all of them can be removed with a specific solvent. Nowadays, the best quality varnishes incorporate filters for ultraviolet light that diminish the discoloring effects of light on paintings.

The old varnish cracks and forms efflorescent areas on the canvas. It can be removed with special restoration products. The varnishing process should be carried out with a reversible varnish, which should be applied in very thin layers making perpendicular motions with the brush.

Solvents for varnish

Almost all of the varnishes can be dissolved and removed with a specific solvent. These products have been designed in restoration studios and are very helpful in restoring the original color of a painting, which can turn dark or yellow when the original varnish ages.

Varnishes in spray form are very practical, but they should be used with caution, applying a series of very thin layers.

Water-based additives

These crystals show the natural appearance of gum arabic. The most transparent granules are diluted in water and filtered, and then used as a binder and a medium for watercolors.

Also called mediums, these additives are substances that highlight or reduce one or several of the properties that characterize specific kinds of paint (oils, acrylics, etc.). They promote or slow down the drying process, and increase or reduce the glossiness, transparency, or thickness; they emphasize the brush marks or minimize them, and so on. Additives such as ox bile or gum arabic have been used by watercolorists since ancient times. Chemical advances have increased their availability, especially in the area of acrylic painting.

Gum arabic for watercolors and gouache can be easily found in small containers in art supply stores.

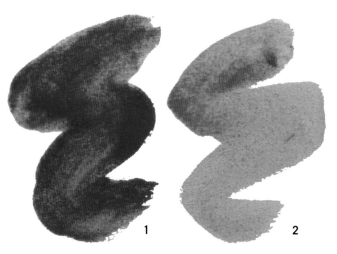

Added to paint in moderation, diluted gum arabic increases the glossiness and transparency of the paint (1). Excessive use muddies the color and gives it a gelatinous texture (2).

When gum arabic is diluted with water, it releases impurities that must be removed (by straining them with a nylon) before the solution can be mixed with paint.

Gum arabic

This is a vegetable resin available in umber colored crystals that are very hard but easy to dilute in water. When diluted, gum arabic becomes a thick and sticky, umber-colored liquid that dries quite fast to create a shiny and transparent layer. All these characteristics make it ideal as a binder for watercolors. As an additive, it is available in solution form that can be added to a watercolorist's water cup to eliminate traces of oil residue, to increase the adherence of the paint, and provide greater intensity, sheen, and transparency.

A fast-drying liquid substance for masking areas of the paper to be left unpainted. Masking fluid is sold in permanent and removable versions (once dry, it can be eliminated by rubbing with an eraser).

Masking fluid

This is used to make small white reserves that are too small to be dealt with comfortably with the paintbrush. The liquid is applied to the paper with a brush. When it dries it creates a thin waterproof layer that is easily eliminated at the end of the project by rubbing with an eraser. It is a good idea to apply it with an old brush because the fluid can dry in the hairs. There is also a version of masking fluid that is white and permanent when applied to paper.

This sequence shows the masking process in a particularly small area of the watercolor. The masking fluid makes it possible to make reserves that are small and have irregular shapes.

Caution

Using additives in acrylic paints is very different from doing so in watercolors and gouache. Acrylic paints have a robust body and consistency that make them suitable for any mixture or experiment; the stability of the acrylic emulsion guarantees the stability of the final piece. Gouache, and especially watercolors, are too delicate to withstand a lot of additives without becoming ruined and losing their natural charm.

Other additives for watercolors

To improve the drying time we can add a small amount of 96-proof alcohol to the water used for painting. The drying speed will depend on the amount of alcohol added. When painting outdoors, on a very windy or sunny day, watercolor paints dry faster than desired; in these cases, or whenever the artist wants a slower than usual drying time, simply adding a small amount of glycerin to the water will keep the watercolors moist for a longer period of time. Ox bile is a moistening substance that improves the fluidity of the paint when mixed in the water in small amounts. Almost all major manufacturers provide a special varnish for watercolors. Some artists use it for both protecting the colors and for making them shinier by applying it just in certain areas in thin coats. Varnishes should not be used to the extreme of making the surfaces overly shiny.

Acrylic and vinyl mediums

Acrylic or vinyl binder can be added to paint to increase its fluidity with little loss of body. The acrylic mediums can be glossy or matte and are always more transparent than the vinyl mediums (latex). Many artists use them to bind their own plastic or acrylic paints.

Acrylic mediums can be glossy or matte. Matte mediums are more transparent. The most commonly used vinyl medium is latex. It has a milky consistency and is less transparent and resistant than acrylic mediums.

Oil-based additives

Most of the mediums for oil painting are based on oils that are more or less diluted in essence of turpentine, with the possible addition of a small amount of varnish.

Oil paints have always been characterized by a more complex "recipe" than any other medium. For a long time artists have been trying to come up with different combinations to improve the paint finishes. Nowadays, there are additives for any procedure and artistic technique. Manufacturers are constantly proposing new formulas and it is left to artists to decide if they suit their specific interests or if they are just variations of products that are already known.

Mixtures

Like in the old days, there are still many artists who make their own medium for painting with oils by mixing essence of turpentine with linseed oil as solvent during the painting process. These mixtures can incorporate varnish to increase the glossiness of the paint. There are many prepared products available, most of them increase the fluidity of the paint and slow down the drying process to make working on the details easier.

Use

Most of the additives are used by adding a few drops to the solvent or medium already mixed by the artist. A common medium can be one part solvent to one part oil; to this solution, we can add a few drops of one or several products (as long as they are not incompatible). It is recommended to test each emulsion before applying it to the final piece.

Stability

All of the additives must be used in small quantities, especially the driers, which we should resort to reluctantly, because commercial paints already have them. Otherwise, most of the additives do not present any risk to the artwork, but they can reduce some of the intrinsic characteristics of oil paints, like the typical gloss, density, and texture.

Three samples of the most common components for painting with oils. From left to right: oil, turpentine, and varnish.

Alkoids and mixed resins

Mixed resins can be combined with water or oil for use as an agglutinate (binder) for water- or oil-based media. They are one of the latest novelties on the market. Alkoid resins are only diluted with oil solvents, but they dry much faster than oil paints. The artist can grind pigments with these resins, creating paints that are very similar to oils.

Additives are usually poured into one of the palette pans, while the other pan is saved for the solvent (usually essence of turpentine).

Mixing a medium

The ingredients of this medium are essence of turpentine, beeswax, and colophony (a natural resin) (**1**). First, with a hammer, we crush a few pieces of colophony wrapped inside a cloth to make fine granules (**2**). This handful of colophony is wrapped in a nylon mesh and placed into a can in a proportion of five parts turpentine to one of colophony (**3**). When all the colophony is dissolved in the turpentine, a piece of pure wax (one part wax to six or seven parts of colophony) is added to the container and is heated in a double boiler until the wax is completely melted (**5**). This medium (**5**) is mixed with the paint in small proportions (a brushstroke of color to half of medium, approximately), during the painting session: it makes the paint go a long way and gives the painting a heavy texture and silky appearance.

This sequence shows how to make a wax medium. Wax, since it is an oil product, combines very well with oil paints. Its texture and transparent quality add an interesting and appealing quality to the finished work.

1

2

3 4 5

The paper

Paper was invented in China; it is known that its use dates back to the year 105 A.D. as a cheap substitute for silk. Eight centuries elapsed before paper arrived in the Western world through the Arab culture. The expansion of paper to the West originated in the northern Chinese city of Canton, crossed the central deserts of Asia to Samarkand (751), Baghdad (793), and northern Africa, and it was introduced in Europe through Spain and Sicily. The first European factory operated in the Spanish city of Játiva in 1150, and was managed by the Arabs. In the Western world, the use of parchment paper was common practice until the 15th century, a time when the invention of the printing press standardized the new support, which continued to be a luxury until the onset of the industrial revolution.

There are an enormous variety of papers on the market. For art purposes, we should look for top quality brands and surfaces that are suitable for each medium.

Composition

A sheet of paper is made of cellulose fibers, which is the basic substance found in vegetable fibers. This cellulose can be extracted from wood, cotton, linen, and many other plants. The best papers are made of linen and cotton fibers, the latter being the most suitable for their durability and their greater absorbency. To ensure the durability of the paper and to prevent it from turning yellow with time, the paper must be free of acids. These acids come from substances found in the vegetable fibers themselves as well as in the chemical components used for breaking the fiber down and from the water used in the maceration process. Therefore, labels such as "100% acid free cotton" are the ones that we look for in the literature provided by the manufacturer.

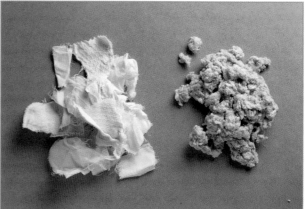

The best paper is made from cotton rags. Pictured are fabric pieces and a "refined" (broken and beaten) cloth, part of the process for obtaining pulp.

The uneven edges of the paper are an indication that each sheet has been produced individually. These uneven edges are called deckle edges.

Manufacturing

The raw vegetable fibers become the paper pulp after a process of fermentation with water and lime and beating and refining, the purpose of which is to separate the fibers without damaging them. Once the maceration of the pulp is complete, it is combined with a large amount of water, into which chemicals like whiteners and glues have been added, and it is mixed in large vats.

In industrial settings, the pulp is poured onto rotating cylinders, that can be heated or not, that subject it to different amounts of pressure to create a continuous thin sheet that is cut into smaller sheets. In the production of quality watercolor papers, special cylinders are used that put out the paper sheet by sheet without cutting, which is why they have uneven or deckle edges.

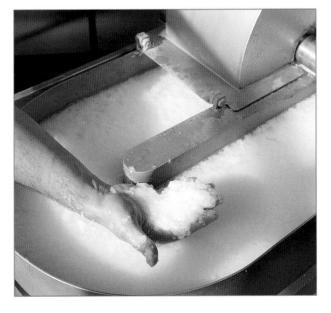

Pulp of the proper consistency after being beaten in a vat with large amounts of water.

Handmade sheets of paper are made by dipping a mold or deckle (a very large one in this case) into the vat containing the pulp. The mold is a metal screen, attached to a frame, which retains only the pulp.

The metal screen gives the paper its final shape; after the screen is laid over a felt it is left to dry until it is ready to be used by the artist.

Drying room for the paper in a traditional mill devoted to the production of handmade paper. The sheets are left to air dry naturally; no induced pressure or heat is used.

Papers for drawing

Like any paper used for art purposes, drawing paper must be completely free of acids to guarantee its preservation and prevent it from turning yellow. Among the professional quality ones, drawing paper is available in satin finishes, fine grain, and laid paper. The last two formats are also suitable for working with charcoal. Each drawing medium calls for a specific type of paper. However, graphite, because of its oily nature, can be used on any surface, even smooth or moderately textured ones.

Ingres Type Papers

These are medium-grain papers that have a characteristic machine made texture (laid paper). Laid paper is the one traditionally used for work done with charcoal, compressed charcoal, and sanguine. Its special texture has just the right tooth to retain the charcoal and chalk particles and to produce good gray colors and blends.

75 lb (160 gram) paper for drawing and doing calligraphy with India ink.

45 lb (100 gram) Ingres paper for drawing with charcoal and sanguine.

Sketching paper

Sketch paper is drawing paper specially designed for sketching. Some sketch paper is multi-media, while others are specialized for a particular medium. The tooth of the sketch paper, along with the weight, determines whether the paper is multi-purpose or not. A smooth surface is ideal for line drawing, while a medium surface may be used for all drawing media, including pencil and charcoal, and can even produce good results with Chinese ink.

Light paper and medium quality sketchpads are an affordable, practical, and suitable alternative for almost every drawing technique.

shading with pencil on different types of paper

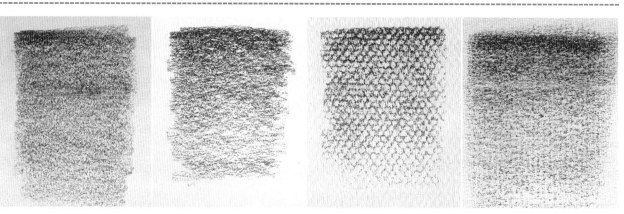

Sketching paper. *Medium-grain paper.* *Heavy-grain Canson paper.* *Ingres type paper.*

Medium-grain 40 lb (90 gram) paper for sketching.

Bristol type papers

These are papers with a satin finish, and an imperceptible texture. They are hot pressed to specifically enhance their smoothness. As supports for graphite they allow a wide range of grays and provide very good results in blends and rubbing. These supports are the most suitable ones for drawing with reed or nib pens, because these tools can slide across the paper with ease. On the other hand, they are not good for drawing with charcoal.

Standard papers for drawing

Drawing with graphite is not too demanding when it comes to supports. That is why there are many medium type papers of fine grain and light weight that fulfill the basic requirements for drawing with graphite and with charcoal. These are the papers for sketching and studies. They are available in pads of various sizes.

Heavy-grain 80 lb (180 gram) drawing paper.

Japanese paper

This is a very light paper produced with special fibers that make it very absorbent. It is the traditional paper for Japanese washes, whose appeal in the Western world as a drawing style explains the paper's availability in art supply stores. It is sold as individual sheets and in pads.

35 lb (80 gram) Japanese paper for drawing with a brush and India ink.

Bristol paper, 120 lb (250 gram), for drawing with ink (and also with graphite).

Eastern painting techniques require a very thin and absorbent paper that makes it possible to create the characteristic effects of Chinese and Japanese washes.

Papers for drawing with pastels

Any surface where pastels can find texture to grind the stick and that allows the pigment particles to adhere to it is suitable for working with pastels. While all papers are good except for the ones that have a satin finish or are very thin, the ideal paper must have the right amount of texture. Special papers for pastels are also available in a wide range of colors.

Gray laid 40 lb (100 gram) paper of the Ingres type for pastels.

Papers with fine texture

Papers with fine texture (cardboard, conventional drawing paper, recycled or wrapping paper) can be covered quickly, the support can be painted easily, and the pastels slide well, but it is difficult to paint in layers because the grain is quickly filled. When this happens, the pigment particles no longer adhere easily, the paper does not hold them, and the pastel comes off after it is applied. Therefore, these papers are only suitable for sketching and for work that requires very little repetition and can be resolved with a few applications of color.

The Canson brand has a wide range of colored papers for pastels.

Paper for drawing and painting with pastels must be rough so the pigment has a surface with tooth to hold it in place.

Every paper has its own texture and provides a different finish.

Rough texture

In papers with rough texture it is more difficult to cover all the small pores completely with color; therefore, it is easier to work with successive layers to create an artistic result of rich quality.

Colored papers

The colored papers most commonly used by watercolorists are light sienna, ochre, and different shades of gray. Due to their soft and more or less warm or cool tones, these colors go well with all subjects and with all color ranges. Many manufacturers produce colored papers for pastels that come in a wide range of the colors already mentioned: light and dark grays, with blue and gray tones, various shades of ochre, ivory colors, neutral earth tones in different shades, etc. These papers are available in the most common format of 20 × 26 inches (50 × 65 cm), but they are also sold in pads of various sizes, in packages of individual sheets in the same color range, and in rolls.

Pad of 60 lb (130 gram) colored paper.

Pad of 75 lb (160 gram) colored paper in six different tones (earth tones and grays).

Cardboards, canvas, sandpaper

Because of its hardness, cardboard is a very comfortable support, although it is important not to bend it to avoid causing folds and wrinkles. Canvas primed with an absorbent primer is also a good surface for painting with pastels because it provides good tooth for the pigment; because of the roughness of its surface, canvas needs to be worked with generous amounts of color and in large formats. Some artists like to paint on fine-grain sandpaper surfaces because their grain is tight and fine. These papers provide good color saturation and sharp outlines.

The importance of texture

Pastels highlight the paper's texture more than any other technique. Therefore, it is important to choose interesting textures that are pleasing to the touch and to the eye, and to avoid machine made textures (bottom right) because they create a monotonous effect when the work is finished.

Papers for watercolor painting

In the art of watercolor painting, the quality of the paper is of the utmost importance. Quality papers are heavy, 140 lb (300 gram) or more; they are made from 100% cotton rag and produced in individual cold-pressed sheets, with special attention placed on the sizing, because this dictates the response of the paper when painting with a large amount of water. This high-quality paper is expensive, which is why some brands manufacture medium-quality papers that are equally as good. Good papers are recognized by the presence of the manufacturer's logo or name, which appears on one of the corners of the paper as a traditional watermark that is visible against the light.

Stamps and watermarks are a guaranty of the paper's origin.

Light watercolor paper pads are very practical for sketching and for making color studies outdoors.

Sizing

Water buckles the paper. This is one of the reasons why watercolor papers should be heavy. Even then, buckling is inevitable when working with wet techniques. Water makes the cellulose fibers spongy and throws them out of order, which can cause the paper to fall apart if it does not have a substance that makes it firm and cohesive. That substance is sizing; it can be a gelatin that allows the surface to maintain its consistency and prevent the fibers from separating. During the production process, watercolor papers receive size "in mass," first on the inside and another time on the surface. Because of this the consistency returns to the fibers after the paint has dried.

The grain of the paper

There are three kinds of paper: fine grain, medium grain, and heavy grain or rough. The fine grain emphasizes the glossiness of the colors applied on it, but the colors dry very fast. Medium grains make it easy to work liberally. And finally, heavy grains have a coarse surface that is very sought after for techniques that are more spontaneous and expressive.

Fine-grain watercolor paper.

Medium-grain watercolor paper.

Paper pads and loose sheets

It is not necessary to stretch the paper if the painting is done on heavy sheets that come in 20 or 25 sheets per pad. These are bound on the sides and form a compact unit that keeps the paper perfectly stretched while working. Generally, the small formats do not require any special treatment because the warping caused by the moisture is not very significant. However, if the work is done on loose sheets of paper it is a good idea to attach them to a board with pins or metal clips.

Heavy-grain watercolor paper.

There are pads with sheets of paper glued on one side and others with sheets of paper that are spiral bound. The former are of higher quality than the latter.

The quality of watercolor paper

The quality of the paper is a determining factor in watercolor painting. This not only means that the paper should be top quality but also that within the range of professional quality papers, there are many variables that can produce completely different results. The characteristics of the paper that determine the final appearance of the work are: the weight, the surface texture, and the sizing on the surface. The weight should be high, 140 lb (300 grams) or more; the surface can range from very smooth to very textured, depending on the artist's choice; the grainier the texture the deeper and the thicker the color will be (and less luminous). The sizing should be sufficient enough for the paint to penetrate the paper without restricting the free flow of the brush; excessive sizing on the surface tends to cause the paint to puddle and makes the layering of the colors difficult.

Watercolor papers act differently depending on whether they are dry or wet. In general, the papers that have little primer change their absorbency greatly when they are dampened, especially if they are thick. This can be a problem for detailed and well-defined work.

Heavy-grain paper with a very small amount of sizing. If it is wet, the paint will bleed uncontrollably.

Medium-grain paper with a large amount of sizing. There is a big difference depending on the dampness of the paper.

Heavy-grain paper with normal sizing. The quality of this paper provides regular absorption whether dry or wet.

Dry papers **Wet papers**

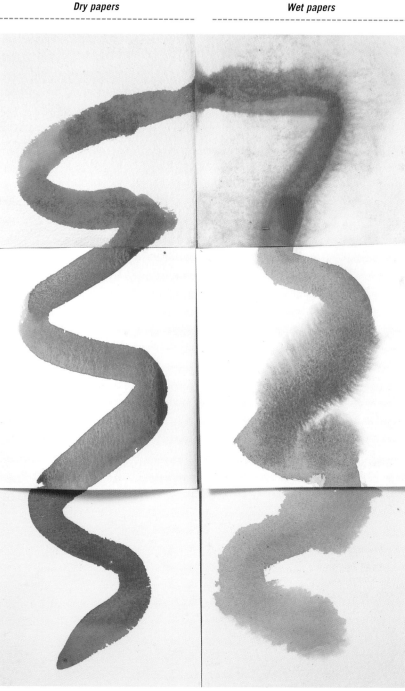

This work has been painted over several different pieces of paper. The detailed illustrations show the changes in the definition of the forms and the color due to the different textures and absorbencies of each paper. Lower absorbencies favor detail but their color is not as deep.

Heavy-grain handmade paper restricts the movement of the paint producing interesting textured effects.

Very fine-grain paper provides luminous colors with clean tones.

The different grain and absorbency of these two papers produce effects that are visibly different: the most absorbent paper (right) favors darker colors.

Special and handmade papers

Handmade papers come in many different textures, tones, and sizes depending on the offerings of the manufacturer. Their handmade finishes, with deckled edges and irregular textures, are the most appealing. But the greatest advantage of these papers is the high quality of the materials involved in their production and the absence of industrial chemicals; the disadvantage is their price—they are truly expensive.

Handmade papers are available in every color and size imaginable. Some of them incorporate small pieces of fabric or visible natural fibers.

Handmade papers are also sold in regular and spiral book format for studies and sketches.

Handmade papers

Nowadays, there is a wide range of handmade papers available for artists that are aiming for a very personal, rustic, and unconventional look.

These papers are generally thick or very thick, of varied weight, and can incorporate fragments of other papers or flowers and natural fibers. It is important to experiment with them because they tend to be very absorbent and do not respond like conventional papers.

Availability of handmade papers

Nowadays these papers can be found in the most diverse colors and most surprising textures. They occupy an important niche in the market and, although they are somewhat more expensive than conventional papers, they are still affordable.

Handmade papers are sold in formats that have no relationship to the standard sizes of typical drawing papers.

Fine grain, low sizing, 500 lb (1,150 gram) handmade paper.

Very low sizing, 120 lb (250 gram) handmade paper.

Handmade papers in warm and cool color ranges.

Low sizing, mottled, 120 lb (250 gram) handmade paper.

Papers for acrylic and oils

These are papers whose textures mimic primed canvas. They have a plasticized surface that protects them from excess water and solvents. They are a practical and affordable alternative to conventional supports, although they are not true substitutes.

Normal sizing, 140 lb (300 gram) handmade paper.

Stretching the paper

If the paper used for painting is not sized and it weighs under 90 lb (200 grams), especially if it is large, buckling could make painting difficult and can also ruin the results. In those cases, it is a good idea to stretch the paper on a board or a frame. This is a simple procedure that ensures the complete flatness of the support once the painting is finished, no matter high light the paper is.

Stretching over a board

The materials needed to stretch paper are a board that is larger than the paper itself and masking tape. First, the paper is dampened on both sides with abundant water. To do this a sponge can be used or the paper can be placed under running water until it is completely soaked. Next, the paper is laid on the board and held in place with four strips of gummed paper tape (which adheres when dampened). Once dry, the sheet is ready to be painted.

The tape is cut and dampened before it is adhered to the sides of the paper (attaching it to the board).

The sheet of paper should be dampened with abundant water, submerging it if needed.

Adhesive tape can be substituted for gummed paper tape.

In this watercolor we can still see the pieces of adhesive tape on the sides of the paper. The tape should be removed only when the work is completely dry.

Restoring the paper
There is little problem with buckling when painting on paper that has been stretched, and even if buckling does occur, the paper recovers its shape upon drying. Once the work is finished, the tape should not be removed, because it would tear the paper; the borders should be cut with a blade and then the remaining tape still adhered to the board should be scraped off with a spatula.

If you use tape that is adhered with water, you will need a blade to remove the paper.

Stretching over a frame
Watercolor papers can also be stretched over a wooden frame. First, the paper is dampened and then it is attached to the frame by folding each one of its sides over and around the frame. The paper is held in place by stapling it to the back of the frame or attaching it with thumbtacks. When the work is finished there is no need to remove the paper. All that is needed is a decorative frame.

The paper can also be stretched (previously dampened) on a frame as if it were canvas.

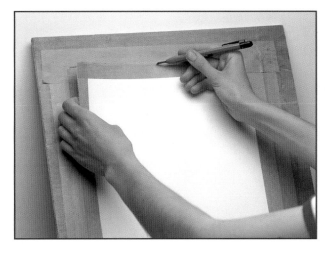

If masking tape is used, it can simply be removed when the work is finished.

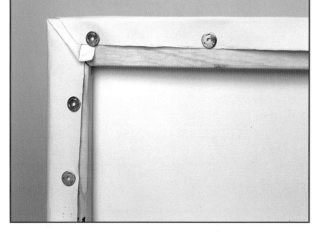

The corners of the paper are folded over the back of the frame and held in place with thumbtacks or staples, forming a wide angle.

Conventional attachment
When the paper is sufficiently heavy, it can be attached to the board simply with thumbtacks, staples, or tape (without wetting it beforehand). Metal clips can also be used, although in this case it would not be stretching it but holding it in place. In either case, it will depend on whether the artist wants to paint on paper that is perfectly smooth or somewhat buckled. Some artists prefer the latter and that is why they paint on papers of various weights without any previous preparation. Furthermore, some like to use heavy, handmade paper that has texture and is deckled, which is sold more or less buckled; the result is a crudely attractive piece.

Canvas

Fabric and canvas are the most common and traditional supports for oil painting. The materials used to make fabric are linen, hemp, and cotton threads. The best quality fabrics are those made of linen, for their smoothness and their performance in humid weather (tension does not change much with humidity). It is also the most expensive, its price depending on the thread count. There are also fabrics that have a blend of linen and cotton, which are more affordable. Hemp supports are heavier, with the heaviest of all being burlap, which is suitable for working with heavy impastos.

Fabric can be purchased in bulk, primed or raw, in 30 foot (10 m) rolls.

Canvas fabrics

Close-up of a piece of linen fabric.

Close-up of a piece of cotton fabric.

Close-up of a piece of hemp fabric.

Linen fabrics

These are woven with thin and very durable fibers, which are not as flexible as cotton fibers, but are less sensitive to changes in humidity, and therefore are more stable. They provide the best results as canvas for painting. Their price is established in relation to their density (threads per square inch [or cm^2]).

Cotton fabrics

Cotton fibers are shorter and less durable than linen fibers. They absorb a lot of water, which means that the fabric can buckle (expand and contract) as a result of changes in the atmosphere's humidity. However, their generally good characteristics make cotton fabrics (or a mixture or cotton and linen) some of the most reasonable options for artists.

Hemp fabrics

Hemp and burlap have thicker fibers that are much rougher than cotton. They are also more durable and resistant. They provide a very heavy texture that is appealing to artists that like to work with heavy impastos.

Textures

The texture of the canvas depends on the fabric and the primer. Good quality linen has a very fine texture and a good thickness. Since some artists prefer having more texture, some manufacturers produce fabrics with considerable texture. They are usually expensive fabrics and are more suitable for acrylic paints than for oils. On the other hand, the texture left by the dry paint on a piece that we do not want to save can be an excellent background for a new painting.

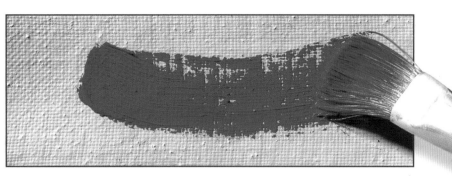

Primed 100% linen fabric, with a high thread count, 70 threads per square inch (28 per cm²).

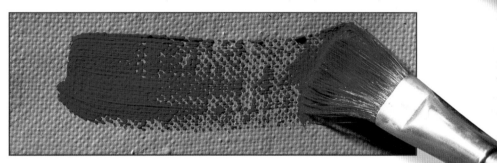

Primed 100% linen fabric, with a high thread count, 60 threads per square inch (24 per cm²).

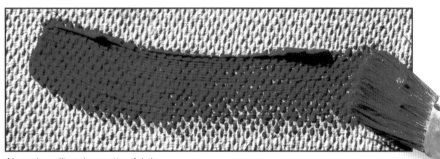

Normal quality prime cotton fabric.

The density of the fabric

The very heavy fabrics are always preferred over those with an open weave; they are easier to prime, more durable, and they stay evenly stretched. This factor is determined by the thread count per square inch (or square centimeter) and it greatly affects the price of the canvas.

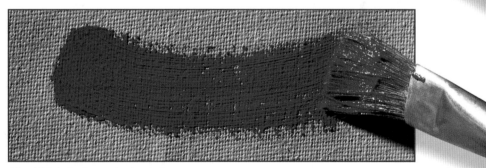

Mixed fabric (cotton and polyester).

Primed burlap canvas.

Stretching and mounting the fabric

Many artists buy their fabrics in bulk (in rolls) and they stretch them on frames that they put together themselves, rather than buying the canvas and the stretchers already assembled. Besides being more affordable, this has the advantage that the size can be determined when needed, without leaving the studio. The artwork that the artist does not want to keep can be removed from the stretcher and rolled up (or can be painted over), freeing the frames for later use.

2. The wood pieces are assembled by inserting the corners together (depending on the model and the manufacturer). In each corner there is a small space to insert wedges that secure the joints, making it possible to stretch the fabric completely once it is mounted on the frame.

1. Stretchers are sold in standard sizes or as separate pieces of various sizes that the artist can choose and assemble in the studio.

3. The materials needed for assembly are: fabric, stretcher, canvas pliers, and a heavy-duty stapler. For stretchers without cross bars, a metal square can be useful to check the corners of the frame.

4. The fabric should be cut about three fingers larger than the size of the frame, from 2 to 3 inches (10 to 12 cm) on each side. This will allow for comfortable mounting with sufficient margin for the clips to hold it together.

The stretchers

These are wood structures, with crossbars in the medium and large formats, over which the fabric is mounted. There are many kinds; the heavier they are, the more expensive. They are available in standard sizes divided by format: figure (vertical format), landscape (wide), and seascapes (very wide); but nowadays they have been diversified into formats that cannot be referred to as "standard" sizes. Some models provide pieces of different sizes that can be combined as desired.

For a tight stretch, small wedges can be inserted in the corners of the stretcher and in the areas where the crossbars are located.

5. The stretcher is centered on the fabric before mounting. Make sure that the front of the stretcher (the one with the rounded interior edges) faces the back of the fabric.

6. Each side of the fabric is attached to the stretcher with staples in the center of the wood. Staple opposite sides first so the fabric is tightly and perfectly stretched.

7. Once each side of the stretcher is stapled (four staples), continue stapling from the center of the edges outward on each side making sure that the fabric is properly tensioned.

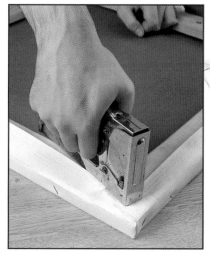

8. After stapling the entire perimeter of the fabric over the sides of the stretcher, the loose fabric on the back is folded over and stapled. To secure the corners, the fabric is tucked under and carefully folded.

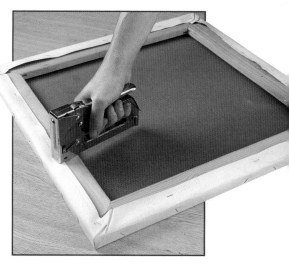

9. The fabric should be folded over properly and secured to the back of the stretcher bars.

Cardboard, wood, and other surfaces

Wood, cardboard, copper, aluminum, and even cement tiles can be used by artists as support for their work. Each one of them is suitable for a technique, as long as the surface is properly prepared. On the following pages we will show several alternative supports and surfaces that form part of the materials available to the artist.

Cardboard

Cardboard is used by many artists to make color studies and sketches. A drawback is its absorbency, which, with time can cause the paint to lose its glossiness. Traditionally this problem was solved by rubbing the surface with a clove of garlic, which reduced the absorbency. Nowadays, the normal approach is to apply a layer of primer, sealer, or most commonly, gesso. Be sure to use cardboard that is not too soft or spongy.

Canvas boards

Canvas boards in various sizes, especially suitable for oil painting, are available from many manufacturers of art materials. These are hard cardboard supports with a canvas sheet firmly glued to it. They are very practical for making studies and small format paintings. Artists can make these themselves by gluing a piece of fabric over a piece of heavy board.

Wood

Many masters used to employ pieces of wood as supports for oil painting. These consisted of wood planks made of several parts, covered with a white or gray primer. Wood is much more absorbent than fabric and its surface, once it is primed, is completely smooth. The work painted on this type of support has a special transparency and gloss, although the wood does not work well for large impastos because it can crack or bend with time. While wood is not as absorbent as cardboard, it also needs a layer of primer, which can be gesso. Ancient masters used hard woods; modern artists can use plywood or chipboard, as long as they reinforce it with a frame or with crossbars to avoid warping.

Canvas boards of various formats for oil and acrylic paints.

Chipboard and plywood supports.

Pictured are further examples of possible painting supports. Some are more conventional than others, but all can be used for specific types of work.

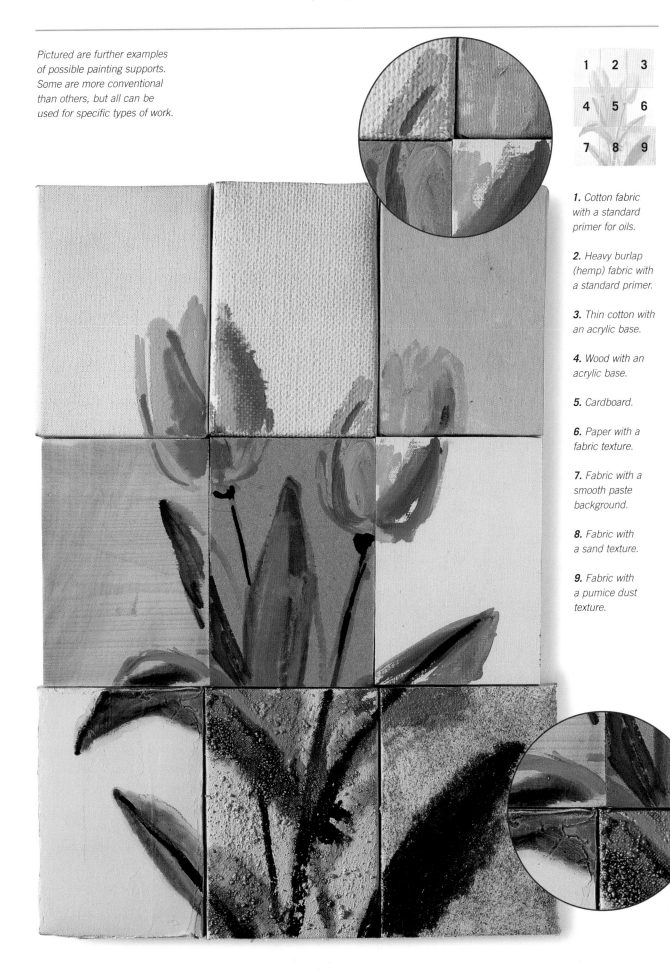

1. Cotton fabric with a standard primer for oils.

2. Heavy burlap (hemp) fabric with a standard primer.

3. Thin cotton with an acrylic base.

4. Wood with an acrylic base.

5. Cardboard.

6. Paper with a fabric texture.

7. Fabric with a smooth paste background.

8. Fabric with a sand texture.

9. Fabric with a pumice dust texture.

Preparations

Also called primers, these are substances that are spread over the support (normally fabric, cardboard, or wood), to prepare it for painting. The preparations create a base with the appropriate conditions for the absorption, adhesion, and texture of the paint. Nowadays, the industry produces chemicals that are ready to use. They tend to be very stable and permanent.

Traditional preparations

Rabbit skin glue is the most common of all. Suitable for painting with oils, it is sold in tablets or granules that must be soaked in water for several hours before they are cooked in a double boiler. The glue should be creamy and applied hot. It is transparent, but it is normally mixed with white chalk to give it a matte white finish. It can be colored with pigment and is mainly applied over fabric.

1. Rabbit skin glue is sold in granules that must be soaked for 24 hours to absorb water.

2. The soaked granules increase their volume until they fill up the container. The proportion of glue and water is approximately 3-1/2 ounces of glue per quart (100 grams per liter) of water.

3. The glue is heated in a double boiler until it becomes a creamy and homogenous liquid.

4. The glue is poured into a white filler (normally calcium carbonate) to make a paste that can be colored by adding small amounts of pigment.

5. The mixture is blended until the paste is smooth.

Color primers

All base preparations, whether made by the artist or purchased in an art supply store, can be colored with pigments or with paint (acrylics in water-based preparations, and oils in oil-based preparations). Colored primers are very often used by artists who do not want to work directly on the pristine white fabric or paper.

White primers

These are very thick paints (acrylic or oil) that have very little color. They are used to create base textures that are painted over. One variation of these preparations are the acrylic modeling paste, which is even thicker and thus able to create very pronounced grooves, bumps, and textures.

When white textured bases (with some type of added charge or mixture) or very thick primers are applied, artists normally use spatulas to spread the mixture on the support.

Sealants

These are used to reduce the absorption of the porous or very porous surfaces. They are applied with brushes, rollers, and even in spray form. Although they can be painted over, generally these are used as a base for gesso.

Gesso in a universal product that is very easy to use; it dries fast and can serve as a base for any medium.

Gesso

Gesso, a mixture of acrylic resin and titanium dioxide, is the most commonly used preparation these days. It is suitable for virtually any painting technique, but it provides the best results with acrylics. It is a white paste that can be diluted in water and applied with a brush or with a roller in thin or thick layers. It adheres to any porous and oil-free surface. It dries quickly and in doing so forms a water resistant, insoluble, and very flexible surface. It has optimum adherence and can withstand any filler.

Application

The primers can be applied with a roller, spatula, or brush. In the latter case it is best to apply several thin layers rather than a single, very thick one. The layers should be spread with perpendicular brushstrokes: first vertically and then horizontally, or vice versa. The fabric is ready when all of its pores have been sealed.

The product is spread with perpendicular brushstrokes in successive, thin layers.

Easels

For work done in the studio and outside (especially the latter) easels are a must. There are many different models that come in different shapes and sizes, and have different mechanisms. In general, there are two distinct easel groups: those for outdoors and those for the studio. The outdoors easel is collapsible and portable. The studio easel is more solid and stable and is larger. It is important to have a good quality easel that is strong and can hold large and small frames.

Studio easels

These are the most solid and strong. They consist of a vertical wood structure with a horizontal tray to support the canvas, which can move up and down along the structure. The entire structure is mounted on a solid frame that stands on four wheels. They can be blocked to make the easel very stable. Some models are very heavy and have a lever (or even a small electric motor) to lift and lower the tray. Top quality studio easels are expensive, but extremely useful: they are the best support for any size painting. The simplest ones consist of a tripod with an upper support that holds the canvas. They are suitable for working in the studio and also outdoors (as long as the legs can be collapsed). They are used especially for light formats in small and medium sizes.

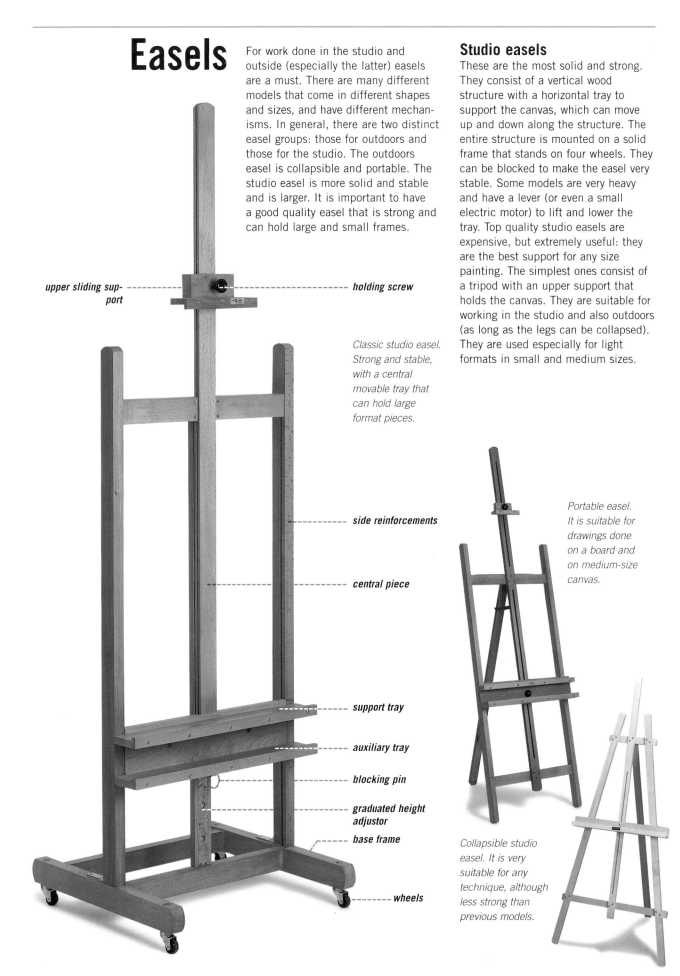

upper sliding support ---- holding screw

Classic studio easel. Strong and stable, with a central movable tray that can hold large format pieces.

---- side reinforcements

---- central piece

---- support tray

---- auxiliary tray

---- blocking pin

---- graduated height adjustor

---- base frame

---- **wheels**

Portable easel. It is suitable for drawings done on a board and on medium-size canvas.

Collapsible studio easel. It is very suitable for any technique, although less strong than previous models.

Outdoor easels

These are portable easels used by artists who paint with oils and acrylics. They look like boxes when they are folded. In fact, they are exactly that: paint boxes with a support. The support is a tripod with a movable wood structure that holds the canvas in place. The box contains another box with a palette, the brushes, paints, pencils, and other small materials. The entire piece can be set at different heights and angles to adapt to the terrain, the light conditions, and the size of the canvas.

Collapsed portable easel. It takes up the space of a box of paints and can hold medium-size canvases.

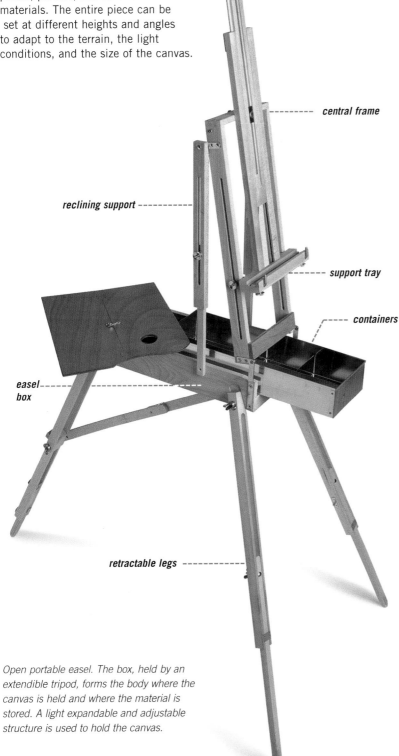

top sliding support

central frame

reclining support

support tray

containers

easel box

retractable legs

Open portable easel. The box, held by an extendible tripod, forms the body where the canvas is held and where the material is stored. A light expandable and adjustable structure is used to hold the canvas.

Tabletop easels

In reality these are like lecterns that are used to hold the canvas or a sketchpad in a properly tilted position when the artist is seated working on small formats. They are especially good for watercolor painting, because the angle can be adjusted to secure the most comfortable position.

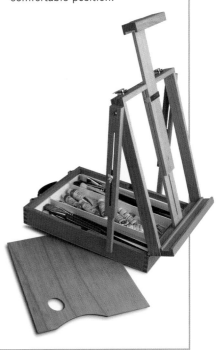

Palettes for oil paints

A palette is a vital tool for oil painting. Oil painting palettes are made of varnished wood and typically have an opening for holding the palette with your hand. But it is also possible to substitute with any surface with low porosity that can be cleaned at the end of the session. Palettes can be rectangular or oval and come in different sizes. The medium-size square palettes have more room for mixtures than oval ones. In very large sizes, the oval ones are more comfortable because the weight is distributed more evenly around the thumb.

The order of the colors on the palette responds to the particular needs of the artist and to the number of colors used. Black and white tend to occupy a preferential place.

Oval palettes are more ergonomic, that is, they adapt better to the artist's arm and hand.

Paper palettes

These are disposable paper palettes (a pad of bound soft paper sheets) that can be discarded when they are full of paint. Many artists use sheets of newspaper as palettes because they are easy and disposable; or a sheet of glass or a varnished wood surface that is placed on a table. In reality, any non-absorbent surface can work. It is a good idea to clean the palette after each session by scraping the paint with a spatula and cleaning the wood, plastic, or glass with a cloth soaked with mineral spirits. Some artists save the leftover paint (usually a dirty gray color) to use it for backgrounds or as an additional color.

PALETA OLEO PAPEL
bloc de 50 hojas de papel impermeable

Referencia/ 1979

afscheurpalet
strip off palette
abreisspalette
palette détachable

Waxed paper palettes are sold in pads. Each sheet is for only one use.

Square palette used exclusively for mixing grays.

Palette with a selection of colors that has increased with use.

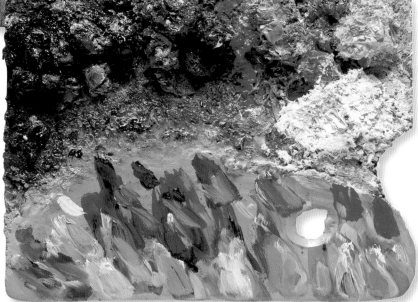

Color arrangement

Every artist arranges the colors on the palette in a personal way, according to the number used and individual work methods. The most common approach is to separate the warm colors from the cool, and all of them from black and white. Some artists use two whites: one for warm colors and the other for cool ones. A plausible arrangement would be one that begins with yellows, continues with ochres, reds and carmines, siennas, greens, earth tones, and ends with blues and violets.

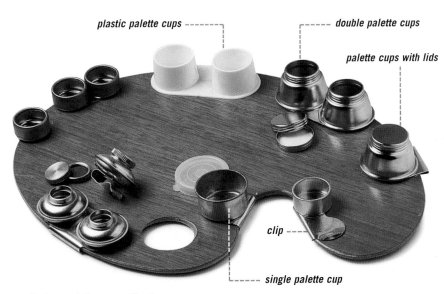

plastic palette cups

double palette cups

palette cups with lids

clip

single palette cup

Various palette cups with clips that attach to the palette.

Palette cups

Palette cups, the containers that hold the mineral spirits, are important accessories. Some artists use two of them, one for mineral spirits and the other for refined linseed oil to adjust the thickness of the paint. Others mix both to create a solvent that has greater adherence and glossiness. There are aluminum palette cups that can be clipped to the palette, but most artists prefer to use larger containers. Some of them use several containers for mineral spirits to prevent the dirty liquid from altering the mixtures; for example, one can be used for warm colors, another one for cool colors, and another one for very light colors, and so on.

Palettes for watercolors

A palette is half of the equipment used by a watercolor artist. The brushes and the paper are the other half. Any professional should be aware of the tools of the trade, and the artist even more so, because he or she must get as much out of his or her tools as possible. The watercolor artist has to feel comfortable with the palette and the color selection must conform to his or her own style (it is absurd to buy colors that will never be used).

Metal palette for tube colors. This is a very useful tool: it has a lot of space and it is portable and easy to use.

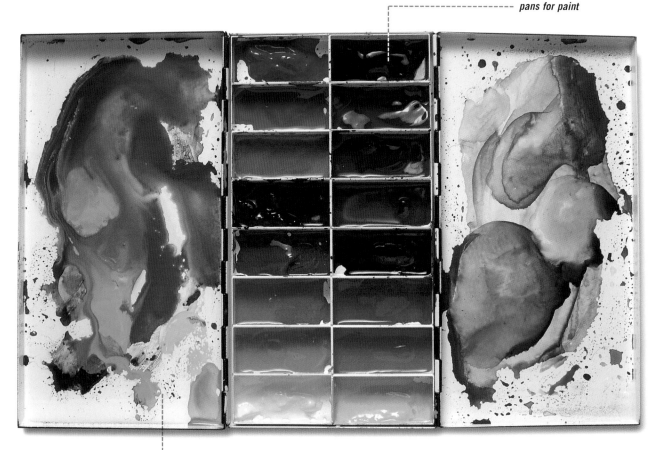

pans for paint

mixing trays

Sizes

The size of the palette can vary greatly. On these pages we show a studio palette that is very large and heavy (made of steel). It is very useful for working on large pieces that require a lot of paint and large surfaces for mixing. No one would think of carrying such an enormous piece for working outdoors, which is why there are conventional palettes or light palettes with cakes of paint.

Palettes and surfaces for mixing

Most of the metal boxes for watercolor painting are also palettes for mixing colors. These metal boxes are made of white enameled steel, and have a series of partitions or concave grooves where the different color mixtures can be kept separate. In some of them the tray that holds the colors can be removed, which creates one or two mixing palettes.

Most of these palettes have a hole or a ring on their lower part so the artist can hold the palette with his or her thumb.

However, despite its undeniable functionality and comfort for mixing colors, professionals usually work with a single palette, with both cake and tube paint.

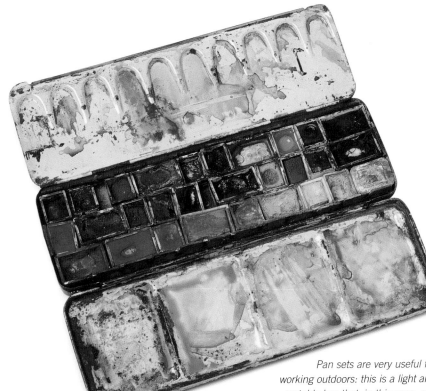

Pan sets are very useful for working outdoors: this is a light and portable box that, in this case, can hold many different colors.

A metal palette with multiple pans for paint and ample room for mixtures. It has an opening for the thumb, which makes it easy to hold with one hand.

Other surfaces

Instead of a conventional palette, or in addition to one, white porcelain or ceramic plates as well as containers made of the same material can be used. Some artists use plastic trays or dishes of various shapes and sizes, even plastic egg cartons. The important thing is for the mixing surface to be glossy, waterproof, and that it allow clear view of the mixed color.

This aluminum palette with pans is very useful for detailed work that does not require a lot of color.

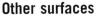

A ceramic plate can be a perfect palette when the work involves very few colors and there is no risk of unwanted mixtures.

Plastic egg cartons can become emergency palettes when no other more suitable surfaces are available.

Erasers

Erasers are indispensable in the tool-box of an artist who makes pencil drawings. Their predecessor was bread: a material used for centuries to erase pencil lines. Erasers, as we know them today, were originally made from natural rubber. Rubber absorbs the oily particles of graphite, leaving a series of crumbs on its path. Nowadays, natural rubber has been partially replaced by polyester and a wide range of materials derived from plastic, turning this humble tool into a very specialized implement for all drawing techniques.

Natural rubber erasers

These are the typical school quality erasers. They are soft and leave many crumbs. They are very good for erasing lines made with graphite that is neither too soft nor excessively hard. They are also good for cleaning the marks and smudges that may appear on the paper during the working process.

Plastic erasers

Their main characteristic is that they are very clean and not aggressive on the support. They release very few crumbs, which tend to stick to the eraser. They are suitable for erasing any graphite line made on thin and delicate paper. They can be transparent or brightly colored and they are always very soft to the touch.

Every eraser has a specific application. Shown in the illustration are four types of erasers with the erased effect on a series of lines.

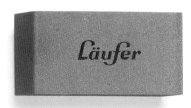

Rubber eraser. The most suitable and effective for erasing pencil drawings.

School eraser. Tends to muddy the drawing and releases many crumbs.

Kneaded eraser. Too soft for pencil; only recommended for charcoal drawings.

From left to right and from top to bottom: polyester eraser for hard pencil lines, abrasive eraser for ink, school eraser and rubber eraser for any type of graphite lines.

Abrasive eraser. Recommended for ink; ruins the surface of the paper if used repeatedly in one place.

Abrasive erasers

These contain a varying amount of abrasive agent (generally, very finely ground pumice). They are used to erase India ink lines or the ink from ballpoint pens and fountain pens. They are usually blue or red and they come in different grades, more or less abrasive, according to the type of ink that has to be erased and the durability of the paper.

Kneaded erasers

These are made of natural rubber and are extremely absorbent. Their particular characteristic resides in the fact that they can be kneaded nearly as much as clay dough, conforming to specific shapes for different erasing needs. Since they are so soft, they are not suitable for graphite lines or for pastel pencils; in fact, they are used especially to reduce areas of charcoal and pastel. They are, to a certain degree, self-cleaning, which means that when they are kneaded they absorb the dirt and spread it through the material. This is the reason why they end up turning into a black ball with continued use.

Kneaded erasers in various sizes and hardness. The largest ones tend to be the softest.

The dirt adhered to the malleable erasers can be eliminated in good part by kneading the eraser until the clean areas are exposed.

Electric erasers

These are small electric motors that hold small rubber erasers and cause them to rotate. They are battery operated and are useful for detailed work of small or medium size. They are very efficient, but they should not be pressed too hard on the paper because they can easily make a hole.

Kneaded erasers can be used for erasing both large and small areas; they can be squeezed into the most suitable shape for the job.

Battery operated electric eraser.

Pencil erasers and eraser holders

Pencil erasers and eraser holders are ideal for working on small drawings and for detail work. Eraser holders offer a comfortable grip and convenient pocket clip. The erasers are retractable and can be easily replaced as needed. Pencil erasers can be sharpened in the same manner as regular lead pencils. Often these come with a small brush on one end to wipe away debris.

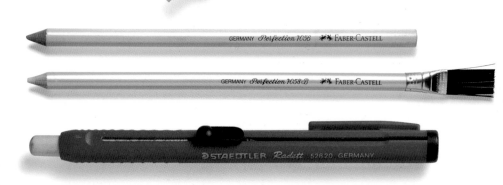

Eraser holders have a retracting mechanism with a rubber eraser that keeps the eraser always clean and in good working condition.

Other auxiliary tools

The continuous practice of drawing requires certain complementary tools to make the work more comfortable and efficient. Very few tools are needed for drawing, especially when sketching outdoors: all that is required is a sketchpad and a pencil. But in the studio it is a good idea to have a few things on hand to solve any problem that the artist may encounter.

Pencil sharpener

This is a common, universal tool that is known by everyone. Sharpeners come in different forms and sizes. The most simple ones for graphite pencils should be made of steel and have a correctly angled opening for inserting the pencil. The blade, also made of steel, should always be properly sharpened and must be replaced as soon as it shows signs of wear.

Wide metal clips for holding paper.

Boards and holders

It is a good idea to have a few wooden drawing boards of various sizes. They are the best support for drawing paper, especially the large formats. They should be light and have a surface in which the tacks can be easily pinned. The clips hold the paper on the board without damaging it; we recommend different size clips for the various sizes of paper. The best pins are the ones that have a large head (usually known as map pins): they can be easily removed and hardly leave any marks on the paper. Finally, masking tape is an interesting option when working with watercolor pencils, because the possible warping of the paper (due to the use of water) is neutralized by the action of the tape. The tape should be made of paper (like the tape used by painters) and should not be left on the paper for more than one day.

Scissors for cutting paper.

Pins.

Masking tape.

Scissors

The best tool for cutting paper is a pair of scissors with long blades and an ergonomic handle. It is very easy to make straight, clean cuts with them without causing ragged edges. They should always be well sharpened, which will make cutting gentle and easy.

Special sharpeners

Sharpeners come in a wide variety of sizes to sharpen pencils that are fat and extra fat. In general, the manufacturers of this type of pencil (Stabilo, Lyra) also make the appropriate sharpeners. Other brands provide dual sharpeners to sharpen conventional pencils as well as fatter pastel pencils.

Sharpener for thick pencils.

Sharpener for extra large pencils with a chamber for the shavings.

Replacing the blade

A sharpener does not last forever. The steel blade gets chipped and stops sharpening properly, ruining the wood and the tips of the pencils. Specialized manufacturers sell replacement blades; this is an option, another one is to buy a new sharpener.

Tabletop pencil sharpener.

Mechanical sharpener

This tool can be attached to a desk or worktable. The pencil is inserted into an extendible clamp and the sharpening mechanism is activated manually with a handle. This sharpener has a chamber that collects the shavings. The sharpening mechanism lasts a long time without the need for replacement. The procedure is simple and effective and the way the pencil is held in place prevents the lead from breaking. It is suitable for graphite and colored pencils (hard lead) in conventional sizes. There are also electrical versions, without a handle.

Craft knives and blades

Craft knives and blades are vital for sharpening fragile leads (pastel pencils, compressed pencil leads, etc.) In fact, it is better to use these tools instead of conventional sharpeners, even the large ones, because the risk of breakage is much higher.

Cúter.

To make very fine points, many artists use a strip of wood covered with sandpaper.

Pointers

These are small sharpeners, especially designed to sharpen only the lead. In some dual sharpener models the pointers are located on side openings. The most traditional sharpener is a strip of wood covered with sandpaper on its upper part. The lead is sharpened by rubbing it against the paper.

This multiple sharpener has blades for removing just the wood, sharpening the pencils, and sharpening just the graphite leads.

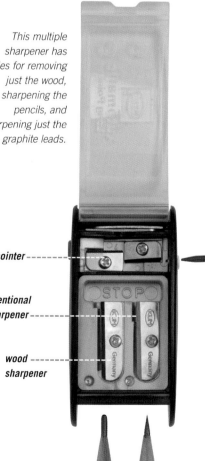

pointer

conventional sharpener

wood sharpener

Blending

Sticks of paper, cotton balls, and rags can all be considered blending tools. Blending tools are used in all the dry drawing techniques, especially in the ones where the medium releases many particles that are susceptible to blending, for example, charcoal and pastels. Some artists do not use tools for blending: they use their fingers, or the side or the palm of their hand. However, in some instances artists go back to using these simple tools.

Blending sticks

These are sticks made of blotting paper that have points at both ends. The paper is rolled up and does not wear out as it is used but absorbs the graphite, charcoal, or pastel sediments with its fibers. To clean the stick, simply rub it again on a piece of clean paper. With time, however, the areas of the blending stick that have been subjected to continuous rubbing become saturated and lose their absorbency. Then it is necessary to restore the porosity of the tip by rubbing it on a piece of fine-grain sandpaper. In addition, this operation completely cleans the tip.

Blending sticks come in many different sizes. All of them are made of compressed and rolled up absorbent paper.

The artist can use different mediums for blending, depending on the type of work and the desired effect. Fingers can be used to touch up details; a blending stick to model small areas in chiaroscuro; a rag to spread the color and, occasionally, a brush to eliminate the pigment particles that are loose on the support.

The artist's hand is often the best blending tool.

Cotton balls and rags

Cotton swabs are very efficient tools for blending. They do not leave any marks on the paper, although they are not as comfortable to use as blending sticks. Rags are used for blending in large format work, where there are large areas of color and not a lot of detail.

Rags are used to extend and blend charcoal and pastel when the work is large.

Cotton balls are useful for delicate blending where the artist does not want to leave marks and defined edges.

Blending graphite

Soft, solid colored graphite can be blended with a blending stick to create grays and gradations without leaving any marks. However, most artists rub directly with their finger to better control the blending.

A blending stick not only blends pigment and charcoal but it can also be used for shading when its tip is dirty.

Blending charcoal

The tone of the charcoal lightens when it is rubbed with a blending stick, a rag, or with fingers. This is almost the only way to create gradations, because the tonal change that results from applying more or less pressure on the paper is hardly noticeable. There are more options for blending when natural charcoal sticks, rather than compressed charcoal pencils or sticks, are used.

Blending pastels

When blending pastels the color is extended, without leaving any marks, by forcing the pigment particles to penetrate the texture of the paper. When working with quality pastels, the blending does not lighten the color, although it does affect the texture, because the layer of color becomes sharper and more uniform.

Sponges and rollers

Sponges are used in wet techniques and especially when painting with watercolors. They can also be used with acrylic paints as a quick way of applying color or creating special textured or mottled effects. Rollers are used for spreading very diluted preparations and for creating brush marks. Sponges can be natural or synthetic and they are available in every size and shape.

Natural sponges

Natural sponges have an irregular round shape (no two are the same). They are very soft and extremely porous, which means that they do not damage the paper and can hold large quantities of water. There are many different sizes; the larger ones are the most expensive. Painters do not need large sponges, and a small or medium size can hold enough water. Sponges are used to dampen the watercolor paper before painting and also to dilute and erase the color in areas that were previously painted.

Rollers are used to apply the background paint perfectly even, but they can also be used like rolling sponges to create interesting color effects.

Natural sponges have uneven surfaces, and some are more porous than others. Artists can choose the ones that best suit their needs.

Synthetic sponges

These are square or oblong in shape, and are coarser and stiffer than natural sponges, and hold less water. In addition to basic cleaning chores, sponges can also be used for spreading and cleaning oil and acrylic paint when working on large formats. It is important to remember that the solvents for oil paints end up destroying the sponge's synthetic fibers.

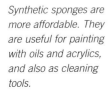

Synthetic sponges are more affordable. They are useful for painting with oils and acrylics, and also as cleaning tools.

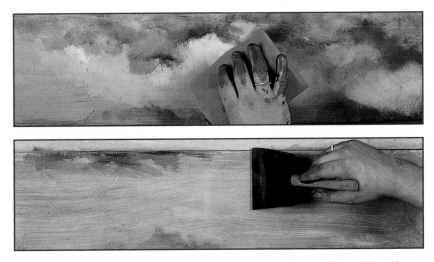

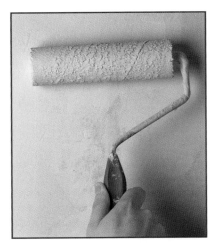

Synthetic sponges, with or without a handle, are the most suitable tools for working with thick paint (oils, acrylics, etc.).

Sponges with handles

Flat sponges are available with a handle that makes it possible to spread the paint easily with wide and uniform "brushstrokes." They are normally used in large formats painted with acrylics and are especially good for applying paint that is very diluted with water.

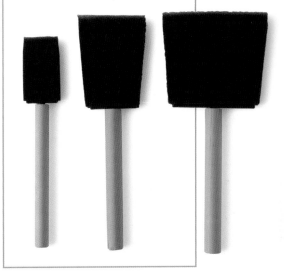

Sponges in water-based procedures

When working on large formats and on paintings that have a more painterly rather than a graphic approach, sponges are almost indispensable for cleaning the palette, for spreading the color, and for creating light areas by cleaning areas of paint to restore the original color of the paper. Another important use of the sponge is for dampening the paper before it is stretched on a board. In any of these cases, the amount of water they can hold is an essential factor. Sponges are as useful for cleaning as they are for applying paint. They need to be rinsed in water after each use.

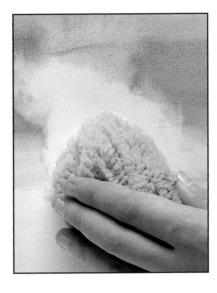

Watercolor artists prefer natural sponges. Their softness and ability to absorb large quantities of water make them ideal for washes and for diluting color that is already on the paper.

Rollers

Rollers are very useful for applying thin layers of acrylic or oil primers on wood, canvas, or cardboard. They should be like sponges, that is, free of loose fibers, because the ultimate goal for their use is to create smooth and even surfaces, without leaving any marks.

Rollers should be made of synthetic fibers and have a smooth surface to avoid leaving marks when spreading background paint or primers.

Rollers are used to prime supports and to apply background colors. In some models, the roller itself can be removed from the handle and replaced.

Fillers

Fillers are substances that are added to paint that change its texture but not the color. Many artists use fillers to add a personal touch to their work: a material quality that is particularly coarse that can evoke murals or rock formations. Only inert materials are suitable for this procedure, that is, the ones that do not produce organic decomposition or unwanted chemical reactions when they come in contact with the paint. The amount of filler and the thickness of the support determine the texture of the final piece. Only media with strong binders (oils and acrylics) can withstand these fillers.

Paint mixed with a filler acquires a thick and grainy texture, like the paint in the illustration, which was mixed with marble dust.

Calcium carbonate

Calcium carbonate or Spanish white is the most common filler. It is useful for increasing the volume and the body of the paint without changing its color. It produces matte and earthy finishes and greatly thickens the paint. Too much of this filler makes the paint lose its adherence and can separate the color.

Mineral dust

Mineral dusts are obtained from grinding rocks. The most commonly used fillers for paint are marble and alabaster dust They are very heavy and need to be mixed with large amounts of agglutinate to ensure their adherence. These fillers are available in various thicknesses, from dust to coarse grains of sand.

Marble dust and sand are good fillers: heavy and with a very attractive texture.

Pumice dust

Ground pumice, also called "grit," is a very fine and light dust that thickens the paint and provides a little bit of texture. Its light weight makes it ideal for creating textures that are not too heavy.

Ground pumice is a light filler with a very fine texture.

Sand (river sand is better than ocean beach sand) should be washed and boiled before being used as a filler.

Shavings

Good quality wood shavings can be used as fillers in oil procedures, but the water-based media can rot the vegetable fibers and produce an efflorescence effect on the layer of paint.

Fine shavings can be a good filler for oil painting.

Sand

Washed and boiled river sand is a filler that is very commonly used by some artists. The grains are round and come in different sizes, which is why the texture is more uneven than that of other mineral charges. It is important to make sure that the sand does not contain any organic matter.

Sand and the rest of the grainy fillers enhance the texture effects of the painting. They should be mixed in small proportions with the paint before application.

There are many acrylic paints on the market that have fillers from various natural sources and with different textures already mixed in.

Abrasive products

Silicon carbide (carborundum) is a very hard filler that forms thick and coarse textures. It mixes with the paint without causing lumps, which makes it especially suitable for artwork.

Its use is recent and has its origins in contemporary printmaking, a technique that utilizes very thick black paints.

Cleaning the tools

Cleaning the tools is essential to ensure good working conditions. Specific solvents for each medium are the best substances for cleaning. In addition, there are different soaps and creams available that make cleaning easy and that are also good for cleaning your hands, a very important factor for artists who work with oil paints. Dry acrylic paint is hard to remove so there are also special products for this task.

Cleaning watercolor brushes

When the session is over the brushes should be cleaned thoroughly, with water and soap if needed, rinsed with abundant water and squeezed with the fingertips to restore the shape of the tip. Brushes should be stored in a jar with the hair facing up, because in this position the water runs through the ferrule, soaks the wood of the handle and, by expanding it a little, makes the handle fit tightly inside the metal ferrule.

For a watercolorist, an old towel becomes a very useful tool: it is good not only for cleaning and drying brushes, but also for carrying brushes rolled up inside.

For any procedure it is important to have cotton rags handy for drying, cleaning, eliminating excess paint from the brushes, and for maintaining a degree of cleanliness during the entire work session.

Absorbent paper is good for removing excess paint from brushes. It is also good for drying the brush bristles after they have been cleaned thoroughly at the end of the session.

1. To clean brushes used with oil paints, first use a sheet of paper to remove the excess paint from the brush hair.

2. Wash the hair with soap until all the paint is eliminated.

3. Restore the shape of the brush hair by hand before storing the brush.

Cleaning brushes used with oil paint

Brushes used with oil paint should be cleaned after every session. The most practical way of removing the excess paint from the hair is with a piece of newspaper; after this the hair is washed with mineral spirits to dissolve all the paint. This operation may not be sufficient to clean the bristles completely, and even if it did they would be adversely affected by the corrosive effects of the mineral spirits. Therefore, after the mineral spirits the brushes should always be washed with water and soap. Repeat as many times as needed until the soapy water runs clear. After the last rinse, the shape of the hair is restored and the brushes are stored in a can or jar with the hair facing up.

A container that has a spiral support for holding the paintbrushes to prevent the brush hair from touching the bottom and losing its shape while submerged in solvent.

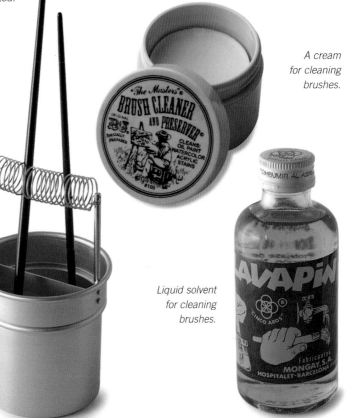

A cream for cleaning brushes.

Liquid solvent for cleaning brushes.

Soaps and creams

There are soaps available for cleaning brushes, as well as special solvents that fulfill the same purpose. Some brands market special creams that create a barrier on the skin that makes it possible to eliminate paint from hands very easily. Soaps and gels made with citrus essences are very useful for washing hands after a painting session, and they have a very pleasant aroma. All these substances contain protective and hydrating ingredients that prevent skin from cracking.

Specific products for the cleaning and caring of hands of artists who work with oil paints and use aggressive chemicals.

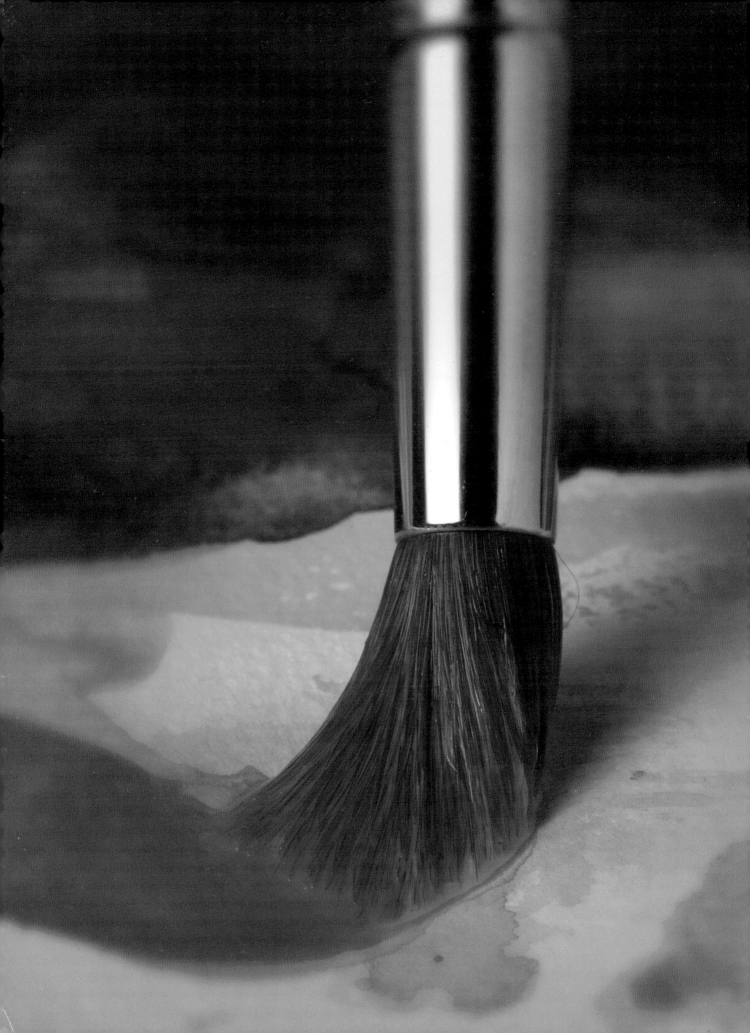

Techniques

The purity of line and stroke

The study of the different ways of drawing lines brings us to the conclusion that drawing with ink, and drawing with a reed pen in particular, is the approach that incorporates all the virtues and expressivity of the line considered in isolation.

The nib pen (used with ink) makes an intense and opaque line, which has great character. This is a type of line that registers every movement of the hand across the paper. The key to the success of these drawings resides precisely in the spontaneity, the agility, and the decisiveness of a line that cannot be revised or corrected. The corrections, if any, are drawn over the mistakes and the result is a line of incomparable freshness and immediacy.

The immediacy of the line drawing is manifested from the beginning. There is no preliminary pencil drawing that can be used as a guide. The ink lines are drawn directly, defining the general outlines and working with both sides of the reed pen to make lines of various thicknesses.

If the first lines are acceptable, we continue with the work, drawing lines that suggest the volume and the movement of the body. The principal of austerity is: if something can be expressed with a single line never use two.

The thicker lines result from the accumulation of different reed lines. In some areas the line becomes almost a blotch because the wide edge of the reed has been used.

Materials

- Nib pen
- Reed pen
- Ink
- Watercolors
- Thin round sable-hair brush
- Medium-grain 140 lb (300 gram) watercolor paper

Watercolors can be diluted in a small dish and used like ink.

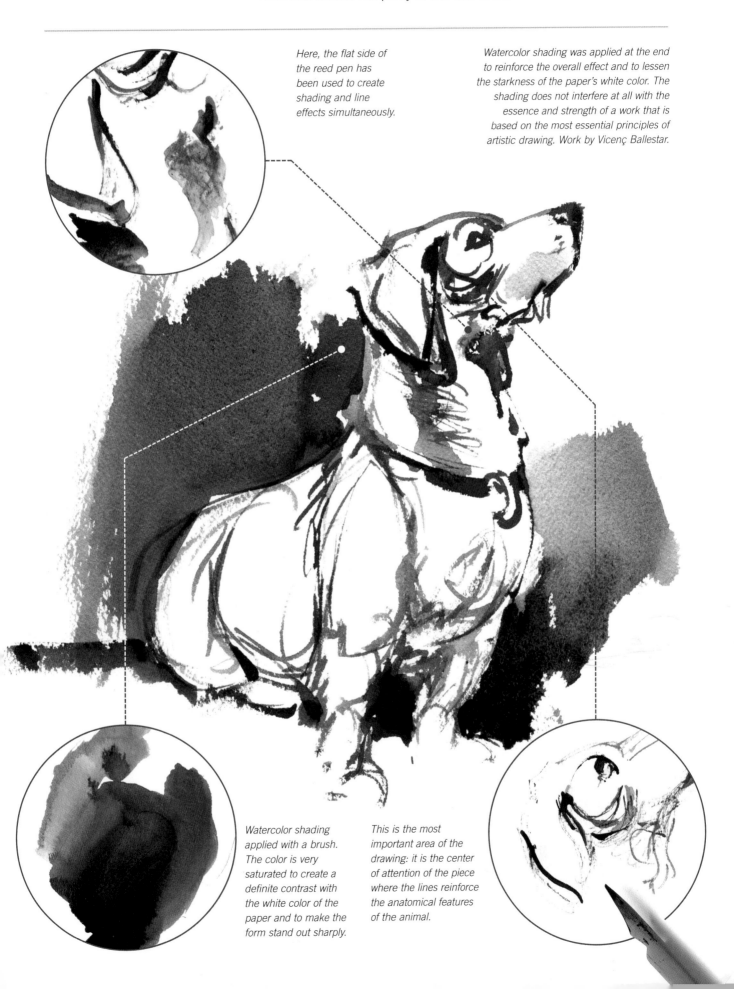

Here, the flat side of the reed pen has been used to create shading and line effects simultaneously.

Watercolor shading was applied at the end to reinforce the overall effect and to lessen the starkness of the paper's white color. The shading does not interfere at all with the essence and strength of a work that is based on the most essential principles of artistic drawing. Work by Vicenç Ballestar.

Watercolor shading applied with a brush. The color is very saturated to create a definite contrast with the white color of the paper and to make the form stand out sharply.

This is the most important area of the drawing: it is the center of attention of the piece where the lines reinforce the anatomical features of the animal.

Lines and shading with a reed pen and markers

In this example we have combined two drawing media that are rarely seen together in a single work. Reed pens can make a variety of lines; markers on the other hand provide a heaviness and intensity that are unchangeable. This is why markers can be used together with reed pens to resolve details that call for a firm or methodical treatment. Due to the greater graphic power of the reed pen, it is a good idea to use it in the most

important areas of the work or for highlighting the overall structure. We have also used a brush to apply some areas of ink as the background for the drawing.

The result of combining a reed pen with markers is great luminosity and considerable graphic power. This vitality is due as much to the areas that have been drawn as to those that were left untouched: the contrast between the shading and the lines against the white of the paper is an essential factor that must be taken into consideration when reed pens are used in a decisive and expeditious way. Work by Óscar Sanchís.

Reed pens lend themselves to a loose drawing approach because the interest of its line resides precisely in its unevenness: sometimes wide, other times thin, sometimes with more ink, other times drier. Taking advantage of this unpredictable character of the tool we have loosely drawn hatching without even lifting the tip of the reed off the paper.

The marker, due to its consistent and regular line, contrasts vividly with the reed's hatching. Here, the marker's hatching is conventional, made by superimposing parallel lines drawn in different directions.

Here, the variety of lines that are possible to draw with reed pens can be carefully studied. Quick lines are thinner than slow ones (the ink has more time to soak into the paper). Some lines show a lack of ink while others indicate that the reed had just been charged.

Materials

- Reed pen
- Green marker
- Round sable-hair brush
- Burnt sienna ink
- Fine grain 130 lb (270 gram) watercolor paper

These areas of watercolor are extensions of ink on the paper made with a watercolor brush soaked in a great amount of water. The reed was used on those areas while still wet, causing some of the lines to dissolve.

The marker lines become saturated and quickly form masses of color that are almost dense, though not completely, because the ink from the markers is not totally opaque and always leaves the underlying areas of color exposed.

Neutral strokes with pastel pencils

The essence of line drawing is the evenness of the contours and outlines. When the subject does not present those characteristics, the lines become uneven to the point of turning into strokes, that is, brief applications of the drawing medium. In this example we are faced with a wide variety of strokes of different values and intensities that construct the theme through the accumulation of movements and applications of pastel pencil. The colored paper allows for white highlights that complement the darker accents of charcoal black. This is an impressionist approach that is used very often by artists in the elaboration of landscapes.

The darker strokes, drawn with a black pastel pencil, correspond to the foreground of the panoramic view. The secret resides in the continuous change of the direction and the form of the strokes to create the feeling of dense and intricate foliage. The applications of pastel pencil (charcoal pencil in this case) have different intensities so the web of pencil strokes appears three-dimensional: the dark lines appear closer than the lighter ones.

The white strokes, or highlights, are used to represent the effect of light on the foliage. The gray tone of the paper makes it possible for these strokes to be easily visible and to become an integral part of the overall harmony, which ranges from the darkest black to the clean white of the pastel's tip. These strokes must be reserved for the composition's middle ground and background. It is better not to draw with the white pastel over previously drawn black areas to prevent them from turning gray.

Materials

- ▨ Black pastel pencil (charcoal pencil)
- ▨ White pastel pencil
- ▨ Light gray 72 lb (160 gram) Canson paper

The combination of strokes of various intensities, directions, lengths, forms, and tones is the true protagonist of this drawing. Better than any other media, pastel pencils make it possible to create this ensemble due to the variety of intensities that can be created by changing the pressure that is applied on them. The changes are also very significant depending on whether the drawing is done with a very sharp tip or one that is worn by use. Work by Óscar Sanchís.

The foliage is constructed with strokes applied in different directions, without insisting too much in one particular area and leaving some areas unpainted.

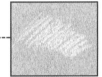

The darkest blacks have been achieved by applying greater pressure on the pastel pencil.

Parallel white pastel pencil strokes give form to the areas of light. There are no details that interrupt the continuity of the lines.

A series of soft parallel strokes made with a charcoal pencil are sufficient for defining the shadows of the foreground.

Strokes and hatching with pastel pencils

When we use drawing media that make thin or medium lines a common approach is to shade by hatching. This consists of an intuitive drawing approach where the darker values are achieved by intensifying the strokes by applying greater pressure on the drawing instrument. The advantage of the strokes over areas of color or blends is the luminosity of the results because the paper "breathes," that is to say it can be seen through the many open spaces among the strokes. In this example we can see a method of shading based on those principles; the work is created with pastel pencils on white paper.

We can begin the work by doing a simple line drawing (if the subject presents some compositional problems), or with compositional sketches done with a hard graphite pencil. From this moment on, the process consists of accumulating strokes in the most shaded areas, intensifying them as the drawing progresses until a final balance between light and shadow is achieved. To reinforce the shadows we can combine dark tones of different colors (sanguine and charcoal, in this example).

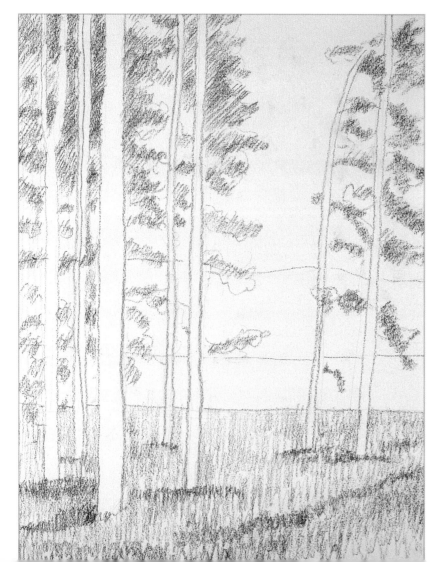

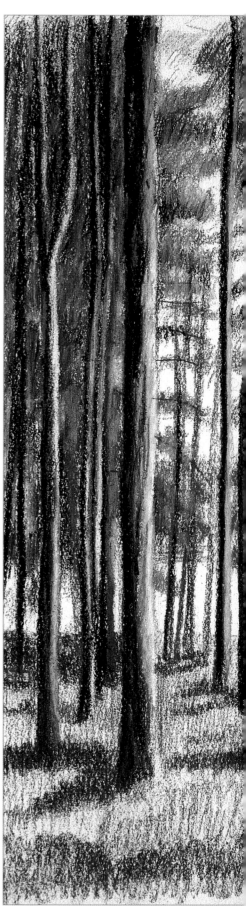

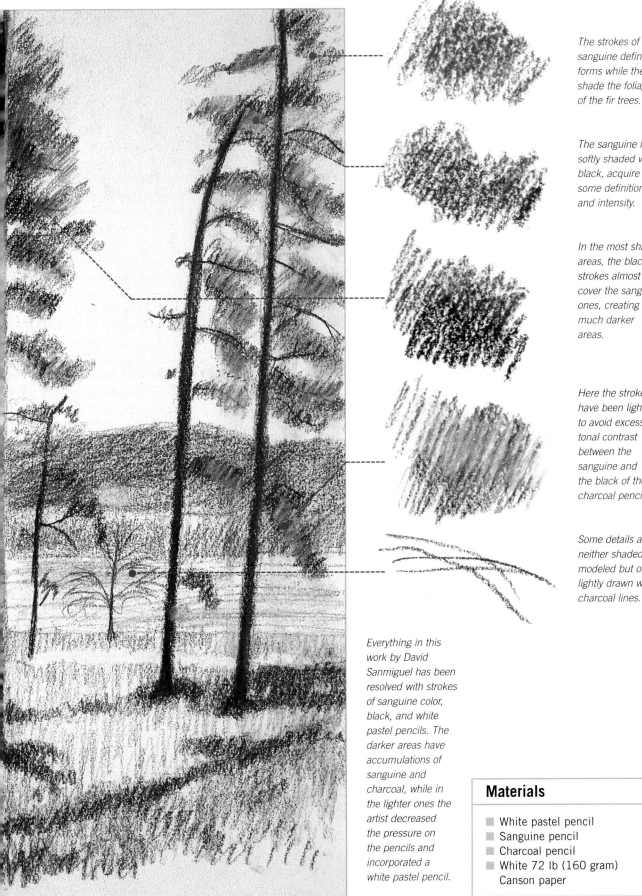

The strokes of sanguine define the forms while they shade the foliage of the fir trees.

The sanguine lines, softly shaded with black, acquire some definition and intensity.

In the most shaded areas, the black strokes almost cover the sanguine ones, creating much darker areas.

Here the strokes have been lightened to avoid excessive tonal contrast between the sanguine and the black of the charcoal pencil.

Some details are neither shaded nor modeled but only lightly drawn with charcoal lines.

Everything in this work by David Sanmiguel has been resolved with strokes of sanguine color, black, and white pastel pencils. The darker areas have accumulations of sanguine and charcoal, while in the lighter ones the artist decreased the pressure on the pencils and incorporated a white pastel pencil.

Materials

- White pastel pencil
- Sanguine pencil
- Charcoal pencil
- White 72 lb (160 gram) Canson paper

Lines and hatching with color ink

The technique of hatching with a nib pen can be used with color inks. The difference is that several pens are needed (one for each color), unless one is very careful to clean the nib pen with water to eliminate the ink residue before each color change.

The appeal of this technique is the sensitivity of the line and the subtle changes of color. In this exercise we also use a dry brush to create color effects over the areas of accumulated ink that occur when drawing the lines.

Before the ink accumulated on the lines made with the nib pen dries it can be rubbed with a dry, soft-hair brush. This produces very graphic effects and compensates for the coldness of the fine India ink lines.

The hatching does not need to be systematic: here we draw very short lines to create a dark and richly textured area, working with India ink and not applying too much pressure on the pen.

The thin lines that we are able to draw with a nib pen become even more subtle when we use color ink: the red or orange lines are much less obvious than the typical black stroke of the India ink.

This hatching enriched with previously applied blotches of ink is quite open. The effect of the folds in the fabric is created by drawing long lines that are separate from the hatching.

This blotch is an accident. The absorbency of the paper does not allow for scratching the ink or for correcting mistakes; all lines are permanent. But the drawing is not ruined, rather its spontaneous character is the result of this type of accident.

Materials

- Color inks
- Nib pen
- Soft-hair brush
- Sketching paper 50 lb (110 gram)

The combination of colors, lines, and hatching gives pieces drawn with color inks great variety and visual charm. It is not necessary to fill the work with heavy hatching to make it appealing. Work by David Sanmiguel.

Shading with simple hatching

Graphite makes it possible to achieve exceptional freedom and control when shading. Freedom because it is easy to use, and control because the graphite line is basically constant, continuous, and susceptible to the pressure applied by the hand. In this example, we show a methodical approach to shading by applying very simple systematic hatching to define the different intensities of darkness.

An area covered with parallel lines drawn very close to each other creates a shadow. The lighter shadows are formed by very light lines. The 3B lead is quite soft, but light lines can be made with it by using very light pressure.

When we cover one hatched area with another one the effect of shading is increased. This is how we create a much darker shadow and also an area of linear texture that is quite a bit heavier where the white color of the paper is much less visible. New hatching would darken the paper almost completely and it would result in a very dark, almost black, gray.

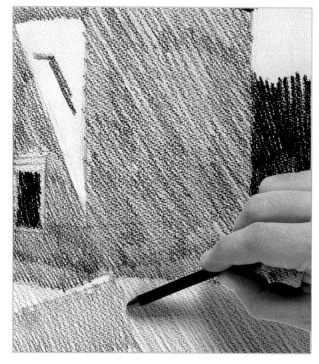

In this drawing the artist has followed a methodical approach to shading. A series of hatch lines were drawn for the darker areas and the lighter ones were left with simple hatching. Work by Gabriel Martín.

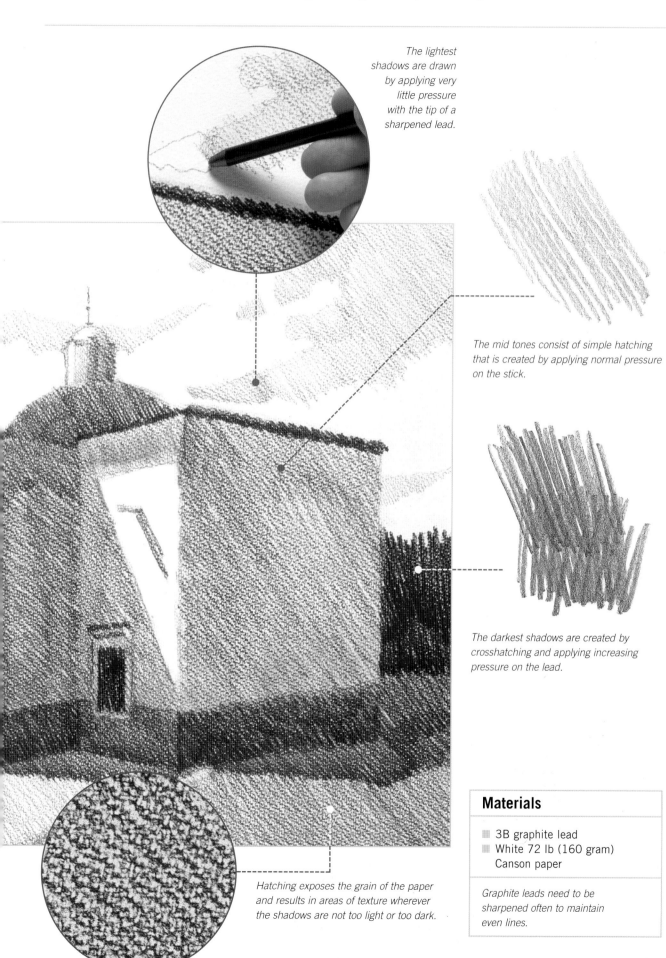

The lightest shadows are drawn by applying very little pressure with the tip of a sharpened lead.

The mid tones consist of simple hatching that is created by applying normal pressure on the stick.

The darkest shadows are created by crosshatching and applying increasing pressure on the lead.

Hatching exposes the grain of the paper and results in areas of texture wherever the shadows are not too light or too dark.

Materials

- 3B graphite lead
- White 72 lb (160 gram) Canson paper

Graphite leads need to be sharpened often to maintain even lines.

Free pencil hatching

There are no hard rules about the technique of shading with graphite. If many artists use the hatching method it is because it is the easiest to control in medium and large format drawings. With hatching, the intensity of the shadows can be easily controlled during the entire process by always working from less to more (from lighter to darker). In these pages, we demonstrate a process that does not follow a systematic approach but rather a loose method of shading, always working by accumulating lines.

A 4B pencil makes very dense and dark lines, ideal for drawing contours and for the creation of very heavy hatching. It requires frequent sharpening, because the tip wears down fast.

The 4B pencil, properly sharpened, can be used to quickly darken areas of shadow through simple hatching done with circular or spiral strokes.

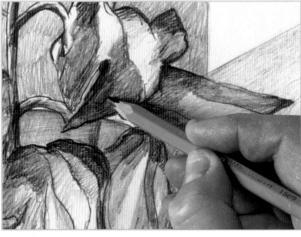

Here the strokes are not systematic. The pencil and the lead used are soft enough that simple pressure on the tip makes very dark hatching of varying shapes: sometimes it is straight, other times round, and on occasion it is undefined. Work by Almudena Carreño.

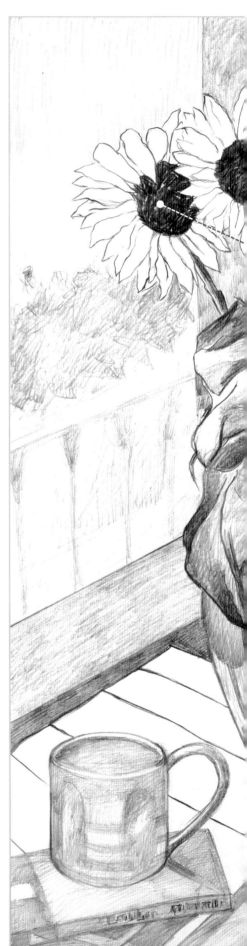

The scaly texture in this area of the drawing comes from the partial layering of hatching created in descending order while not following the same exact direction.

The darker areas of these flowers have been drawn with an accumulation of spiral and circular lines using a 4B pencil.

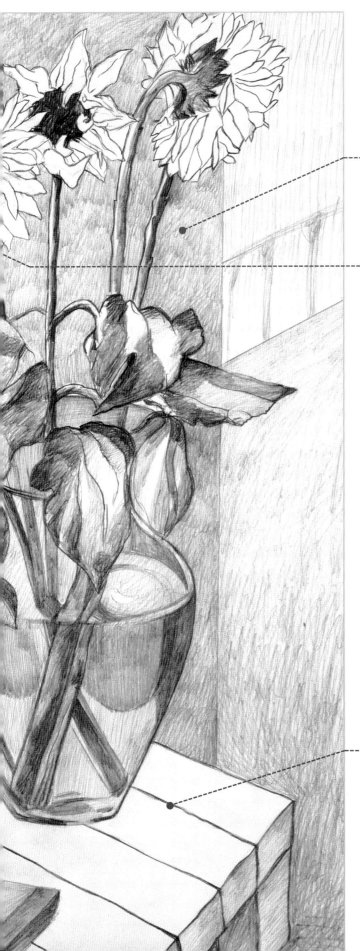

The 6B graphite lead is one the softest available. Pressure applied on its tip creates very dark strokes. The strokes that can be drawn with this lead will undoubtedly be very heavy; it is not necessary to do any hatching to produce dark shadows.

These lines drawn over white stand out vividly in the drawing and offer a contrast in a scene that has been heavily worked.

Materials

- 4B graphite pencil
- 6B graphite lead
- 90 lb (200 gram) Bristol paper

Hatching and highlighting with pencils and pastels

The main reason for working on color supports is the use of white pencils and pastels. In this case we have used both: white pastel pencil and a hard white pastel stick. The same material in two different formats to complement the tonal work of a drawing based on hatching with

black pastel pencils and compressed charcoal. Unlike graphite, pastel pencils and compressed charcoal are able to create very dense and velvety blacks and the hatching turns into opaque areas of color when the strokes become heavy.

This drawing is supported by a very structured line drawing executed with a black pastel pencil. The lines of the main building have been reinforced with compressed charcoal lines, which results in a very deep black.

Materials

- White pastel pencil
- Charcoal pencil
- Hard white pastel stick
- Compressed charcoal stick
- 72 lb (160 gram) Canson paper

The tone of the black pastel pencil is only surpassed by the compressed charcoal sticks, which provide a black color that is even denser and darker. In this example both media have been used to alternate dense areas of hatching with areas of complete or almost complete black shadows. The effect is very artistic and much more powerful than what is possible with graphite pencils.

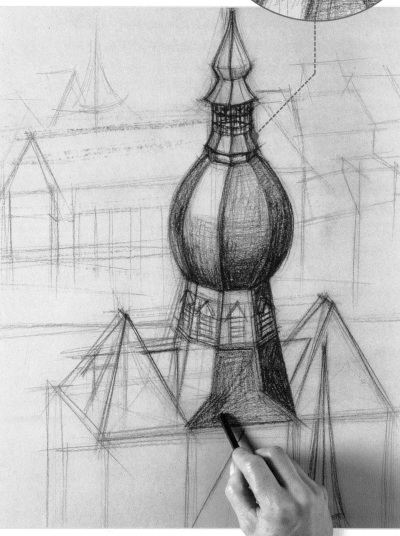

The color of the support makes the white highlights stand out against the black shadows and the paper. A white pastel pencil has been used for the smaller highlights and for the details, while the hard pastel has been used for drawing the large areas of white.

The effect of spatial distance is achieved by contrasting intensities: the foreground looks darker and contrasts with the background. We have created the background by drawing light hatching without going over the lines, using a black pastel pencil. In the foreground the black areas and heavy hatching done with white pastel pencils and hard white pastels are dominant. Work by Esther Olivé.

The liberal hatching creates a dark tone in the area of the sky. A simple change in the pressure applied on the pastel pencil makes the line vary considerably in intensity.

Hatching with nib pens and India ink

The key to success with hatching using nib pens and India ink resides in the variety of hatched lines. A mechanical application of a single type of line looks cold, antiseptic, and repetitive. The artist should be creative enough to develop his or her method for differentiating straight, round, wavy, and angular lines that suggest the various forms and textures of the chosen theme, whether it is a landscape, a still life, or a figure. In this example, many different types of lines are used without losing sight of the necessary unity desired by the artist.

The drawing is based on this sketch. It can be a pencil sketch or a mental sketch. The important thing is for the artist to have a general idea in mind of the overall form of the elements so the strokes will not turn them into an indistinguishable web of lines.

After deciding on the basic forms that will be included in the piece, the artist must think about the different lines that will enrich it: the greater the variety the more interesting the result will be.

Zigzag lines offer a convincing version of the foliage of the olive trees. These lines are not strong enough to produce a sharp contrast against the more pronounced areas of the middle ground.

The tops of the pine trees are drawn with very short hatch lines, drawn almost parallel to each other following an oval configuration. Eventually, these lines will be complemented with horizontal lines that will highlight the shading.

Hatching with India ink has no secret other than darkening the strokes in the areas of shadows and lightening them in the illuminated areas, always following the principle that the greater the variety of hatched shapes the better. The pen should move smoothly on the paper without stopping in any one area in particular, thus avoiding dripping and the formation of blotches. *Work by David Sanmiguel.*

The trees that surround the cypress trees in the center of the composition are drawn with hatched lines similar to the characteristic shape of clouds. These hatch lines mimic rich and more compacted foliage than that of pine and olive trees.

The façades in the shade have very different hatched lines than those of the trees: they consist of parallel and vertical crosshatchings that suggest flat and hard surfaces.

Materials

▦ India ink
▦ Nib pen
▦ 90 lb (200 gram) Bristol paper

The preliminary sketch and drawing were done with a 2H graphite pencil.

Hatching with markers

Markers are the modern alternative to drawing with nib pens and reed pens, an alternative that has not replaced the old tools but one that has expanded the possibilities for expression. The principle involved is identical: a tip that deposits ink on paper. The substantial difference is that markers contain the ink inside and that their sponge-like tip makes an even stroke, despite the amount of pressure that may be applied. In addition, the ink on the markers tends to be transparent, which makes the hatching light, a characteristic that sets them apart from work done with India ink. The markers that are used in this example have two tips: a thick one cut at an angle and a thin one.

The area of the hair has been drawn with very loose hatch lines. More than hatching, it looks like shaded areas applied with the widest part of the marker's angled tip.

It is a good idea to draw a general sketch before starting with the markers, and when using them, to begin hatching with light colors that do not fill up the drawing with heavy hatching from the start. During the first steps of the drawing it is important to work with the thinnest hatching possible, progressing from light to dark, from light to heavy.

The secret to the success of any work based on hatching resides in the variety of the lines and the form of the hatching. Here, we add variety through the thickness of the strokes, something that is much less visible in drawings done with nib pens and that in this case has been achieved by alternating the markers tips. Work by Óscar Sanchís.

Here, we have accumulated a large number of strokes, thin and thick, drawn in different directions. The thickness of the hatch lines never makes the color completely opaque due to the transparency of the markers' ink.

The hatch lines conform to the rounded shapes of the surfaces. As a result of that, the shadows not only control the light but they also represent the forms with precision. The hatching is lighter here to avoid creating areas that are too compact.

The hatch lines should be rounded when shading rounded surfaces and straight when the surfaces are flat. This general principle is valid for any type of hatch lines (whether they are drawn with nib pens, reed pens, or markers), and it can be applied to any configuration: strokes always conform to the shapes.

In this illustration we can see the thick lines applied with the marker's angled tip. This tip makes it possible to draw two types of lines: thick, when the flat side of the angled tip is used, and thinner when we draw with its tip.

Materials

▦ Double-tip markers
▦ 90 lb (200 gram) Bristol paper

The sketch and preliminary drawings were drawn with a 2H graphite pencil.

Hatching and rubbing with pastel pencils

The thickness of the stroke that characterizes pastel pencils does not allow for meticulous lines, but it does not favor the typical pictorial approach of pastel sticks either. The technique demonstrated here is halfway between the two approaches; it is neither completely linear nor totally pictorial, but it incorporates the advantages of both, which are, the precision of drawing with a lead (linear) and the expressive ability of shading.

We are talking about a black and white treatment that produces a chromatic effect that is enhanced by the color paper that is used as a support.

Pastel pencils are used to draw lines and as a medium to create full and opaque areas of color. We can draw hatch lines with them to create intermediate tones and also blocks of black and white. The top of the table is one of those tonal blocks.

To transition from dark to light using a black pastel pencil we first draw some hatch lines, and then rub the lines in the darkest areas. In the lighter part we reduce the pressure of the pencil and we draw the lines farther apart to increasingly expose the color of the paper.

The darkest area of the drawing is a block of black with no visible strokes; the lines have disappeared after rubbing them with a finger.

A drawing like this one provides a clearly pictorial effect through the variety and depth of the shading. The combination of hatched and rubbed lines over a color background enhances the plasticity and the chiaroscuro effect. Work by Óscar Sanchís.

The highlights and reflections on the glass are resolved by contrasting small areas that are completely black with others that are completely white.

This black has been achieved by first extending a very thick black line hatching and then rubbing the hatching with a finger to eliminate any trace of the lines.

Materials

- HB graphite pencil
- White pastel pencil
- Charcoal pencil
- 72 lb (160 gram) ochre Canson paper

This area of hatch lines is progressively thicker and defines the transition from a very dark area of shadow to a lighter part of the composition.

Rubbing and highlights with black, white, and sepia

Rubbing is the most suitable technique for shading with chiaroscuro. It allows the artist to work on monumental and large-scale applications that can be defined and complemented with details as the work progresses. In this exercise it becomes evident that the basically "dirty" nature of rubbing (in this case, it requires spreading the charcoal with your hands and with a rag), does not prevent it from producing finishes that are precise and very distinct in their different tonalities. Here, rubbing is complemented with white highlights applied with a white pastel pencil.

Hard sepia pastel goes very well with black: it defines it and enriches it. The rubbed areas acquire a warmer and deeper tone. By rubbing with the fingers, the pastel stick blends easily with the areas of charcoal.

This drawing is supported by a few schematic shapes drawn with charcoal and blended with the fingers. In this technique, the areas of color and the contrast between light and dark are more important than the line. The details and profiles are only incorporated into the drawing during the last phases of the work.

Materials

- Charcoal stick
- Sepia color hard pastel stick
- White pastel pencil
- Charcoal pencil
- 72 lb (160 gram) white Canson paper

Due to the constant rubbing with the fingers, it is important to wash your hands frequently during the process.

Rubbing is a gradual working technique that is carried out through layering and accumulation of material. The charcoal is applied little by little and then it is rubbed until the desired tone is achieved.

To be able to ensure the balance between the lines, we have occasionally used a plastic ruler to make straight lines to use as a guide. The ruler should be cleaned thoroughly every time it is used so it does not smudge other parts of the drawing.

White highlights can be drawn on an area of dark charcoal and pastel that is properly blended. The highlights lift the visual weight of the big dark masses and introduce the needed details into the work.

To easily draw the highlights, the lower areas of the drawing should be thoroughly blended, without any loose pastel or charcoal particles on the paper. Otherwise, the pastel pencil lines will not be as clean as they should be. Work by Almudena Carreño.

Rubbing with charcoal and pencils

In work done with light blends, using light applications of charcoal or pastels, it is possible to incorporate graphite or colored pencils to create a subtle contrast against the large areas of neutral color. In this example we will use charcoal for the more general tonal layout and pencils for the details of the objects. For this purpose we use a gray pencil and a blending stick (which can also be a silver tone or very light gray pencil). The texture of the pencil is somewhat oily and provides warmth to the areas where it is used.

The volume of the fruit would have been impossible to achieve by working only with charcoal. Colored pencils allow greater shading definition and their presence is not as overwhelming as pastel pencils. Their subtlety is much greater and they are a much more suitable vehicle for the fine sensibility of the artist. Work by Mercedes Gaspar.

A drawing made with a graphite pencil maintains the contours of the objects without being altered by the rubbing of the charcoal. Graphite is an oil medium that is more permanent and does not leave loose particles, therefore, it can be easily blended.

To create a light overall blend the charcoal stick is rubbed horizontally on the paper, while applying very light pressure. Then, the charcoal marks are lightened with the fingers, letting the shading spread over the paper loosely. The resulting effect is always atmospheric and suggestive.

Materials

▦ Charcoal stick
▦ Gray colored pencils
▦ Blending stick
▦ Rubber eraser
▦ 60 lb (130 gram) Ingres paper

The blending stick can be substituted with a white colored pencil.

A blending stick or a white or very light pencil can blend the preliminary colored pencil lines, creating soft transitions between light and dark. This is how we have achieved the delicate modeling of the fruit.

Colored pencils are only used on details to highlight, draw, and define contours and forms. The gray tone of the colored pencil is somewhat warmer than the gray of the charcoal and its consistency is quite a bit oilier.

The gray and white tones of the paper and of the charcoal are much cooler than the gray achieved by blending colored pencils. In this case the contrast is not only a result of different values but also different "temperatures," and this factor is what gives subtlety to the result.

We have used an eraser to restore the white of the paper. Charcoal blends can be easily erased and in this piece the eraser has become a true drawing tool.

Value drawing with a blending stick

The blending stick used properly can be considered a true drawing instrument rather than a blending tool alone, a sort of "paper finger." The blending stick, unless it is new and extremely clean, always smudges the paper, and this characteristic should be used by the artist for shading, highlighting, and defining and not only for spreading previously applied charcoal or any other drawing medium. In this example we can see how it is possible to construct a drawing by using the blending stick with the hard white pastel stick to highlight the lighter areas.

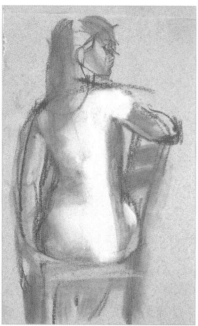

The technical approach to this work consists of layering white highlights with a hard pastel stick on a base of charcoal shading done with a blending stick. This study shows the concept in a general and very effective way.

The work with a blending stick begins over very short charcoal strokes that establish the general lines of the figure. The charcoal is extended by rubbing on those lines and blending to re-create the folds and the wrinkles on the dress, while certain areas are darkened and others lightened. This is a true study in values.

Here, the tip of the blending stick has been used to create blends and linear strokes that will go well with the direction in which the hair falls. The results are intermediate tones between the color of the paper and the darkest strokes.

The blending stick has been used over the areas of white pastel, resulting in very light blends that allow the gray color of the paper to show through and that create a transition between this tone and the maximum white of the lights.

These values are the result of using the blending stick over thick strokes of charcoal, and later spreading the charcoal particles in different directions to create convincing modeling.

Materials

- Charcoal stick
- Hard white pastel stick
- Blending stick
- 72 lb (160 gram) light gray Canson paper

When the work with the blending stick is finished, the hard pastel is applied to highlight the lighter areas of the modeling. The combination of blended areas and white areas is very natural in the decisively cold tones provided by these drawing media.

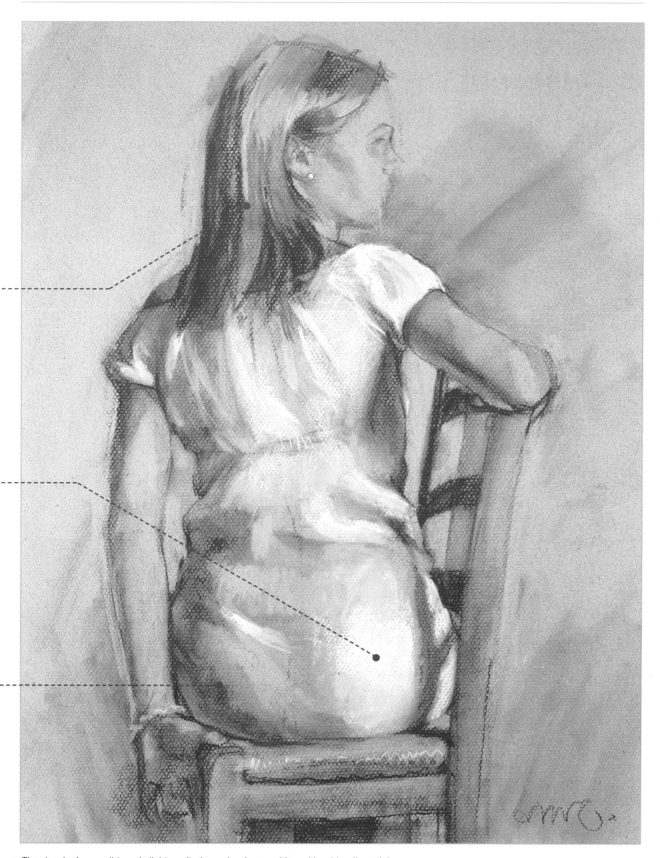

The drawing's overall tone is light, as it always is when working with a blending stick (the blending stick does not handle excessive charges of pigment or charcoal well). Sometimes the areas of shadow blend with the gray of the paper and create overall unity. Work by Mercedes Gaspar.

Value drawing with an eraser

Like the blending stick, the eraser becomes, in the hands of an experienced artist, a drawing tool that goes beyond its use for correcting mistakes. It becomes almost indispensable in work where blending and grisaille (gray, brown, reddish, or any other color grisaille) are predominant. Erasing restores the white or any color of the paper itself and results in a light highlight over a dark context: it becomes the light of the composition. Although many artists use conventional rubber erasers, it is more common to use kneaded erasers.

Using the edge of a malleable eraser we can create white outlines to define certain areas of the figure's hair. If the kneaded eraser is too soft, the edge of a rubber eraser can be used.

Like any drawing destined to be blended, this work was drawn with very light shading. The charcoal and the sanguine are lightly extended over the paper lightly for a later blend, which will end up mixing them and lightening any lines. It is important not to apply too much pressure on the sticks to avoid marks that neither the blending stick nor the eraser will be able to eliminate, which can ruin the result.

A kneaded eraser can be used flat on the paper, and with circular motions we can obtain erased areas that are also blends of the color where it is applied.

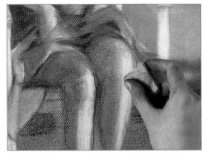

A kneaded eraser can be molded into various shapes according to the circumstances. Here, the triangular shape makes it possible to create the lighted areas of the drawing with precision. Thanks to the lightness of the shaded and blended areas, the white of the paper can be easily restored.

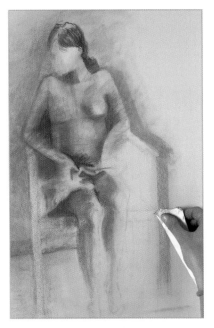

The blends can be produced with a rag, with fingers, or with blotting paper if we want to keep everything clean in the process. The result will always be lighter in the latter case. There is no emphasis at all on the contours because they should be created working with the eraser.

Materials

▨ Charcoal stick
▨ Sanguine and sepia colored dark pastel sticks
▨ Cotton rag
▨ Blending stick
▨ Malleable eraser
▨ 72 lb (160 gram) cream colored Canson paper

If the erased areas need to be really straight, a piece of paper can be used as a reserve so the erasing does not go beyond the edge, thus preserving the color of that area.

The overall valuation of this drawing culminated with the use of the eraser to create the highlights. Thanks to this tool, the use of white pastel highlights was not necessary in this work.
Work by Marta Bermejo Teixidor.

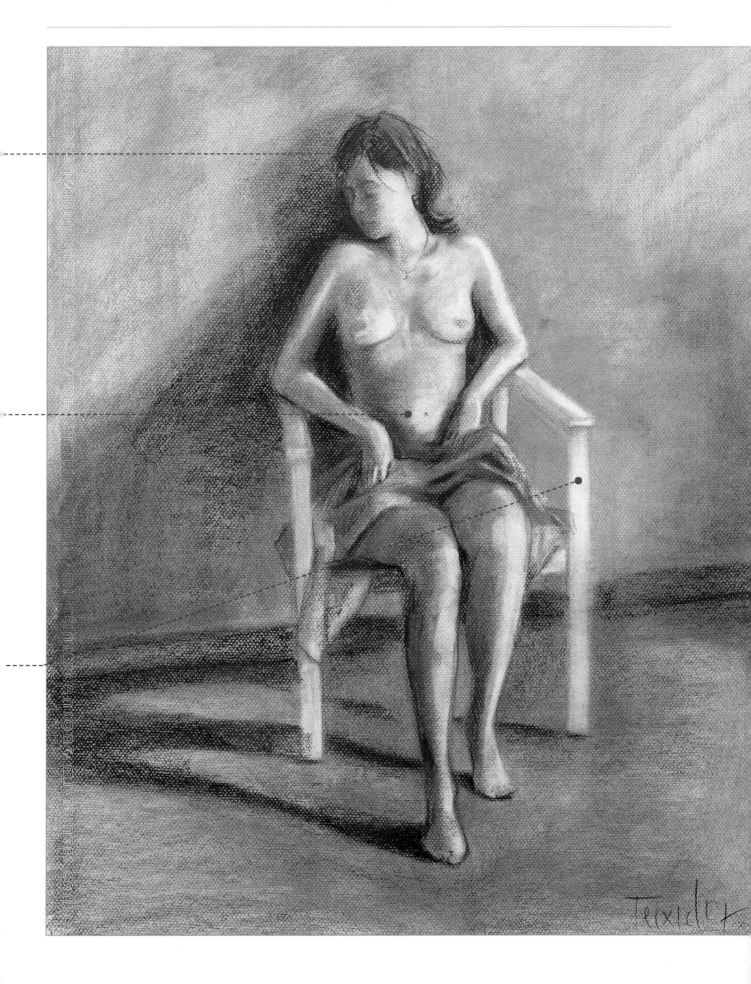

Pastel value drawing with a rag and an eraser

The values in a drawing can be gradual and continuous or they may be drastic and change the overall structure of the piece. The "crudest" media, those that are not known for finesse and precision, are the most suitable ones for the latter approach. One of these media is soft pastel. The sticks of soft pastel are not very suitable for drawing continuous lines and minute details; the pigment crumbles easily and the lines tend to become areas of color that are more suitable for gradations and for generous blending with fingers or with a rag. In this example we show the use of these simple materials in a work of sharp and crude values.

A rag is indispensable when the artist is working with large formats and wishes to spread the pastels (or charcoal) quickly and extensively. The canvas absorbs part of the pigment and this makes it possible, later, to use the rag as a drawing tool to create light areas of color.

The purpose of these strokes is to apply color to the paper rather than define the drawing. They simply separate the spaces that each form will occupy and add large amounts of pigment to the paper, which can then be spread with a rag.

In this work the crude contrast between the wide and streamlined pastel strokes stands out against the background of the paper shaded with light color glazes. That shaded color is the traces of pastel absorbed by the paper itself (the priming of the paper is absorbent) that the eraser has not eliminated. The "ghost" of all the previous trials and errors remain, enhancing the result. Work by David Sanmiguel.

Materials

▨ Burnt sienna soft pastel stick
▨ Rubber eraser
▨ Cotton rag
▨ 72 lb (160 gram) Canson paper

It is a good idea to break the pastel bar into small and easy to handle pieces to prevent it from breaking during the drawing process.

The eraser is very useful for restoring the white of the paper in the areas where the light is cool. Here, we use a rubber eraser instead of a kneaded eraser, because the idea is to maintain a balance between the erased areas and the strokes, without too much intermediate shading: the erased areas are therefore very substantial and require a harder eraser rather than a malleable one.

Continuous erasing restores the light areas, which contain gradually more shading due to the accumulation of pigment absorbed by the paper.

The erasing process is drastic: the entire piece is reworked until the final version is achieved. Inevitably, the paper ends up absorbing part of the pigment.

The repeated application of strokes of pastel results in the definite form after a series of trial and error lines that leave a mark on the paper.

Gradations with watercolor pencils

Most of the commercial varieties of colored pencils can be used as watercolors. The artist may decide whether to use them the conventional way, that is, for drawing lines, or to spread the colors by brushing the lines with water. In this example we show the latter approach on a landscape theme. The fact that the color can be spread with water makes it possible to reduce the number of pencils needed, because the variations in the amount of water in the brush is translated into color differences that model and shade the piece. The chromatic power, however, can never be compared to watercolors themselves. The secret of this technique resides in alternating lines and areas of color, between the graphic spontaneity and the light tones provided by the water.

Watercolor pencils can be used either on dry paper or on wet paper. Here we see the results of the latter application: the lines acquire a spongy quality and lose clarity when they are partially blended with the water.

When the strokes of color are dampened it is not necessary to work in a precise and schematic way. These color lines are applied with the subsequent wetting in mind, which will blend them and make them lose their dry precision. This is why the lines can be liberally applied without paying much attention to the direction or the length of the lines.

When the wet brush is rubbed on the lines and the areas of color, they blend together and the contours vanish. The lines and areas of color accumulate in this fragment and the overall effect is a tonal density that is very appropriate to resolve the shading in this part of the composition.

Here, we have simply applied a wet brush previously tinted with the color of several gray strokes applied on a separate piece of paper. This results in a very light and subtle glazed tone.

Here, we have accumulated hatched color pencil lines, wet areas of color, and a final application of charcoal that highlights the shadows. The charcoal is always used at the end to avoid smudging the areas of watercolor.

Materials

- Watercolor pencils
- Ox-ear hair thin round brush
- Charcoal stick
- 140 lb (300 gram) fine-grain watercolor paper

These roses are the result of applying the brush dampened in clean water over the drawing of the houses. The lines of this drawing remain visible, but they lighten due to the effect of the overall watercolor tone.

This piece, halfway between a hatched drawing and a watercolor painting, provides great graphic richness integrated in an environment dominated by the lightness of the colors. The lighter parts correspond to areas slightly tinted with the color of the pencils, while the darker areas are full of hatched lines. Work by Mercedes Gaspar.

Gradations with markers

The use of gradations is not only applied to drawing media that can be blended directly or whose lines can be lightened (charcoal, pencil, pastel, etc.). Rather, it is an idea that is also valid, for example, for drawing with markers. It is true that lines made with markers are permanent, but it is also true that the lines made with light colored markers are much softer than those made with dark colors. Besides, it is possible to use worn-out markers (and many artists love to do this) whose lines are more irregular and coarse than markers that have a good charge of ink. Therefore, using these resources, it is perfectly valid to refer to gradations in drawings done with markers.

The darker strokes are used to shade the closest façades, and the lightest ones construct the façades farthest away. The key to gradations that are based on hatched lines made with markers resides in this contrast. The almost strictly orthogonal character of the lines makes the modeling of the flat forms of the buildings look sturdy.

The initial drawing of a work with markers can be done with a pencil or with a fine-point or fountain pen. Because the line is so thin, the possible errors are not relevant in the final result since they are concealed by the many strokes that follow them.

The lines that describe the overall structure of the building are thicker and darker than the ones that model its lights and shadows.

Materials

- Alcohol based markers
- Brown stylograph
- 90 lb (200 gram) Bristol paper

The preliminary sketch and drawing have been made with a 2H graphite pencil.

The lines here are very thick and dark to reinforce the contrast between light and shadow that highlights the foreground.

Worn-down markers have been used here to reduce the intensity of the background and to reinforce the gradations of the tones. These strokes are alternated with very thin lines of the initial drawing.

The areas of the panoramic view located farther away have been resolved with worn markers whose lines are very light due to their lack of ink. The effect is a gradation in the intensity that re-creates the aerial perspective: the distant forms have little definition and contrast. Lights and shadows are alternated in a succession of decreasing contrast. Work by Josep Asunción.

Gradations with colored pencils

The main theme of this gradation is the representation of the surface of the water and its reflections. The drawing, in its first phase, is based on light gradations that allow the artist to blend some tones into others by adjusting their gradations depending on the pressure applied to the pencil.

Colored pencils are more efficient in the creation of small details and shading than in large-scale effects. The total dependency of the stroke and hatching forces the artist to concentrate on the small developments of form and color and this includes tonal gradations, which can be extraordinarily delicate and intricate. This example shows the ability of this medium to achieve very rich gradated shading by working with a wide range of colors. Another factor that increases the unity of the piece is working on textured paper that disturbs the integrity of the strokes and the hatched lines.

After repeatedly going over and superimposing some hatch lines over others, and thanks to the paper's texture, the tones are gradated lightly. Work by Óscar Sanchís.

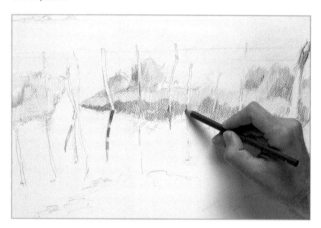

The short strokes are applied in the darkest areas, while the long ones are used to even out the tones and to gradate them until they blend in with the other hatched lines in the drawing.

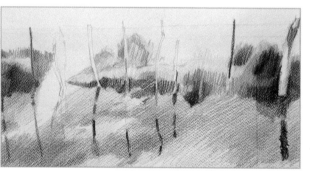

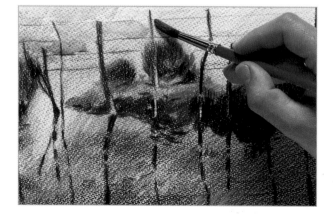

The details are always worked with the pencil's sharp point. These small areas must stand out for their graphic precision within an area that is much less detailed. The texture of the paper contributes to the unification of the overall gradation.

The abundant layers of light strokes have created a very unified general tone that gains or loses intensity depending on the pressure that is applied on the pencils in different areas of the drawing.

The grasses appear very naturally defined thanks to the pencil strokes themselves, which become irregular here and accompany the movement of each leaf.

In the lower part of the drawing, the lines become lighter to clear out an area of the paper and to highlight the reflections of the sky.

Materials

▨ Complete assortment of hard lead colored pencils

▨ 72 lb (160 gram) white Canson paper

The drawing has been carried out on the textured side of the paper; the texture is perfectly visible and stands out through the action of the colored pencil strokes.

Gradations with ink

You would be surprised by all the possibilities that the different drawing media can suggest, especially if you are among those who believe that tradition has covered all the angles. The combination of tools, materials, and different supports has many surprises in store that only surface when the artist approaches the work with an innovative and creative spirit. In this example, we use India ink and colored ink applied with a brush in a very spontaneous and energetic manner. The gradation is provided by the dilution of the colored ink in water, while the strokes and the lines are applied with India ink and a brush, providing great graphic results.

In this close-up of one of the animals we can see how the stripes are not painted with the same ink charge. These nuances are vital for the overall graphic coherence and to express the volume of the subject.

Connecting the strokes with more diluted ink creates a web of strokes through which we can make out the form and volume of the animals. The graphic richness compensates overwhelmingly for the lack of exact definition of each form. The gradation of the ink prevents any possible dryness in the contrast of the lines against the paper. Work by Josep Asunción.

The animals are drawn with areas of colored ink diluted in water. This not only defines their forms with sufficient clarity, but it also creates a preliminary gradation that will give coherence and volume to the finished work: the strokes of India ink are applied on areas that have already been shaded and not directly on the white paper.

Drawing the outline is unnecessary when the stripes of each zebra determine its form and volume. The background is a blur of ink that is a little more diluted with water.

The distribution of stripes is enough to express all the factors of the body of the animals. The form and the direction of the strokes provide information about the shape and the volume of the anatomy.

Materials

- India ink
- Sepia colored ink
- Fountain pen ink
- Ox-ear hair thin round brush
- 120 lb (250 gram) fine texture watercolor paper

Gradations with ink and charcoal

The use of charcoal sticks or pencils is not very common when working with ink; the normal approach is to use hard graphite pencils, which are unnoticeable and can be erased easily. However, used in moderation, without spreading too much or making too many lines and shadows or blends, charcoal can be an interesting complement in some washes or in gradations made with fountain pens and India or sepia ink. If conventional charcoal sticks are used, it is important to wipe off the paper with a clean rag when the drawing is finished to prevent the charcoal particles from dirtying the wash more than is necessary. In any case, the artist that uses this drawing medium already expects that the color will be soiled to a certain degree and counts on those dirty tones to create harmony in the work.

This drawing has been done with charcoal pencils in all or almost all the intensity allowed by this drawing medium. It would appear that an ink wash could be ruined by this type of emphasis on the lines, but that is not the case: the lines are incorporated within the gradation.

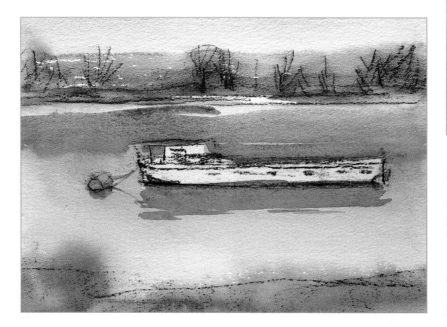

Very fluid and dissolved ink covers the drawing lines completely. The lines have been affected by the water and the latter in turn has been tinted by the charcoal particles. It is important to let the wash dry before every new application. The reflections on the water of the river are barely a few shadows of a tone that is somewhat less dissolved than the gradation of the base. The barge is left unpainted until the end of the process.

Here we have added a small application of sanguine to give a note of color to the monochromatic work.

The very diluted ink is tinted with the particles of charcoal and it integrates the lines into an atmospheric and glaze-like area of color.

The applications of charcoal must be reduced to a bare minimum for the representation of the forms. Too many strokes would dirty the ink gradations too much.

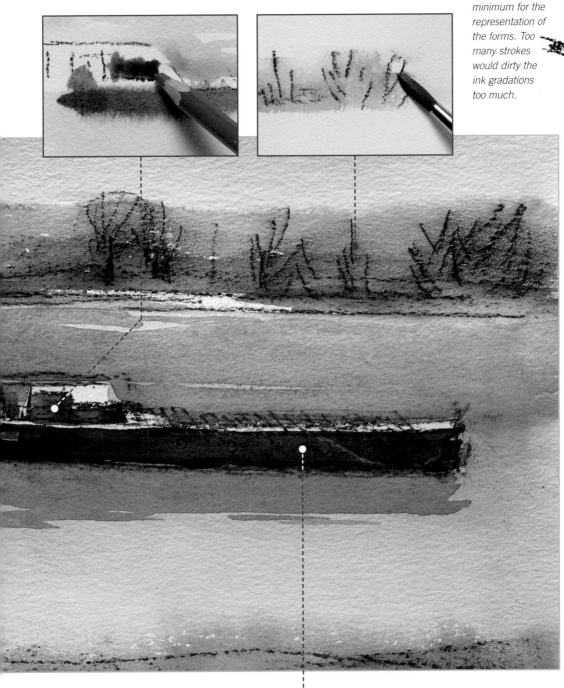

After incorporating a few dark highlights on the barge, the wash is considered finished. The strokes have been integrated perfectly in the scene and they do not contradict its overall tone at all. On the other hand, the grays of the wash itself go very well with the black charcoal lines. Work by Mercedes Gaspar.

This is the darkest application of ink. Since this is ink for a fountain pen, its tone is more delicate than that of India ink.

Materials

- Stick of charcoal
- Fountain pen black ink
- Synthetic-hair thin round brush
- Sanguine pencil
- 140 lb (300 gram) medium-grain watercolor paper

Color with oils

The first step when painting with oil paints is to distribute the different areas of color on the canvas in order to check the overall effect that they produce against each other before creating a work plan or trying to obtain specific effects, whether expressive or realistic. This is done with paint that is fluid but not too diluted because the transparency of very diluted paints can ruin the color integrity. Paint that is too thick can be dangerous as it can produce surface crackling when the paint is applied over layers that are not completely dry. Medium density, enough for the brush to slide easily over the canvas, is best.

Painting with oils consists of covering the white parts of the support decisively and without hesitation with large areas of color. The clear boundaries of the different areas in the preliminary drawing make it possible, in this case, to work by extending areas of color without blends or gradations. The paint is fluid but has good covering power and the overall effect is obtained quickly.

The texture effect and the change of tone created by the different brushstroke directions in this area are good enough that no additional painting or touching up is required.

The areas of the background are much larger but they are equally reserved for evenly applied color that is extended with quick and energetic brushstrokes. When it becomes difficult to cover the support completely with the brush, it is time to increase the solubility of the paint. For example, the brush can be soaked with a solvent and brushed over the previous colors so the brush can slide easily.

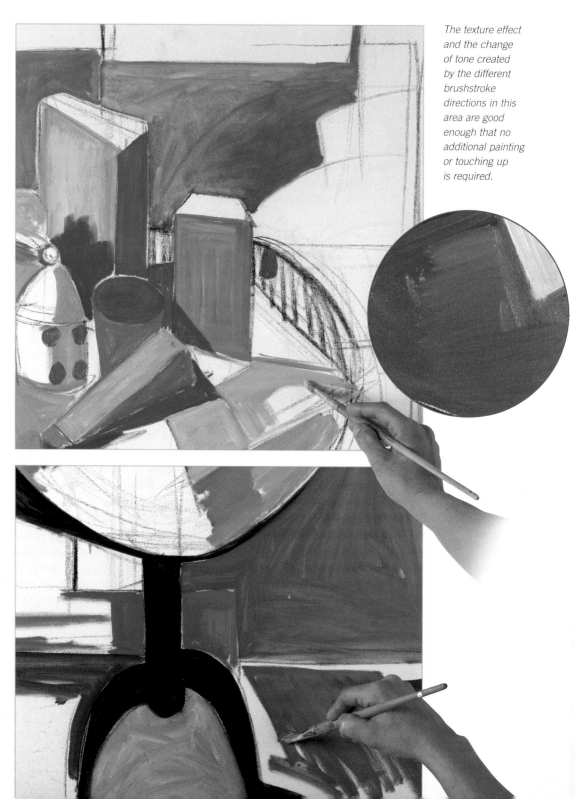

When painting with oils the areas of color show the brushstroke marks because the paint is not thick enough to cover the support completely. However, this effect is very attractive and many artists who paint with oils try to preserve it until the end. Work by Esther Olivé.

Materials

░ Oil paints
░ Flat bristle brushes
░ White cotton fabric

When it is necessary for the areas of color to be clearly differentiated, the paint should be applied somewhat heavily to avoid unwanted color mixtures.

If the artist wishes to preserve the effect of the brushstroke marks, which are very visible, it is important to try to change their direction and to diversify them to avoid monotony. These brushstrokes are applied with a circular motion.

Painting or washes with watercolors

The initial phase of painting with watercolors requires great simplification of the concept, reducing the mixtures on the palette to a minimum, and working at using the brushstrokes to define the forms.

Spontaneity in handling the brush is crucial to achieving a stimulating first effect. There should be a generous amount of water in the solution of the paint. A very basic approximation of the subject, drawn with one of the colors that is part of the heavily diluted work, is more than sufficient. That drawing will be completely integrated into the overall painting if it has been painted with the tip of the brush and without too much detail.

Just a few lines drawn with the main colors of the work are enough as a preliminary drawing for the watercolor. These lines will later be completely integrated into the piece. They will be unnoticeable because the colors in the painting phase are very diluted in water.

These pieces of fruit have been resolved by working very quickly, starting with wide areas of color, and then adding nuances and more color over surfaces of very liquid paint. The result is spontaneous and loose. Work Óscar Sanchís.

The color of these prunes is a mixture of crimson and ultramarine blue. Both colors are applied liberally letting either one or other dominate depending on the evolution of the painting. In general, the red stands out, although never in flat areas of paint, but instead in areas shaded with different applications of water.

Materials

- Watercolor paints
- Sable-hair thin round brush
- 140 lb (300 gram) medium-grain watercolor paper

The amount of water in the paint causes it to run, leaving areas of very transparent color. This random effect is typical of watercolor painting.

A simple movement of the brush creates the form, color, and almost, the volume of the fruit. This is done at the beginning of the process and the result must be maintained without too many touch-ups.

Adding a touch of heavier color to the wet paint creates enough of a sense of volume to describe the fruit realistically.

Painting with acrylics

Acrylic paints are swift and decisive. The paint can be extended over the support very easily once it is diluted in water. In this sense it is somewhat similar to watercolor painting. However, the greater thickness of acrylic paints and the lower purity of their pigments (the proportion of the vehicle that each color has is higher in acrylic paints than in watercolors), prevent the areas of color from acquiring the immediate brightness that characterizes watercolors. In this example, we show a typical acrylic painting, resolved with quick brush-strokes that do not quite blend with one another but that leave a charac-teristic mark, almost a texture made of lines, which gives vitality to the color.

The texture created by the brushstrokes is characteristic of acrylic paints. This texture can later be mitigated with successive applications of thicker and more covering paint; however, many artists prefer a light and rhythmic finish where the brushstrokes are perfectly visible as they are in the initial painting phase. Work by David Sanmiguel.

The amount of water used in acrylic painting always washes away the lines of the preliminary drawing, unless we use fixative on it. If that is the case, the drawing will remain visible in the final stage under the lighter colors. This is why the drawing here has been made with an orange colored hard pastel stick, very similar to the one that is going to be used to paint the animal, and no fixative has been used. If charcoal had been used instead, its particles would have muddied the areas of color.

The paint has been diluted in different amounts of water, producing variations in the intensity of the color. This factor is always used to model the volumes quickly. The quick brushstrokes remain visible on the support and create a texture of colored strokes. Painting does not only mean covering white areas with color but also to re-create the forms with an initial approximation of the lights and shadows.

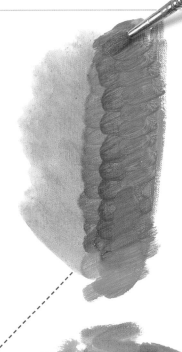

The paint has been applied with a large amount of water. The brush marks, in the shape of a spigot, are perfectly visible and provide a characteristic texture to the surface.

Painting with acrylic paints that are heavily diluted with water produces transparent color that can be modeled by simply controlling the amount of water. In the areas of least diluted paint the color is darker and more saturated. The brushstrokes remain visible because the paint dries very quickly. These strokes can, in turn, become the background for the new areas of diluted color under which they will be visible because of their transparency.

The background has been painted with a transparent color (emerald green). To achieve saturation and opacity, layers of paint must be accumulated, each one of them with its own brush marks.

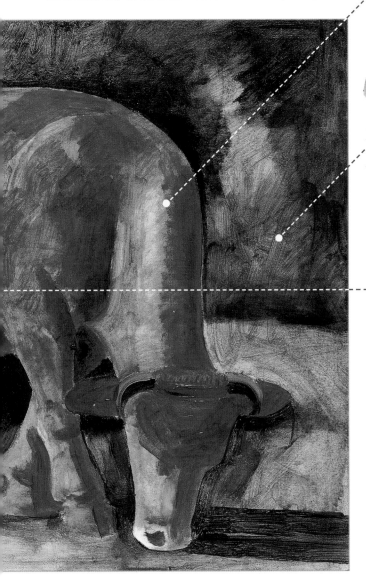

With acrylic paints the colors can be modeled from the beginning by controlling the amount of water in every color and doing it with the sense of volume in mind.

Materials

- Acrylic paints
- Synthetic-hair flat brushes
- White cotton fabric

A certain amount of acrylic medium has been added to the water to increase the transparency of the brushstrokes.

Painting with pastels

The initial areas of color of a pastel painting are basically colors rubbed with fingers or with a rag. This is how most artists usually work and this is how a work with pastels acquires its overall tone. Rubbing has been studied in the pages that cover the drawing techniques and the method is well known. However, when many different colors are used, it is important that these blends be as extensive as possible at the initial phase, avoiding accumulations of color because pastels do not adhere well to the areas where the pigment has been deposited on the paper in large quantities.

The sky is the atmospheric part of the work, therefore, it is the area where the color fulfills a more precise representational function (clouds, gradual light changes, etc.).

The color is spread using the pastel sticks on their wide side. Then these applications are extended by rubbing them with fingers, blending colors and smudging tones to suggest relief and volume.

The coloring phase of a pastel work is finished when the entire support is covered with color or even when the unpainted areas form part of a general tone that expresses the basic color of the theme and its atmosphere. Work by David Sanmiguel.

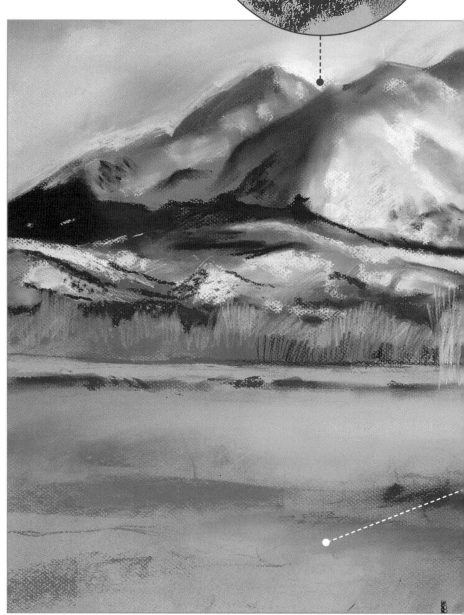

Although many artists begin their paintings by working on areas of color directly with pastels, in this case the composition is organized with monochromatic strokes, which provide more of a linear approach to the motif. The areas of color will blur all the lines and they will give the piece a different dimension.

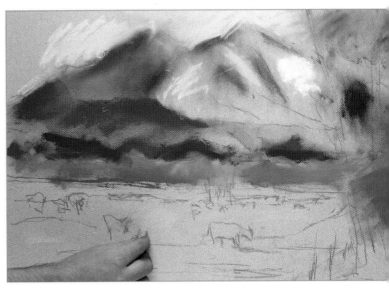

The direction of the color lines is important, because it is logical for the rubbing to follow the same direction as the lines. In landscapes, the extension of the space is better expressed with horizontal strokes, which comprise the entire panorama.

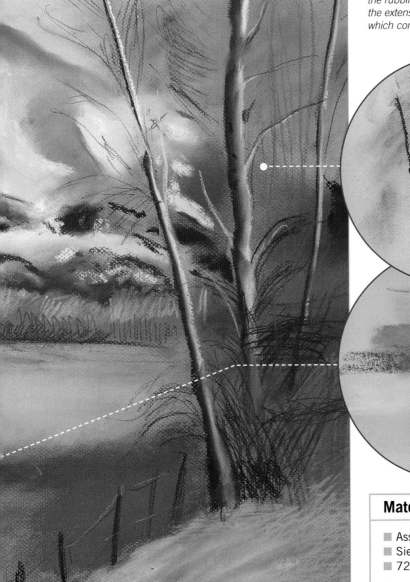

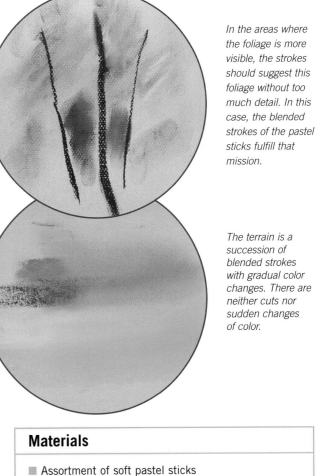

In the areas where the foliage is more visible, the strokes should suggest this foliage without too much detail. In this case, the blended strokes of the pastel sticks fulfill that mission.

The terrain is a succession of blended strokes with gradual color changes. There are neither cuts nor sudden changes of color.

Materials

- Assortment of soft pastel sticks
- Sienna colored pastel pencil
- 72 lb (160 gram) cream-colored Canson paper

Watercolor gradations

From a very saturated color to an almost white shade, watercolors can provide many different values by controlling the amount of water used. This can be done with progressive applications or with a single one that goes gradually from greater to lesser saturation. These gradual areas of color are called gradations and watercolor artists use them very often to represent the sky, the atmosphere, backgrounds, or surface shades that go from dark to light. The secret resides in the progressive extension of an area of saturated color with a few brushstrokes of water: once the color is applied, it is extended only with water; the color lightens progressively until it can barely be told apart from the white of the paper.

The tree has been completely painted with a very diluted single stroke that has later been reinforced with the same color, but much more saturated.

The atmospheric effect of the gradations can especially be seen on the most distant objects, where the strokes blur out the landscape's solid forms.

Working with gradations means working with wet paint on the paper. Therefore, the areas of color therefore do not have much definition, and result in an atmospheric effect.

The surface of the areas of gradated color should not be completely flat, but modeled by the various amounts of paint concentrated in the water. So, the most saturated areas suggest volume in the terrain, expressing its size and topography. All gradated areas are solid and smooth, without any brushstroke marks.

The color of this gradation fades away on the top and is more saturated on the bottom. This reinforces the spatial and atmospheric factors that are so important in this watercolor.

The delicate character of this watercolor results from a very calculated use of color and to the extreme sobriety of the palette. The light green tones of the foreground form a single gradated color, allowing the dynamics of the dissolved color to take care of the brightness. Work by Vicenç Ballestar.

Materials

▦ Watercolors
▦ Sable-hair thin round brush
▦ Synthetic-hair flat narrow brush
▦ 140 lb (300 gram) fine-grain watercolor paper

Gradations with oils

One of the great advantages of working with oil paints is that they can be completely gradated by blending the brushstrokes together. In this way, we can create surfaces where one color progresses into another without any cuts or gaps. A clear example of this characteristic can be seen in chiaroscuro modeling: a tone that goes from dark to light (and vice versa) creates the feeling of three-dimensionality and volume.

Most of the artists that work by modeling through color gradations try not to overdo impastos, nor use small amounts of paint with color that is quite diluted; in no case do they model all the surfaces of the canvas or leave some areas with flat colors or with low levels of modeling.

The gradation of this projected shadow goes from black to gray with successive brushstrokes blended horizontally.

To achieve correct gradations and, in general, to obtain a true chiaroscuro effect, we always go from dark to light. Only this way can we control the values, because we begin with maximum contrast, which can be reduced gradually as desired through the addition of lighter shades.

First, the darker tones are painted. These shadows are worked with a very gray mauve and a neutral gray. The rest of the bowl is modeled by mixing the initial colors with white. By adding white and blending with the brush we create gradations that model the entire surface of the body and give it a clear relief.

In a few brushstrokes we can create enough gradation to solidify the representation of the bowl's edge.

In the areas of cool light we can appreciate the accumulation of white oil paint: the impastos always show up in the areas of light. The result is completely realistic and creates an illusion of volume that is very convincing and coherent. Work by Óscar Sanchís.

Here, the color gradation is very subtle and contains nuances that are slightly different from gray, expressing the slight variations in the shadow's tone.

Materials

- Oil paints
- Flat and round bristle brushes
- White cotton fabric

Gradations with pastels

Pastel gradations are in reality blends created with fingers or with a rag. The inclusion of these blends in the chapter about gradations responds to the fact that when we work in full color, the blending of pastel colors becomes a fully chromatic gradation that progressively reduces the color saturation until it becomes very light. In this example, we show a way of working in which those gradations and a few light and continuous color blends dominate the work. The subject of the female nude requires this approach: the flesh tones must be more subtle and created by multiple color blending; the contrasts must never be brusque and the work should be done using a little color that is very extended (gradated) over the entire surface of the paper.

Superimposing colors is easier when working with hard pastel sticks because the amount of pigment deposited on the paper is less than in the case of soft pastels. This makes hard pastels less covering and easier to combine.

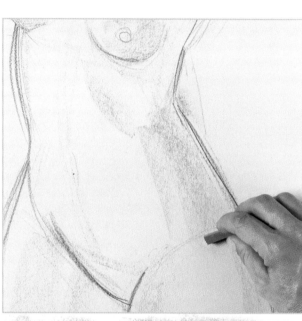

The colors of the background are layered but not mixed together. This gives them different and contrasting textures with respect to the flesh tones.

When working with hard pastels on work done with gradations, the sticks are applied flat on the paper. This way, the surfaces will be wide enough for your fingers to create gradations.

The color fusing and gradations are carried out by rubbing with fingers. The color of the paper "breathes" through many of the layers of color thanks to the intense work of gradations performed in the more volumetric areas of the anatomy. Work by Esther Olivé.

Materials

- Hard pastel sticks
- 72 lb (160 gram) white Canson paper

Fixative was used during the intermediate phases of the work to improve the adhesion of the surface during the work process.

Here, the stick has been rubbed energetically until a good amount of pigment has been accumulated. The gradated mixture of these two colors, therefore, is more covering here than in the rest of the work.

These colors are responsible for providing the flesh tones. When they are gradated and combined they provide a neutral tone that is very rich in shades.

Glazes with oils

Oil glazes consist of layers of very diluted color, which are nearly transparent, or of a naturally transparent color that is superimposed over another color to highlight or modify it. The most obvious glaze is the one created by dissolving the paint with mineral spirits and spreading it on the pristine canvas; the effect is very similar to watercolors (although without the characteristic brightness of the latter). The logical approach is to use dark color glazes over light ones when the latter are completely dry. The glazing technique can become as involved as desired, spreading the colors with the only purpose of making glazes and shading them with thin successive layers. In this example we show a simple and direct method.

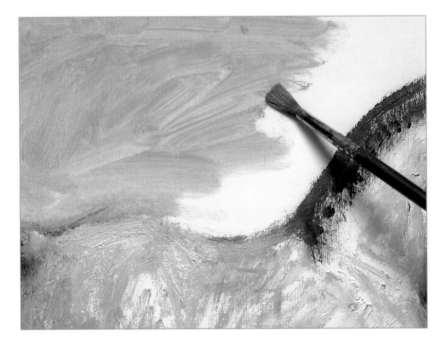

In the first application of color the horse's tail was resolved with brushstrokes of very thick paint over which lines were later drawn with the handle of the brush to represent the mane. No glaze has been applied in this area.

In this example the glazing is done over an oil painting that is completely dry. It is very important for the base color to be completely dry, otherwise the color of the glaze will mix with it and the result will be a conventional mixture rather than a true glaze. The blue color of the background can be considered, in some way, a glaze as well, because it does not cover the support completely.

Here we can see, without altering, the superimposed color shades applied over the base color. This is done by applying the color either very diluted or quite dry. In the latter case, the pigment has to be rubbed with the brush to extend it over the color and to obtain good transparency.

The color of the horse is darker now. The glaze has modified that color without suppressing the shading of the previous coloration. In fact, the base color and its forms are now highlighted by the thin layer of transparent color that covers them. Work by David Sanmiguel.

The previous color treatment consisted of very rough applications of paint. The texture of the dry areas of color makes the glaze more interesting, because the new diluted color is deposited between the relief and the dry areas and provides a quality result.

The drawing of the entire horse was done with quick strokes of undiluted paint. For that reason, the texture of the canvas can be seen on the trajectory of those lines.

Materials

- Oil paints
- Synthetic-hair narrow brush
- White cotton fabric

The glazes were applied once the paint of the horse was completely dry.

Glazes with watercolors

The color of wet watercolors on dry

Watercolors are always transparent. A watercolor glaze is done using a technique called wet on dry, painting one color over another color after the latter is dry. This exercise shows the different applications of yellow, that were glazed one over the other to paint the flower.

Materials

- Watercolors
- Ox-ear hair thin round brush
- 120 lb (250 gram) medium-grain watercolor paper

The large area of yellow color represents the petals that form the flower. To begin, the area of color is spread and its outlines are touched up with the tip of the brush (without making a preliminary drawing). A glaze is then added with more saturated yellow after the paint is completely dry.

The successive strokes of color do not mix at any time because they are always applied over dry paint and also because the glaze has not been applied repeatedly or rubbed with the wet brush.

The brush, wetted in water alone, creates a white area in the center of the flower, which allows the internal details to be painted.

The contrasts between the various glazes
of the same color have created a realistic
effect in this representation, which has
been done with the watercolor glazing
technique, or "wet on dry."
Work by Mercedes Gaspar.

This blotch of color was created by
applying saturated paint over the
completely dry background color.

After painting the
central color, and
before it dries out
completely, we dab
the area with a
cotton rag in an
effort to absorb
some of the
diluted paint.

After lifting the rag we can see
the glaze, which is irregular
due to the partial absorption
of the paint.

Glazes with watercolors and white chalk

Glazes are applications of transparent color. Watercolors are always transparent. From this we can deduce that all watercolor paintings are glazes. The reason for including this exercise in this section is that its intention is to create a variety of transparency effects, rather than a faithful reproduction of the subject. The subject barely has any significant forms, yet the artist has made a very interesting piece thanks to the accumulation of superimposed tones. These tones have been applied on wet and on dry paint. The strokes on dry are the ones that preserve all the chromatic appeal of glazes.

Here, the paint itself, its transparencies and glazes, are the true subject. The natural subject matter is only an excuse to use glazes and color combinations that enhance the surface of the composition. Work by Ricardo Bellido.

Almost the entire surface of the paper (with the exception of the horizon) is reserved for wide strokes of very diluted color. The subsequent applications of color will enrich these areas chromatically without adding more figurative representations: the play of colors alone will be the main feature.

The rows of tilled field are painted with the tip of the brush after the base paint is completely dry. It is very important not to repeatedly go over the painted areas in order to prevent the new applications of wet color from diluting the lower layers.

An application of white wax keeps the color from adhering to the surface of the paper, creating a characteristic speckled color effect.

White wax applied to watercolors enhances the glazing effect. The wax repels water, resisting and pooling the color in scattered areas when paint is applied over it.

The furrows of tilled field are represented with crisscrossed brushstrokes that maintain their shape and color and let the color of the background come through in the form of a glaze.

In this area we have applied glazes on dry and on wet. On the glazes over dry paint, the edges of the area of color are clearly defined. On glazes on wet, the color spreads out at random.

Materials

- Watercolors
- Sable-hair thin round brush
- White wax
- 140 lb (300 gram) medium-grain watercolor paper

Glazes with watercolors and gouache

The colored background was painted with brushstrokes applied liberally in different directions. The color of the brushstrokes varies in brightness (depending on the solution), as well as in form and size— some are rounded, others have a spiral shape—all of them forming a very lively background, which will be the chromatic base for the painting.

Watercolors have a natural tendency toward glazing effects. They are difficult to avoid. Faced with this, most artists choose to emphasize the transparency of watercolors to the maximum and to make as much use of this characteristic as possible.
In this example we can see how the dotted effect of the transparencies, emphasized by the general application of white gouache (also as a transparency), can make the glaze the centerpiece of an entire painting. The colors are applied with short multicolor brushstrokes, which enhance the vitality and color of the theme that by itself is already very colorful.

Other than as a medium for creating glazes, white gouache is used directly in this piece to highlight the white parts of the flowers that have been hidden behind the multicolored brushstrokes. Used diluted, gouache paint provides some degree of transparency, while when very diluted it allows the color to completely show through.

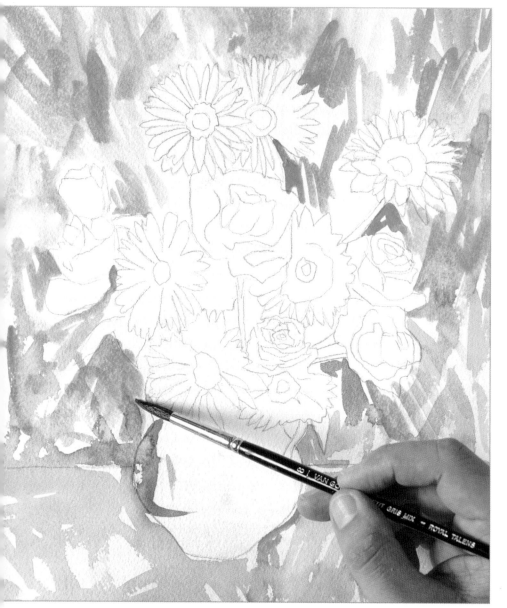

Materials

- Watercolors
- Synthetic-hair thin round brush
- White gouache
- 140 lb (300 gram) fine-grain watercolor paper

The gouache was applied when the watercolors were completely dry.

The brushstrokes that form the background consist of applications of complementary colors (blue and yellow, mainly), which are superimposed as transparencies, wet on dry.

The multicolored brushstrokes of the background maintain their unity thanks to the transparent applications of white gouache. The short brushstrokes form a continuous web of color that unifies the contrasts of the bright tones, and enhances the background. Work by Gabriel Martín.

Over the background of the canvas, which has been painted with dabs of color, we have applied a few brushstrokes of very diluted white gouache. The gouache is transparent and lightens the color effect.

The shadow of the vase is the result of overpainting brushstrokes of lilac and mauve colors over a dry layer of yellow (the complementary color of mauve).

Glazes with acrylics

A brushstroke is an inevitable result of painting, but it can have an important decorative value in the final appearance of the work. The presence of glazed, sweeping brushstroke marks adds vitality and variety to a colored surface, and prevents it from looking dull. Acrylics, if they are very diluted, allow this glaze effect in both opaque and transparent colors. These are ideal for covering and enhancing areas of color that are very light and homogenous. This treatment requires an energetic and decisive technique; there is no room for details that interrupt the quick movement of the brush.

For a treatment where glazed brushstrokes are the main characteristic, it is vital for the brush to be able to glide smoothly over the surface of the painting. This is why supports that have too much texture or that are too absorbent are not recommended. Therefore, fabric is always preferred to paper, wood, or cardboard. Diluted acrylics provide a similar effect, although less luminous, to watercolors in these first phases of the work.

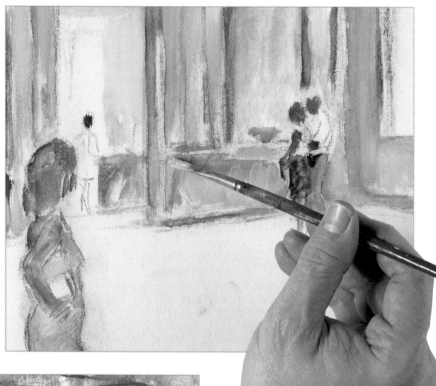

Applying the color by alternating light and dark areas emphasizes the visible presence of the brushstroke. In this work the atmospheric treatment and the luminous vibration find their place in the transparency and in the delicate color and force the application of substantial shading, which is carried out through vigorous brushstroke work.

Materials

▨ Acrylic paints
▨ Synthetic-hair flat and round brushes
▨ Canvas boards

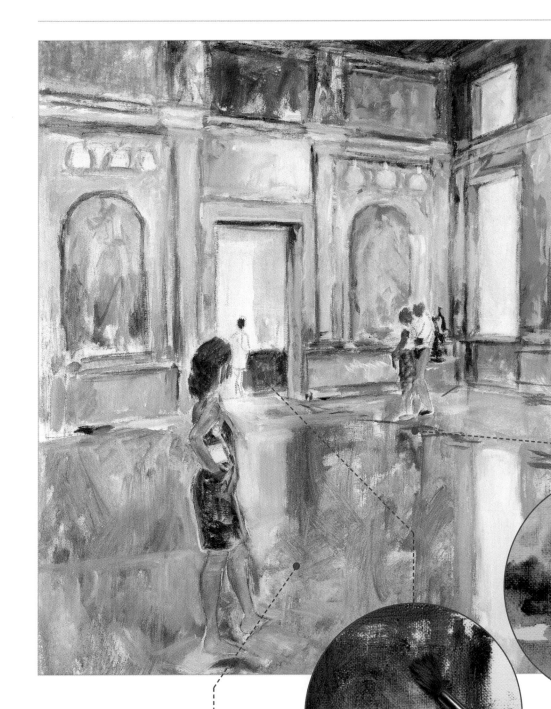

For the brushstroke marks to be clearly visible it is advisable to use transparent colors that can be reinforced with opaque applications, like a few white strokes in areas that define the architectural shapes. When the layers are superimposed, the color darkens and becomes a little more opaque, but the brush marks remain and maintain the suggestive interior atmosphere full of reflections and highlights. Work by Josep Torres.

Ochre is an opaque color that, when very diluted with water, produces transparent glazes.

The earth tones used here are transparent and therefore do not require much water for use as glazes.

Here the work has been done wet on wet, letting the colors blend together when they are applied on the canvas.

Direct mixtures with oils

Not everything in oil painting requires preparation and layering, and constant sessions. Sometimes it is a good idea to forget all that and to paint with oil as if it were a simple medium without complications; taking just a few colors and applying them in a spontaneous manner, without too much mixing and with thick brushstrokes from the beginning. In the example shown on these pages, the artist began painting without a preliminary drawing, giving form and color to each leaf and each flower in a direct manner and without any fear of making mistakes. Working like this provides certain freshness to the piece, especially when the desired result has no light nor spatial effects that complicate the theme.

Even though the working method is very direct, the phases are still distinct. First, all of the leaves are painted with a similar color to immediately resolve a series of characteristics in the motif: the size and the shape of each leaf have been defined with the tip of the brush and without hesitation.

The paint is applied thick, without using any solvent, and the artist accumulates layers each time that he or she adds a shade, lightens a color, or reinforces a shadow. For the brushstrokes to acquire all their potential, it is important to leave some empty spaces between them.

The thick and tactile brushstrokes suggest the complex form of this flower in a very direct and effective way. The purpose of the work is precisely this: immediate results without complications.

The colors of the flowers suggest their shape and volume without being completely finished, and this gives a spontaneous and casual touch to the work.

This vase with flowers has been painted without a preliminary drawing, or grisaille, or initial watercolors; everything has been quickly carried out with direct and thick applications of paint that form the shape of the leaves, flowers, and the base, the same way, for example, that a watercolor artist would do a quick sketch. Work by Óscar Sanchís.

Almost all of the leaves have been painted with very few dense and elongated brushstrokes that describe the form while they provide color.

Materials

- Oil paint
- Flat and round bristle brushes
- Canvas board

Direct mixtures with watercolors

The random effect of watercolors is enhanced by directly applying them to the paper wet on wet, that is, by applying areas of color over paint that is still wet. This unpredictability factor makes painting on wet more watercolorist than painting on dry. Applying layers of color and glazes over dry paint without letting the colors blend together on the paper, provides crude, rigid results that lack atmosphere and resemble children's coloring. On wet, things are different: the colors acquire a glazed appearance, an element that provides depth and a characteristic "ambiénce" to the work.

The result is spongier than when working on a dry ground. Painting wet on wet, overlapping colors, is always more pictorial than painting on dry. The colors blend and bleed into one another, and unexpected tones and combinations appear.
Work by Mercedes Gaspar.

The first strokes are applied with abundant water and also with a large amount of paint to create big areas of color. There is no need to go over the strokes repeatedly or to soak the paper; an even glaze with a few brushstrokes well charged with water and paint is sufficient.

Several yellow brushstrokes of very saturated paint and abundant water are applied over the wet red. Both colors form a mass of varying tones that are very dense and change with every brushstroke. This last application will be spread very smoothly and will produce unpredictable and interesting areas of diluted and saturated color.

Materials

- Watercolors
- Sable-hair thin round brush
- Cotton rag
- 140 lb (300 gram) medium-grain watercolor paper

To lengthen the paint's drying time, we added a few drops of water-based glycerin used for painting.

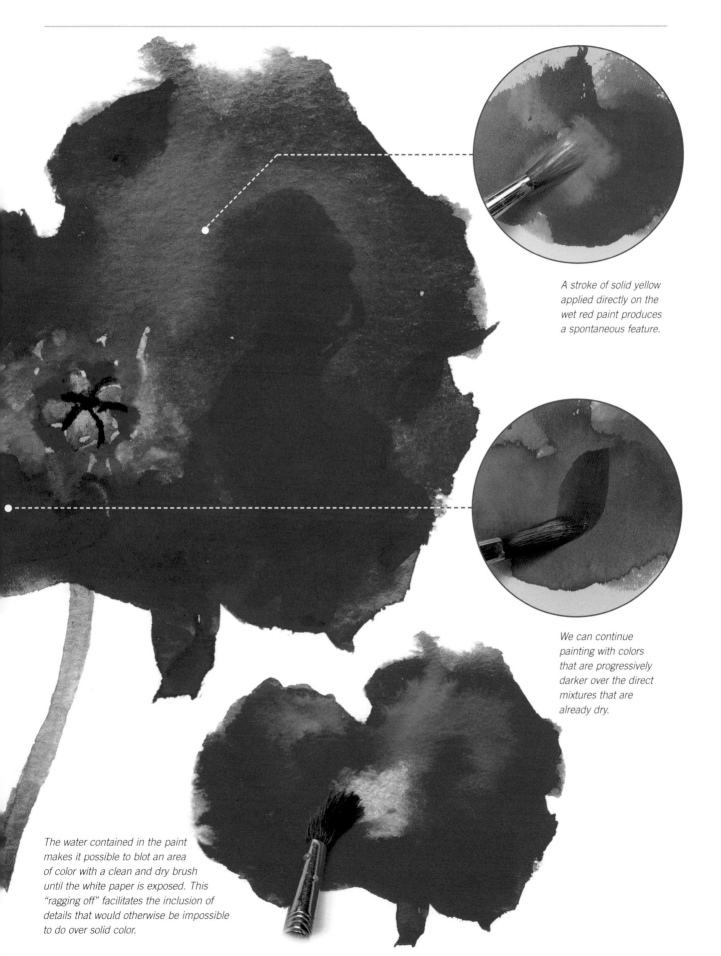

A stroke of solid yellow applied directly on the wet red paint produces a spontaneous feature.

We can continue painting with colors that are progressively darker over the direct mixtures that are already dry.

The water contained in the paint makes it possible to blot an area of color with a clean and dry brush until the white paper is exposed. This "ragging off" facilitates the inclusion of details that would otherwise be impossible to do over solid color.

Brushstrokes in direct watercolor mixtures

For traditional Chinese and Japanese artists, there is no difference at all between painting and drawing: the brush paints and draws simultaneously and every stroke is a form and a color at the same time. Something similar happens with watercolor painting, in terms of Western tradition: a brushstroke is not just another stroke among many others but rather a form drawn and painted. That is how important the brushstroke is in the direct mixture of watercolors: we can immediately see how the pressure and the movement of the hand and the smallest turn of the wrist affect the appearance of the color on the paper. By applying pressure on the tip of the brush we get thick lines full of water. On the other hand, the lighter the pressure the thinner the lines will be.

The shape of the hair on the brush plays an important role when working with direct mixtures. Round brushes are good for painting varied brushstrokes, and flat brushes can be used to apply blade-like effects and lines that have perfectly uniform thickness.

The overall purple tone changes according to whether the paint is applied on an area of the background that is very thick or very diluted. Work by Ricardo Bellido.

The background consists of areas of color applied over each other wet on wet until a chromatic ensemble is formed where the brush creates random forms.

The shapes of the leaves are a direct result of the shape of the brush when applied on wet. The color dissolves a little on the background that is still wet.

The red highlight on the fruit has been obtained by applying a small amount of color with the tip of the brush on the yellow paint that is still wet.

Painting and drawing is the same thing when we emphasize the brushstroke. The differences in thickness, tone, and intention provide all the charm to these leaves, which have been painted on wet. Their tone is the product of colors mixed directly on the paper.

Materials

- Watercolors
- Ox-ear hair round brushes
- Synthetic-hair flat brushes
- 140 lb (300 gram) heavy-grain watercolor paper

Direct mixtures with acrylics

The contrast, the surface variety, and the diversity of treatments that can be created with acrylic paints inspire an endless array of applications. Mixing colors directly on the paper is one of them. It has some inconveniences: acrylics dry very fast (especially if the colors are very thick) so the work must be done expeditiously before the paint dries on the support. Direct mixtures, therefore, are based on the continuous application of paint, layering tones mixed by rubbing or dragging the brush. In this example, the brush-strokes are applied in an organized fashion, as if they were scales.

The tree leaves are a mixture of emerald green and various yellows, lightened a little bit with white in the most illuminated areas. All these colors are applied successively, mixing them on the support before they dry.

The overall color of the treetop is achieved by superimposing colors while they are still wet. The tones are very similar, but no one area is identical to the other. This provides variety to the colors while maintaining the unity of the form.

Here the blue greens have been applied with diluted brushstrokes that are mixed without blurring them completely.

The way the brushstrokes are arranged is reminiscent of a scaly surface. They blend partially with the previous colors, having been applied when the previous layer was not yet dry.

In this area the brushstrokes are almost completely blended, but their direction and arrangement are still visible.

Green can be created by mixing a random variety of colors. The richness of the gray in this motif can be achieved thanks to the multiple possibilities and the different nuances of this color, which can be obtained by mixing yellow, ochre, blue, and white directly. The resulting greens are obviously "dirty" colors that are not very saturated, but rather greens with an ochre or yellow tendency. Work by Almudena Carreño.

Materials

- Acrylic paints
- Synthetic-hair flat and round brushes
- White cotton fabric

Direct mixtures with pastels

Direct mixtures on the support are the only viable way to paint with pastels because the colors are applied directly, with the stick laid flat on the paper; they can be combined, rubbed, blended, and layered over each other. In addition, pastels have good covering power, and like the rest (oils, gouache, wax, acrylic paints, etc.), the colors can be superimposed and lightened with white. With pastels we can repaint a color with white to make it lighter. However, as is common with procedures that have good covering power, overusing white has negative effects. In terms of mixing colors, it is better to mix to make them lighter rather than darker.

We have alternated hatching with hard pastels and rubbing with white pastels over the dark areas on the horizon. In this case alternating like this provides rich texture.

The result is very beautiful: the color mixtures and the white impastos for the highlights on the water have created a golden glow that is repeated in the sky and that unifies the composition. Work by David Sanmiguel.

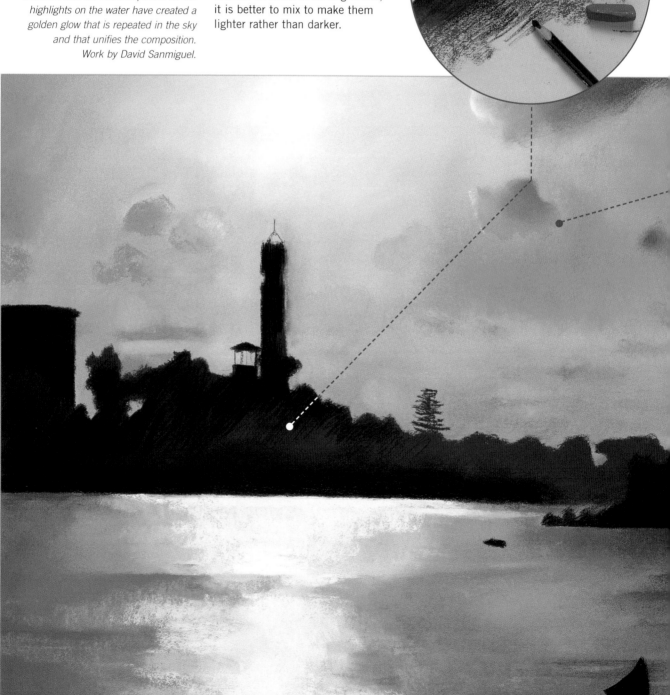

The atmospheric effect of the sky is based on the tone of the clouds, which is darker and colder than the sky, which maintains a warm color.

When painting with pastels we can use colored papers. The paper color is chosen according to the overall tone of the theme. In this case it is a cream color. The color of the paper establishes the half tone (the intermediate tone of the composition) and the first color applications correspond to the areas of greatest light: the highlights on the water and the sun. The color in these areas is spread with fingers.

Some reflections on the water combine rubbing and blending with color mixtures of the same tonal range.

The rag is used especially to spread the paint and to reduce the amount of pigment in it. This means that the rag becomes impregnated with pigment and leaves the paper smeared but not saturated with color. It is very useful for layering colors and for mixtures, or if the artist wishes the color of the base to come through when colored papers are used. In addition, the rag helps spread the paint on the paper over a much larger area than when working by hand.

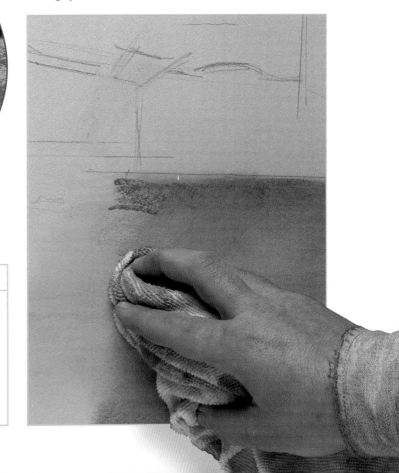

Materials

- Assortment of white pastels
- Sepia pastel pencil
- Charcoal pencil
- Sanguine colored hard pastel stick
- Cotton rag
- 72 lb (160 gram) ochre colored Canson paper

Impastos with oils

Oil paint is especially good for making impastos. The consistency of oil paint becomes thicker as it dries on the support, and the artist can take advantage of this characteristic to create interesting effects. The normal approach, however, is to work the impasto directly and without complications. This example is created with a very limited color range: ochres and grays. It may seem drastic to limit the palette to this extent, but it becomes evident that the variety of forms and the free treatment of the strokes and the impastos can produce interesting compositional effects that are very rich from a spatial and pictorial point of view.

The colored background, with a very saturated iron oxide red, can be painted from the beginning using either very dark or very light colors, and drawing outlines with black and white. The shapes of some of the objects are outlined with the saturated black and others with white. The drawing is not a complete representation but a tentative outline.

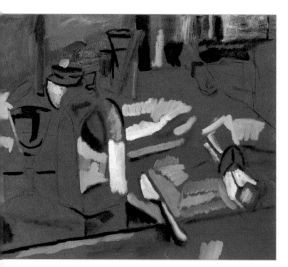

This work has been constructed with very heavily painted impastos. Some of these impastos reflect the marks of the brush going back and forth, others are so thick that they become large protruding lumps of paint. Work by David Sanmiguel.

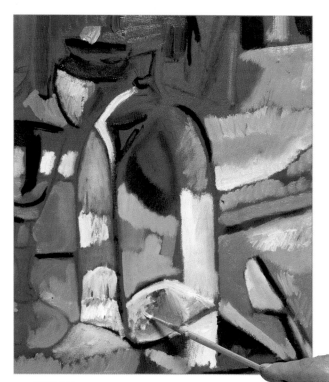

Against a warm background, the grays and blacks are very important to relax the chromatic monotony. The bottle glass is a good element to introduce a rich palette of dark and pasted grays and some blacks. The transparency is achieved by freely interpreting the highlights and reflections with impastos.

The impastos done with a brush adapt to the forms determined by the movement of the brush on the support: circular, straight, angled, etc.

Grays and blacks accumulate in this upper corner and the excess paint requires removal with the spatula. Oil impastos also involve eliminating what is not needed and adding applications of thick paint.

Over the accumulated paint, the highlights can only be applied in large lumps of paint, which shows very obviously the large amount of material employed in this type of painting.

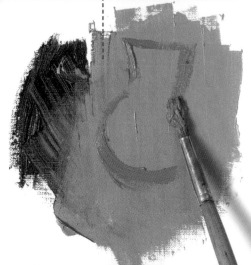

The form can be defined with a line drawing also done with the paint, which highlights the blurry contours of an object.

Materials

- Oil paints
- Flat and round bristle brushes
- Spatula
- White cotton fabric

Impastos with a spatula

Spatulas have their own, distinct place in the oil painting world. The technique is like a genre in its own right and it has many practitioners. Other than the manual difficulty involved, painting with a spatula depends on a skilled technique, which otherwise may have monotonous and repetitive results if the artist is mechanical in his approach. However, if the artist develops a good rapport with this tool it can provide very interesting effects that enhance the richness of the material and the sumptuous creaminess of oils.

Materials

▨ Oil paints
▨ Spatula
▨ White cotton fabric

The initial drawing has been done with very diluted oil paints working with the tip of the brush (a thin, round synthetic-hair brush).

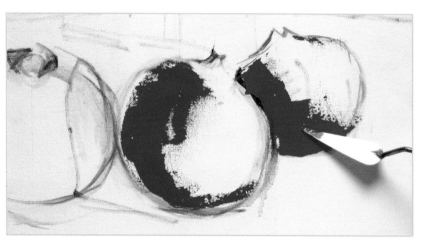

There is no blending nor smooth transitions from light to dark colors: the modeling is done with separate applications of paint that are mixed randomly with the spatula.

Each application with the spatula creates an area of color that has irregular outlines that are difficult to predict. The artist mainly stays within the contours of each fruit and paints the interior forms randomly. The colors (reds and cadmium yellows) are mixed directly on the fabric with very little mixing at all on the palette.

The charm of the spatula rests in the way colors are painted next to each other in a manner that appears to be accidental. There is no blending nor smooth transitions from light to dark; modeling is done with separate lighter or darker applications.

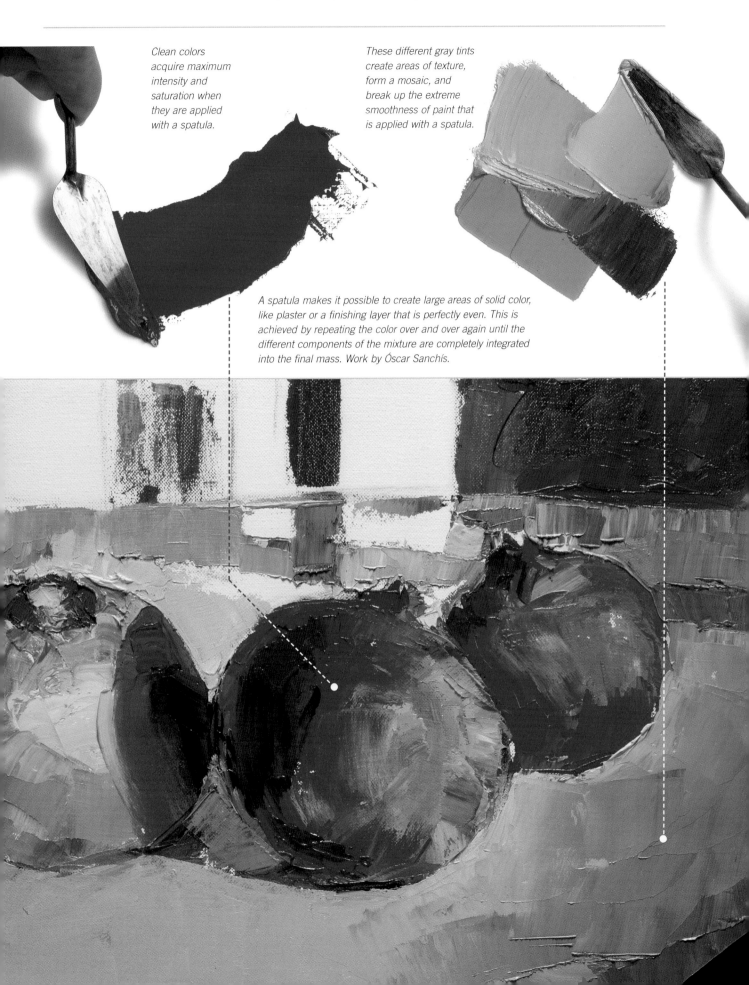

Clean colors acquire maximum intensity and saturation when they are applied with a spatula.

These different gray tints create areas of texture, form a mosaic, and break up the extreme smoothness of paint that is applied with a spatula.

A spatula makes it possible to create large areas of solid color, like plaster or a finishing layer that is perfectly even. This is achieved by repeating the color over and over again until the different components of the mixture are completely integrated into the final mass. Work by Óscar Sanchís.

Impastos with pastels

The word impasto seems exaggerated for describing pastels: this is a dry medium and the idea of impasto always seems to imply a creamy paste that is applied with a brush or a spatula. However, the chromatic density of soft pastels is suitable for applying color the same way as impasto: very thick strokes with good covering power that reflect the accumulation of the pigment. In this example, we show this accumulation effect that should be carried out only in the final phases of the work, when all the areas of color and the chiaroscuro and blending are properly resolved.

White impasto is painted over the diffused base color to represent highlights.

As with any work done with pastels, the drawing, planning, and initial coloring is done sparsely. If we use impastos from the beginning, the texture of the paper becomes saturated with pigment and makes subsequent work more difficult.

Here the impastos include colors that are not typical of a pomegranate but rather respond to the reflections on a polished surface.

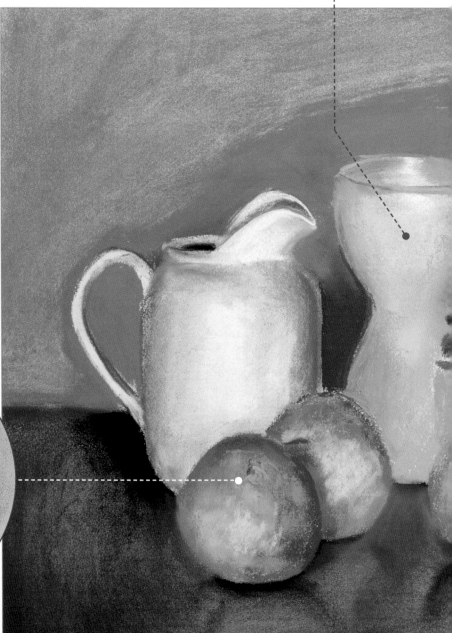

The colored impastos are applied with very similar sizes and forms that suggest the silhouette of the dry flowers.

The colors are placed by extending the areas well, trying to distribute the pigment correctly over the entire paper to avoid an excessive accumulation of paint.

The leaves, pomegranates, and the white highlights on the objects are finished with color impastos. We can see on the details a chromatic density that emphasizes the volume and creates a suggestive pictorial quality. Work by David Sanmiguel.

Materials

- Soft pastel sticks
- 72 lb (160 gram) white Canson paper

Impastos with acrylics

The style of impasto developed in this example consists of constructing the subject through the accumulation of thick paint, as it comes out of the tube. A style also known as "pointillism," or systematic development of pure color applications, creates the effect of chromatic mixture. This mixture occurs only in the eyes of the viewer, because on the fabric or on the paper each stroke is an application of pure color and the brushstrokes do not blend together. The term systematic really defines the essence of pointillism: the texture of small dots should be continuous and homogeneous, without any areas reserved for any other treatments. This texture is achieved only by using the impasto technique with undiluted paint.

The quick drying time of acrylic paints suits the impasto style. This speed is the reason why the colors do not blend together on the support and destroy the texture of single color dots. If the first phases are carried out with paint that is quite diluted in water, the drying is even more complete and the risk of mixing is further reduced.

The pointillism technique with a dry brush can easily result in the accumulation of areas that are full of texture. This can enhance the work as long as the accumulation is the result of small brushstrokes. If, on the other hand, this is an area in which there are very many large and heavy areas of color, the final result can be overwhelming and lack vitality.

Materials

- Acrylic paints
- Flat bristle brushes
- Round synthetic brushes
- Canvas board

Sometimes, it is a good idea for a few brushstrokes to blend together with the previous ones to create intermediate tones.

The accumulation of very thick dabs of paint on a dry layer reinforces the value of each brushstroke, even when very similar shades are involved.

This still life owes its color appeal to the pointillist separation of the impasto color strokes and to the characteristic texture of all its brushstrokes. The color has seldom been mixed on the support: the brushstrokes maintain their personality and their individualism. Work by David Sanmiguel.

Here, the brushstrokes are longer and more irregular to give the piece an overall lighter feeling and to avoid repetition.

Impastos with wax

Waxes or oil pastels are a transparent media that can be worked easily. Normally, they are associated with use by children; however, the color saturation and their immediacy are very appealing to professional artists and amateurs alike. Wax can be applied as an impasto to a certain degree: given that it does not need to dry it cannot produce a pasty consistency and when the work reaches a certain degree of saturation, the piece should be deemed finished. In this example, the transparency and the versatility of a medium that is not widely explored by artists are both very evident here.

The approach of the work consists of distributing the large areas of color with lines. The wax lines are thick and it is useless to try to work with precision. The artist must accept the crudeness of the medium and use it to his or her advantage.

The layering of lines and colors reaches a point in which the color saturation does not allow further applications. Waxes do not dry or harden completely: each new application has an impact on the color of the background. Excessive layering ruins the final effect. That is why the finishes should be light. Work by Josep Asunción.

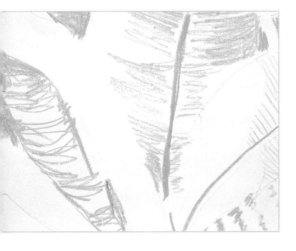

A few lines made with a craft knife leave marks on the paper, which are enhanced by the superimposition of colors.

The wax makes it possible to create fields of color with ease. It is a transparent medium and therefore bright. The typical light and transparency effects of wax are perfect for this motif, where its particular characteristics are displayed.

The yellow strokes of color cover and unify the green strokes, creating an area of luminous transparency.

The white gives some opacity to the color and enriches the texture of the strokes.

Materials

- Oil pastels (wax)
- Craft knife
- 72 lb (140 gram) drawing paper

Impastos with oil sticks

The size and the direction of the brushstrokes can greatly affect the way the work is arranged. A painting done with wide brushstrokes indicates a focus on how the objects are arranged in terms of areas of color rather than the gradation of values, which pursues a vibrant overview of the chromatic components of the theme. In this example the brushstrokes are replaced by strokes of color painted with oil sticks. The clear presence of the strokes and the impastos in the final phase not only form part of the work but give it personality; their direction and size could vary, but they could not blend together completely without destroying the integrity of the piece.

The drawing of this dog is done with an ochre oil stick. It is a very simple drawing, based on a more or less continuous line. The ochre integrates perfectly into the range of earth tones that was chosen.

To make sure that the color blends completely it is important to press hard on the stick and accumulate material.

The darker areas of the animal are painted with burnt sienna. The intermediate tones will be a mixture of the latter and ochre. The color is not dissolved with the brush, rather the stick is rubbed against the fabric persistently to build up the material and emphasize the texture.

The thickness of the impasto covers the support completely. If enough pressure is applied on the stick, the colors will blend evenly.

There are no color blends, or modeling, or continuous gradations. The approach that has been used here is basically the application of thick and contrasted areas of color to evoke the quality of the animal's fur. Work by David Sanmiguel.

Rubbing without pressing too much produces light impastos that allow the texture of the fabric to show through.

Materials

- Oil paints in stick form
- Canvas board

No solvent has been used in this work.

Reserves with oils

The differences between line and color can be explained in many ways, but almost everyone agrees on one point: the outlines of the forms are a product of the contrast between areas of color. The areas left unpainted, in reserve, are also part of the overall piece. In this subject, the areas of pure color can convincingly represent every flower without the need for modeling, color, or brushstroke blends.

The final result is very fresh and luminous, enhanced by the cool and soft colors that cover the composition's background. Using a completely chromatic approach, the painting is worked as if it were a continuous canvas where every color corresponds to a form.

The forms that decorate the tablecloth have been painted with quick strokes of the tip of the brush.

The drawing consists of very thin brushstrokes of diluted carmine, enough to join the areas of color with those lines. Ochres and yellows are the warmest colors of the palette, and around them, pinks, mauves, and a cool tone like violet can be incorporated quite naturally.

The work is carried out with a small amount of paint: it should be creamy enough for the strokes to be opaque and covering, but without thickening the fabric and creating a heavy result. All of these are sharp and fresh colors that produce an attractive atmosphere in the painting.

The final result shows a lovely blend of light and fresh tones enhanced by a blue sky in the background, without modeling and unnecessary darkening effects. The areas left in reserve, unpainted, suggest more flowers and leaves. Work by Yvan Mas.

The flowers are created with separate and very light areas of color. The parts left in reserve, unpainted, are part of the overall form.

The overall tone of the tablecloth is created with layers of very light paint applied with diluted brushstrokes.

Materials

- Oil paints
- Round bristle brushes
- Canvas board

Reserves with watercolors

The reserves are a way of defining the boundaries of the forms, in other words, of drawing. In watercolor painting, the forms are outlined by the colors that surround them. In fact, a good portion of watercolor painting is a work of reserves in different colors. Therefore, the reserves not only require talent for color but also mastery of drawing and a good eye for forms, since any form can be represented with a reserve, by painting only its outline. Reserves are usually made of light colors that must stand out against a dark background. The color of the background is the one we use to "draw" the theme.

Despite the various colors and shadows that make up this flower, the white reserved at the beginning is clearly visible. They form a truly bright drawing that stands out vibrantly against the dark background. Work by Mercedes Gaspar.

When making direct reserves, that is, drawing the objects by making reserves of the things that surround them, it is better to be spontaneous rather than too guarded. The areas that are resolved quickly and decisively usually give better results (even if the drawing does not look as properly finished) than the ones applied with hesitation.

When the reserve is finished, we can paint inside of it, creating all the light shades required by the motif. This drawing requires experience and spontaneity: the work should be approached without fear and with complete confidence. The outlines should be convincing from the beginning.

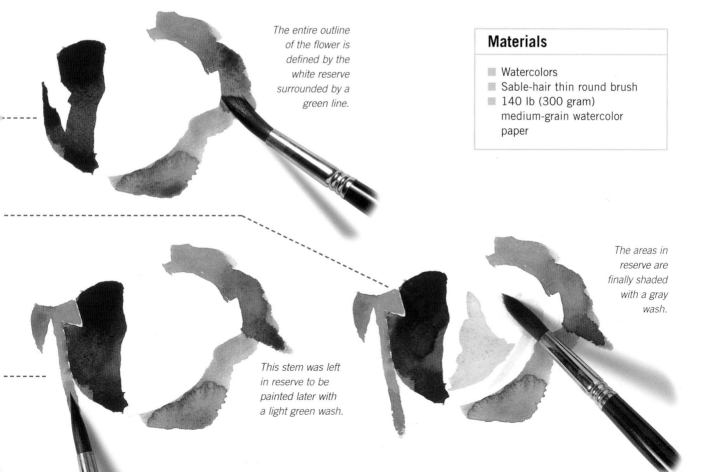

The entire outline of the flower is defined by the white reserve surrounded by a green line.

This stem was left in reserve to be painted later with a light green wash.

The areas in reserve are finally shaded with a gray wash.

Materials

- Watercolors
- Sable-hair thin round brush
- 140 lb (300 gram) medium-grain watercolor paper

Wax reserves in watercolors

White wax is the easiest medium for making reserves on paper when the reserves are so small that doing them with a brush would be too complicated, or else when the desired effect is one of texture rather than a tight representation. Wax repels water, and since it is so white, it works like a conventional reserve. The most important difference is that the wax lines leave random marks on the paper that would be impossible to obtain with any other typical method for making reserves. In this example, the wax is used generously and this produces a result that is unusual in terms of watercolor painting.

The complicated combination of dry leaves, snow, and the dense atmosphere of the background have been resolved very effectively with wax reserves and lines on the top of the central tree. This detail of the background, much more elaborate than any other on the foreground, reinforces the spatial effect created with the color contrast. Work by Mercedes Gaspar.

We have reserved several areas of the paper beforehand with white wax; therefore, the color only adheres to the areas that are not covered with wax: a light pink on the sky and a gray brown on the most distant areas of the landscape.

The white wax is also used to provide texture to very light color areas.

Incorporating pencil lines during the intermediate phases of the work is perfectly feasible. In this case, the pencil helps define small contrasts and adds details in some areas without altering the overall color: the farmhouse that appears in the distant background is a detail that can be created with this simple approach.

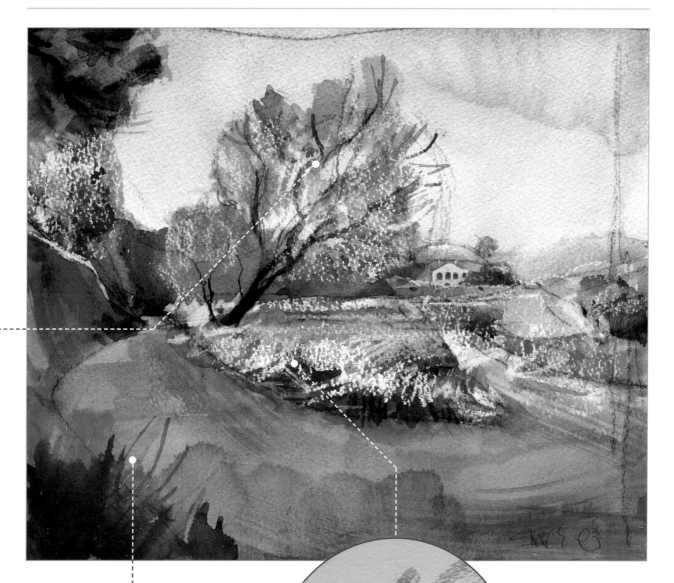

We have made white zigzag reserves that will suggest the texture of the terrain once they are covered with paint

Textured effects that represent the grass and the branches can be made by pressing hard on the wet color with the handle of the brush.

Materials

- Watercolors
- Charcoal pencil
- White wax
- (300 gram) rough-textured watercolor paper

Watercolor-like oils

The main rule of oil paints dictates that the dissolved paint should be applied first, followed by the thick paint. Paints lightened with mineral spirits (lean) dry faster than those rich in oils (oily). However, many artists prefer a light, watercolor-like finish, with strokes of color that allow the fabric to show through, and they seek very fluid colors that mix directly to promote an effect that resembles water-based paintings. In those cases, the artist should work with a good amount of solvent, applying the paint thick without any final touching up. The watercolor-like phase of oil paints is almost unavoidable and can be, as shown in this example, very interesting.

When the artist wishes to produce a work that has very diluted areas of color, the best is for the "drawing" to also be a series of brushstrokes in a color that is quite neutral (blue in this case) extended with a large amount of solvent.

In this work everything has been resolved in a simple and direct way with diluted brush-strokes. As in watercolor painting, the white is not present at any time and the light areas are the result of the fabric coming through the paint. Also as in watercolors, the unpainted areas lighten the feeling of the end result. Work by Óscar Sanchís.

Notice how the fruits can be modeled without the need for thick and covering paint. Some colors, like yellow and carmine, are more transparent than others (than red especially) and their effect is more luminous.

This form has been created by painting an area with very diluted orange. Red brushstrokes were added immediately following that pass.

Materials

- Oil paints
- Round bristle brushes
- White cotton fabric

Here the color is thicker than in the rest of the composition. Even then, there are some areas that have been left unpainted to define the volume of the fruits.

The points of cool light are areas that have been rubbed with a brush wetted only with solvent; the paint has been diluted to such a point that the white fabric is exposed.

Mixing wax with oils

Wax and oil paints are perfectly compatible. Both media are oil based and their solvent is essence of turpentine. In fact, some artists use wax combined with oils to obtain creamier and more transparent consistencies than the ones resulting from using conventional oil paint. In this exercise these media are combined successively: oils are the last colors applied on a scene resolved with wax colors. Solvent is used to extend the wax, and the oils are applied almost undiluted.

The oil paint is applied with a pointillist approach to evoke the thick foliage. The oils mix with the wax very easily so this way it is not difficult to integrate the brushstrokes into the large background color. Work by David Sanmiguel.

Wax colors can be applied freely, mixing them together, while trying to keep dark colors to a minimum to prevent them from altering the lightness and transparency of the chromatic harmony.

The darkest colors of the tree trunks and the branches are easily superimposed over the lighter background. As with all transparent procedures, we must always work from light to dark when painting with wax colors, leaving the darkest tones for the end of the session.

The leaves are oil color impastos that barely mix with the wax base.

The tree trunks are mixtures of greens and grays blended together with applications of solvent.

The color background has been covered with applications of wax and later with a layer of solvent.

Materials

- Oil pastels (wax)
- Oil paints
- Round thin bristle brush
- Canvas board

Solvent (essence of turpentine) has been used to dilute the colors.

Watercolor washes

One characteristic of watercolors is that they are especially suitable for all types of effects: the color can be diluted over and over again. This can be a problem, because some accidents can be fatal for a finished piece, but in the work illustrated here that factor is an advantage. This wash effect consists of undoing what has already been done by dissolving the areas of color with a general application of very diluted paint. The colors used in this theme have not disappeared as a result of the water: the color "ghost" of the original object remains.

The flower is painted in a conventional manner and without much detail. Generous amounts of paint and water are applied. The color is very permanent and penetrates heavily into the paper's fiber in such a way that it will remain visible even after the wash.

With a flat brush, the ochre paint is spread over the previously applied paint that is already dry. The color is spread and blurs the form, but the theme remains perfectly recognizable.

A piece of blotting paper is used in the areas where there is too much water to easily remove the excess liquid without making the paint dry faster.

Materials

- Watercolors
- Sable-hair thin round brush
- Ox-ear flat brush
- Blotting paper
- 140 lb (300 gram) fine-grain watercolor paper

Ochre is applied all over the paper after the flower has been finished. The brush passes over the design, blurring it and making the color bleed downward. The effect is very suggestive and its chromatic quality cannot be obtained with conventional methods. Work by Josep Asunción.

Acrylics with mineral fillers

Working with mineral fillers (marble dust in this case) is one of the most spectacular technical possibilities afforded by acrylics. This is a direct color technique in which the motif is constructed through successive brushstrokes or applications of thick and charged paint that are layered and mixed directly on the support to create the different nuances of the subject: a channel of seawater surrounded by rocks. This technique should be used on hard supports: heavy cardboard or canvas board. It is a good idea to use brushes with thick bristles and it is better if they are worn because then they can hold more pigment and more filler.

In the area reserved for water, the blue color is applied as it comes out of the tube and it is diluted with water for the lower part of the composition. A mixture of white and marble dust (a sort of mortar) is used for the light areas of the rocks.

The tone of the rough base is shaded with somewhat diluted colors. It is best to do this when the paint is completely or almost dry. It is important to have contrast between the rough areas (rocks) and the smooth areas (the water).

One of the advantages of charges is that the colors can be shaded and even modified by painting directly over the previous colors with a different color, covering them completely. The final result is a work of very thick impastos that convey a physical appearance of texture. Work by David Sanmiguel.

The seawater has been resolved by applying paint with a spatula over areas that were previously dampened.

The spatula has also been used to spread the acrylic paint mixed with the marble dust and the overlapping paint.

Some areas have been resolved by applying paint with a brush.

Materials

- Acrylic paints
- Marble dust
- Thin and round bristle brush
- Putty knife
- Canvas board

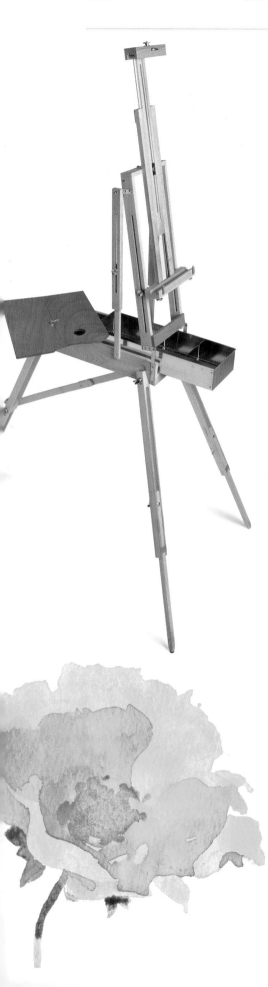

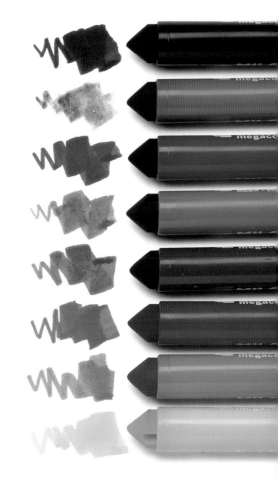

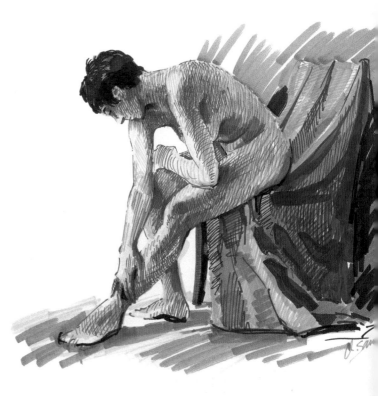

Complete Guide to

Materials

and Techniques

for Drawing and Painting